frank films
the film and video work of robert frank

Edited by
Brigitta Burger-Utzer, Stefan Grissemann

Steidl

Films and videos

June 2002, New York: I could have thirty minutes for a conversation, Robert Frank told me, after several letters went unanswered and I finally got his telephone number from a mutual friend. When I arrived at his building on Manhattan's Bleecker Street at 9 a.m., he sleepily took me into his tiny studio. Photographs were strewn about, half-open drawers, and the wooden cot from which he had obviously just gotten up gave the impression of a monk's cell. He immediately made it clear that he wouldn't be able to come to the retrospective of his films in Graz, and refused to reconsider even after I reminded him that it wouldn't be for another sixteen months. Somewhat intimidated and at the same time touched by his natural, modest and gruff manner of greeting me, I was unable to get a real conversation going. Frank rummaged around, looking for publications or texts about his films. In vain. He said that the Museum of Fine Arts in Houston might have some. Curator Marian Luntz would be the one to contact for videotape copies of his work. At precisely 9:30, his wife, artist June Leaf, called to remind him that the lawyer would be right there. Their house was in danger of falling victim to real-estate speculators.

This was my first and last personal meeting with Robert Frank. He refused to give an interview for this book. He doesn't give any, anymore, I was told matter-of-factly through the Pace/MacGill Gallery in New York.

After weeks of unsuccessfully searching for material—I already had all the tapes the museum in Houston offered, and Frank's Swiss distributor was unable to provide any at all—I turned to Frank again, disheartened. He gave my number to Laura Israel, his editor and partner in crime, and she promised to send me video copies, a few at a time. Master tapes had to be made for a few of the films first, though this would not be possible in all cases. They would now begin to process everything. I was surprised, but suddenly understood why Frank's films, with the exception of *Pull My Daisy*, are screened so seldom. It also became clear that we were in a sense pioneers, that the book and retrospective would be the first contribution to a comprehensive assessment of his film work.

Not a single tape had arrived by November of 2002. I sent Frank the first folder announcing the retrospective, which made use of a still from *Candy Mountain,* as no other material was available. Frank was enraged: He doesn't like *Candy Mountain.* He also rejected the accompanying texts and retracted permission to use his films, he even ordered us not to publish any of his photographs.

His modesty does not apply when essential matters are involved. The shy seismographer challenges and motivates in his own way. In December 2002, Stefan Grissemann and I went to Zurich; we wanted to finally see some of his relatively unknown films. Motivated by this experience, we then made a number of attempts to renew contact with Robert Frank, to win him over. After several weeks of uncertainty we received an OK for the book and retrospective through Frank's gallery. The condition was that no images which had *ever* been published anywhere could appear in the book. At first Frank insisted that video stills were the only visual material we could use. At first we were baffled that a photographer of his stature would allow publication of a book with only video stills. And after our initial communication, characterized by laborious detours and brevity, where did Frank's sudden and immense trust come from, his willingness to put the entire visual world of his films, his visual universe, at our disposal?

The "quality" of the book and retrospective were apparently of no concern to him. He wanted additional facets to be discovered in his works, he wanted them to be subjected to new tests. His idea of creating new film and video stills, while risky in an artistic sense, was his contribution to the "script," and influenced the project's character considerably. This idea wiped away his deep-seated fear of repeating himself and guaranteed uniqueness. Certain of his work, he opened up new creative spaces for us. Without realizing it at first, we would be actors under Robert Frank's direction. Respected actors he could constantly examine and question, in the same way he examines and questions himself and his work. Rejecting the myths surrounding his work and person and the *icons* already published in collections of his photographs was what gave us the freedom to make selections from his visual œuvre, arrange sequences, and in fact work with him.

He was satisfied by the very first samples we showed him, and even expressed concern about all the work we faced. When I told him that, despite the relatively low quality of the video images, his films developed in their mutated materiality a new concentration, and at the same time a unique expressive power, he cheerfully stated, "Yes, there is still something."

While doing research for this book, and certainly as a result of our close work with individual frames, we were surprised again and again by the richness of Robert Frank's (still unknown) motion pictures. Karl Ulbl, who is responsible for this book's visual design, Stefan Grissemann and I would like to thank Robert Frank for entrusting us with this richness, enabling us to gain new insight into his works, and for allowing us to help shape the visual analyses. And also, thanks for challenging us.

P. S. (November 08): A few months after publication of the first edition and the retrospectives of the films and videos in Graz and Vienna, I received a letter: "A belated thanks for this well done and elegant book. It surprised me—maybe I should apologize for being so negative—but maybe such a cold relationship had a positive effect, and we might meet again in this world. (...) Many personalities, some I know and others I don't, and even some random unemployed people, told me how well I presented myself. And so I'll bravely struggle on (bad leg bad feet right side) through the current landscape in NYC. But I hope to see Mabou again soon, the snow must have melted—A LITTLE SONG OF SPRING. To everyone who worked on 'frank films,' many thanks for everything, truly yours, Robert Frank." Before that we had already gotten positive responses from Peter MacGill, the authors (especially Philip Brookman) and many others: We were proud as peacocks. And after two years the first edition was already sold out.

Robert Frank has had a number of major shows and film retrospectives at important venues since 2003 (a selection can be found in the biographical section of this book), and his motion pictures can no longer really be termed unknown. New prints of his films and videos are being made by Laura Israel together with the MoFA in Houston, who have a lot of work finding the negatives. Gerhard Steidl is publishing a DVD edition of all "frank films" and a few unfinished fragments so that they're available in excellent quality, and not only for screenings. AND: R. F. is really struggling on in spite of his age. He's publishing new books, reworking earlier editions, taking new photographs, producing new film stills (their expressive power makes me envious), traveling to some of his shows, and has released two new videos, which are of course described in this book in words and images. His dark, melancholy art is still in the process of ripening.

Last but not least: June and Robert welcome me warmly whenever I'm in New York (which is not often enough). We also have a friendship via postcards and letters. I call it "a kind of ping-pong without competition, with a mirror in-between, so we both can hide." He calls it "from the 'drawer' of old acquaintances." Thanks again.

Brigitta Burger-Utzer

How does one approach an artist who has repeatedly avoided everyone and everything, including interpretation and critical examination? Robert Frank has always faced up to one thing only: himself. That is shown by his work, the films even more than the photographs. This book is dedicated to Frank's film and video œuvre, which grew and developed impressively in the years since 1959. He worked untouched by fashions and schools, his art literally growing out of and for itself, which is the reason it is so singular, so inimitable.

frank films, the first edition in German and English, this revised edition in English only, offers an introduction to that œuvre. Originally published primarily to accompany a retrospective of Robert Frank's films, it also provides detailed descriptions of all his works, representing a definitive and vivid portrait. The book's structure was chosen with the intention of assembling this œuvre in a single volume, thematically and chronologically, with all its stylistic wrinkles and abrupt changes in direction. The introductory essay, a tour of Frank's cinematic work as a whole, offers an initial overview attempting to identify his most important artistic tools and achievements. The following five essays address selected characteristics, styles and ideas which have shaped him and his work and search for recurrent themes and distinctive motifs in these divergent artworks. In the final section, each text is dedicated to one of his twenty-seven films or videos.

We hope that this book will help clearly show Robert Frank as the highly original and one-of-a-kind auteur he is. What is described here from a number of different angles and points of view is the paradox of Frank's films, which are so bluntly open but in many cases also mysterious and inaccessible at the same time. What is offered here, what must be offered, is a close look at a great man who refuses to make compromises, one of the last of his kind.

Stefan Grissemann

frank films was made possible by the cooperation and help provided by numerous individuals: Laura Israel, who has the best overview of Frank's film œuvre as a whole, was our ally from the very beginning; the Pace / MacGill Gallery in New York (especially Lauren Panzo and Peter MacGill) served as an intermediary for our communication with Frank: thanks for their permanent support; Christa Auderlitzky was able to find rare publications on Frank, performed a great deal of research, and was a reliable and committed proofreader; translators Charlotte Eckler, Barbara Pichler, Lisa Rosenblatt, Bert Rebhandl and Steve Wilder worked quickly and precisely; Jean Perret of Visions du Réel in Nyon was a source of numerous videotapes; Peter da Rin of Pro Helvetia, Switzerland's arts council, was an enthusiastic supporter and interested observer of our work; Marian Luntz helped us with information, various materials, and affordable rental fees; and Walter Keller of the Scalo-Verlag publishing house provided valuable tips for the first edition. Thanks to Alexander Horwath and Regina Schlagnitweit for their inspiration for this project. Many thanks to the Diagonale for the idea of honoring Frank's work with a retrospective and a book as part of Graz's role as the 2003 European Cultural Capital, and special thanks to Constantin Wulff and Viktoria Salcher for their trust that the book we had in mind was feasible despite a number of difficulties and delays, but without compromise. This second edition would not have been possible without the generous financing of Gerhard Steidl and the help of his professional team.

Vérité Vaudeville.
A Passage through Robert Frank's Audiovisual Work

Stefan Grissemann

"A decision: I put my Leica in a cupboard. Enough of lying in wait, pursuing, sometimes catching the essence of the black and white, the knowledge of where God is. I make films. Now I speak to the people who move in my viewfinder. Not simple and not especially successful."

This is how Robert Frank recalls the break that he made in his work at the end of the 1950s: no big deal, a simple logical result, an act filled with self-doubt but nonetheless necessary. The transformation from photographer to filmmaker did not provide him with success. On the contrary, the move contributed to the almost complete disappearance of the artist from all public discussion. Whatever Frank worked on after 1959 occurred (largely) in obscurity, his work slipped de facto underground, to the farthest flung borders of contemporary art. As a filmmaker, he has been a well-kept secret for almost five decades now. Among those who still know Frank today, he is primarily considered a photo artist—and perhaps, here and there, the co-director of two films which are in no way definitive for his work: the filmic Beat poem *Pull My Daisy* (1959) and the road movie *Candy Mountain* (1987)—productions, by the way, that Frank himself does not consider among his most important. Some authors who specialize in avant-garde film (such as Jonas Mekas, David E. James and Amos Vogel) also mention *Me and My Brother* (1965-68) and *The Sin of Jesus* (1961) peripherally. The vast remainder, Frank's complex cinematic œuvre, is virtually non-existent in literature and movie houses.

Frank's works often meet with strong rejection, and even disapproval among cinephiles. As film critic Andrew Sarris reports, the young Francois Truffaut once described *The Sin of Jesus*, 1961, as the worst film he had ever seen—and the legendary US critic Parker Tyler, in his classic work *Underground Film*, called Frank—as an aside—"inept and imitative," an "untalented and unoriginal" filmmaker. One of the complications in dealing with Frank's

works is being able to find such declarations of open antipathy at least somewhat understandable. A filmmaker like this, who is so demonstratively uninterested in any form of mediation, but only in his own ideas of living up to odd visions, will constantly encounter a great deal of misunderstanding along with the respect that he deserves.

If there were a term that could aesthetically outline Frank's work, it would be "fleetingness." Frank's documentary pieces, but also his fictional works, possess an unbridled love of the present, a devotion to the transience of the moment. Frank is a master of radical understatement, of refusal. His style, his language and his time is the present—as though he wanted to cross the constitution of his medium that keeps time alive, having it eternally reproducible as memory. Frank's films and videos contain—at least seemingly—hardly any "great" pictures and no "distinguished" moments. His films refuse "cinema." Anyway, Frank is not interested in being at the height of any type of "art." These films aim to be present for the moment only in two respects—the moment that they replicate, just as much as the moment that they are observed—to then immediately "retreat" from consciousness, as if they had never been there, like dreams that you can't really piece together when you wake up. These films are not made for leaving behind tracks, they remain pale, ungraspable, are more "atmospheric" than "pictorial." (If one looks a bit deeper, however, this impression changes: when reviewing stills from Frank's films, for example, a unique compositional beauty is immediately noticeable, a visual precision that is difficult to recognize in the films themselves. A constant fascination with this work lies in that it seems to play down, to even deny its own beauty to such an extent.)

Frank, born in 1924 in Zurich, was on the verge of artistic fame at the end of the 1950s (his controversial photo book *The Americans* was published in November 1958). Without hesitation, as though already bored by the sudden attention he was beginning to receive, he stepped into a new field: cinema. The entry is legendary: with the beautiful words "Early morning in the universe" Jack Kerouac's melodic voice introduces *Pull My Daisy*, to this day Frank's best known film, co-produced with the artist Alfred Leslie. Based on Kerouac's poetic tour de force, which the author speaks, sings and howls from off-camera in a veritable verbal jazz performance, *Pull My Daisy* takes place in Manhattan's Lower East Side as an inside view

Pull My Daisy – Gregory Corso

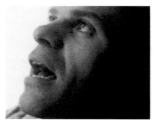

of the New York Bohemian lifestyle and the Beatniks' self-perception at the end of the 1950s. Frank and Leslie's *Pull My Daisy*—financed, by the way, by two Wall Street investors—demonstratively presents a remarkable artistic credo: what is cinema there for if not the everyday, the banal? The filmmakers and their artist friends (including Allen Ginsberg, Gregory Corso and Peter Orlovsky) show themselves, present their world, and put on no greater airs than is necessary when people decide to film their own lifestyle.

A room, an environment monopolized by art: the camera pans across an apartment, a loft downtown in New York, past bare walls and a few paintings. Disorder reigns, precious chaos, but only inside—the world outside is hazy, desolate, or at least it looks that way: the windows do not reveal much, the daylight that penetrates them and shines into the room is milky, impermeable, as if there were no sky behind these windows, no streets, no people. The film's protagonists—the poets, the poets' families and friends—stay indoors, take refuge in private space, half swallowed by the smoke of their cigarettes, in the orbit of beer and poetry: Beatniks (we learn here) are "inside people," *living room people*, commuters between clubs and bedrooms and bars and apartment buildings. *Pull My Daisy*—a home movie in every (and also the best) sense of the term—thus remains programmatically in the inner space: inside its characters, for whom and of which the film speaks; and inside the rooms that these characters inhabit. Kerouac, the demiurge of the narrative, synchronizes and melodiously describes the goings-on in a "spontaneous prose" that is omniscient and motivating, affectionately distant. The erratic voice-over takes on a foreign tone and repeats dialogues, only to distance itself from them a second later, to move back to the commentary, to escape into a narration based vaguely on the third act of a never-produced play by Jack Kerouac.

Pull My Daisy lightheartedly throws overboard what others believe cinema to be: the film delivers almost no "story," movement, glamour or great viewing value, but instead a cinematic stream of consciousness, an act of related poetry. Everything has to do with everything else if we only twist and turn it well enough, just like the words that Kerouac to himself, and we to each other, turn around in our mouths: baseball and religion, America and cockroaches, self-love and oblivion. The painter Alfred Leslie and the photographer Frank stage the

Pull My Daisy – Allen Ginsberg

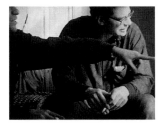

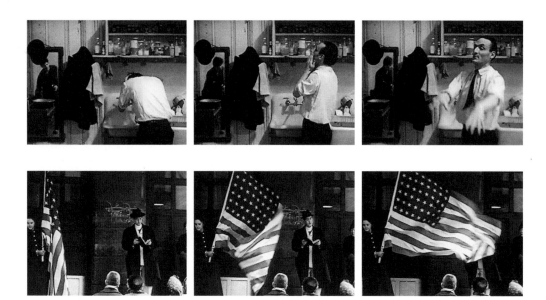

Pull My Daisy

documentary, the coincidental and improvised elements, and simultaneously they document the staging that they undertake. A comical tone is generated via this self-reflection and openness. The borders between fiction and documentary blur. This will remain a constant in Frank's later works. *Pull My Daisy*, not even half an hour long, juggles with genuine cinematic contradictions, with paradoxes that only cinema can create: "dialogues" are represented as monologues, a "story" as delirium, as fantasy, as pure sound increasingly released from "sense" and ambition—cinema becomes musical, lyrical, expressive, gestural.

 Pull My Daisy is a type of avant-garde film—but then again, it's not, in its very concrete social, semi-documentary portraits of life, which do not necessarily seek affiliation with the pioneers of New American Cinema. In any case, Frank's debut is a truly independent film, which through its conscious "amateur-like" form can be read as a piece de resistance directed at the highly polished styles of the US narrative cinema of the times. Together with *Shadows*, the contemporaneous, likewise decidedly jazzy directing debut by John Cassavetes, *Pull My Daisy* had its premiere in November 1959 in New York's Cinema 16: a double feature as a glance into the future of film art.

 Pull My Daisy permanently damaged the friendship between Alfred Leslie and Robert Frank. As soon as the film was complete, each began accusing the other of illegally and falsely stylizing himself as the actual creator, the director of the work. Until the present day it is not clear which of the two is right. Actually, one of the stories about this argument sounds like a cruel fable. Leslie, three years younger than Frank, reports on the genesis of the film (in a detailed interview in the book *The Naked Lens*, 1997) as follows: he, Leslie, had to first convince the "totally disinterested" Frank to participate in the production of *Pull My Daisy* as

a cameraman. When they then finished the film, Frank suddenly wanted credit as co-director. Because Leslie at the time considered Frank to be his best friend, he agreed to share everything. He would give him co-director credit if Frank in return allowed him to be named co-cameraman. Leslie placed only one condition on this: after ten years the truth had to be reestablished—and Leslie was to be recorded as the sole director in the credits. From that moment on, Leslie recounts, Frank did everything possible to be recognized as the driving force behind *Pull My Daisy*. He lied in interviews, used every possibility to play down Leslie's participation. Naturally, Frank's version of that story leads in the opposite direction.

In 1966, Leslie's studio burned to the ground. Twelve firefighters died in the blaze. Innumerable works by Leslie—paintings, writings, films—were destroyed in the flames, including a great deal of unused film material from *Pull My Daisy*. It was said that one could see the Beat poets in cowboy costumes in this material.

The sarcastic debate about holiness, which Kerouac introduces in a (famous) moment in *Pull My Daisy*, the contemplation of the sacredness in everything, in all things and pictures and living beings, continues in Frank's second film. *The Sin of Jesus* (1961) risks approaching a spiritual theme, which the filmmaker anchors quite decisively in the worldly realm. Frank's adaptation of the like-named tale by Isaac Babel (Leslie also claimed the idea to film this material) begins with the picture of a field, with a view of the gray earth. At first *The Sin of Jesus* is a film about work, about the farm labor and the housework of a young woman who complains from off-camera about the monotony of her existence ("day after day, winter,

The Sin of Jesus

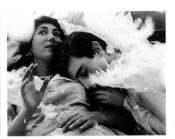

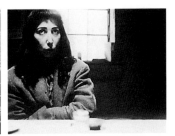

summer, winter") while her marriage falls apart under the pressure of routine. The heroine's husband, played by a young Telly Savalas (according to the credits "Telli Savales"), decides to leave "for a while," but one suspects that he will most likely be gone for good.

Frank sticks with jazz in this work, and the impression of a certain introversion is thus reinforced. The music of Morton Feldman very gently accompanies this chronicle of a Fall of Mankind by Jesus. A soft tone saturates the film, which seems, although not beautiful, strangely mellow in its visuals: it covers the animals, the landscape, the people. Even though Isaac Babel's short story has been categorized as magic realism, Frank holds less to the magical than he does to the realism. He imposes a great deal of documentary elements in his staging of a story, which, as we will see, is bizarre enough in and of itself. At first it seems to simply lead into a drama: the woman is pregnant, she attempts to talk her husband into staying, but fails. Instead, she only provokes him to an outburst. He crudely rejects her love and her call for help. He has had enough of her and this place, he barks. And we can see what he means: the hut in which they live in poverty and the fields of gray outside. Help is first attained by a retreat into transcendence. The abandoned woman (Julie Bovasso, with silent movie expressiveness) meets Jesus himself in her barn. Frank presents him and his companions as early hippies. Here the film slips into a (strangely mute) grotesque tale: a gaunt Jesus promises the woman an angel to ease her desperation, an "unhappy angel" named Alfred, whom she can have for four years, just for fun. Thus a marriage takes place, right then and there. A hippie happening results, a love fest among Bohemians. The new couple's joy is abruptly cut short: sex, which the woman demands of her new husband despite all warnings, leads to the angel's death.

Rather than forgiving her human fallibility, God scorns the woman from then on, therefore perpetrating the sin of not forgiving. The heroine despairs over this, becomes depressed and lonely. She does not need an angel, she calls out to Jesus, imprisoned in ever more extreme mental states. The film ends in the open field, once again entirely gray, with a final confrontation between the remorseful Savior and the proud, lonely woman: Jesus sinks to his knees in front of her, pleads with her to "forgive your sinful God". She leaves him, walks away, disowns him. The roles have been reversed.

During the early 1960s, the filmmaker Robert Frank was still in a searching phase. He was also occupied with themes and (feature) film forms, which he would shortly drop, which would not influence his later work. After his rough Jesus parable, *OK End Here* turned out as an almost too elegant urban story of everyday life reminiscent of Antonioni— another half-hour long examination of a relationship, whose smooth narration would remain alien among the artist's works. A type of search maneuver introduces the film, a tentative movement forward, to the core of the story, to the private: after a fast drive past a New York residential block, Frank's camera moves through the hallways of a spacious apartment toward its protagonists' bedroom, finds a couple still in bed, just waking up at that moment.

The young woman speaks more to herself, formulates the question of what a "deus ex machina" actually is. The man next to her talks about something else, informing her that it is time to get up. The day is not special; it has nothing to offer them. They are waiting for something that they just can't name, living alongside one another. There's nothing to do, and obviously they don't know what to do with each other (or themselves). There is calm between them, in weal and woe. Images of the city outside reflect in their windows. The conversations that they strive for seem like monologues rather than dialogues. The television has more of a tonal life of its own than they do. It temporarily drives away the silence between them, blaring, dramatic, enervating.

It seems as though a love has come to an end, which is what the film tells about: the young couple, apparently leading successful lives, are ossified in their ennui, they paralyze each other. The early scenes in the couple's bedroom, the soft jazzy rhythm in the narration and the soundtrack once again recalls Cassavetes' *Shadows*, shows intimate moments, including those of doing nothing, of waiting, moments nonetheless, unheard of in American cinema at the time. The title of the film, which seems to have been coined for the failure of the protagonists' relationship, also refers to the craft of staging by playing with the form of a director's order. It is only in this regard that *OK End Here* is a typical Frank film. In this refusal to see a difference between reproduction and reality, between art and life, he also gains energy and a certain pull. By the cinematic means he uses, Frank presents himself as a director who is already working with amazing stylistic certainty. Frank counters his heroes' boredom with a nervous montage and an extremely mobile camera. Autobiographical remnants in this film are to be found in its preoccupation with photography: the man is busy with pictures that he observes, among other ways, on a light table; later the woman will publicly explain that photographs "at least hold everything," that they "stop the passing of time." In the following years and decades, Frank's work will deal with precisely that point.

OK End Here

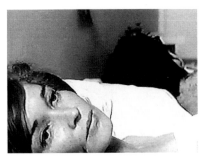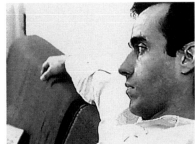

One must consider that the filmmaker does not show the central relationship from only one perspective, that he does not see it polemically, but analytically. *OK End Here* observes love as an ambivalent phenomenon, as a fragile affair. An intimacy is definitely traceable between Frank's two main characters, yet at the same time one begins to feel the narrow confines of that intimacy. The most minor disagreement can ruin everything; one word is enough to end a life together. Love dangles on a string. It doesn't take much to reach the edge. The man uses his lazy day to openly terminate communication: what should one talk about? he asks cynically. About politics? Films? Proust? "Just talk to me," she counters with resignation, and the honesty of this request shatters his cynicism. *OK End Here* is a bourgeois tragedy: without arriving at a reconciliation, the two receive guests and chat with them because the situation demands it. Almost the entire film takes place inside an apartment, just like *Pull My Daisy*, and like Frank's first film, it is essentially about presenting a specific lifestyle, revealing the actions and reactions of certain people under certain conditions: a laboratory setup—art as an arranged experiment. For the last few minutes of the film the protagonists leave their inside space, go out into a gray day. The couple walks through the fog, near the water, and reasons about the dreariness of their existence: they are childless; perhaps the relationship grew cold for that reason. In a small restaurant where they eat, a woman is crying; she reads a letter out loud. No one pays attention to her, not even the others at her table react. Everyone lives for themselves, everyone keeps to themselves. On the couple's way home at night she tells him that he's getting old. She had seen that in the morning. It's hard to decide if she sounds horrified or merely weary. *OK End Here* concentrates on things that one cannot speak about: a form of psychodrama, only without tragic peaks.

Me and My Brother

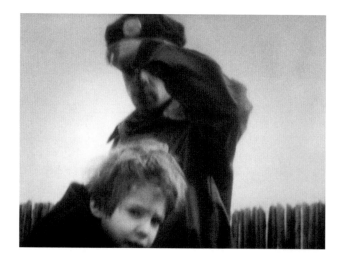

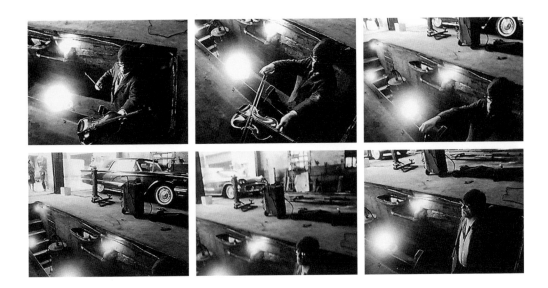

Me and My Brother

Frank was in no hurry with cinema. After three short films, in the mid-1960s he dared to make a feature-length film. Frank risked a lot with *Me and My Brother*, that evolved between 1965 und 1968, and as should be noted, his main aim was not to achieve success. He was about to shock all of those who until then had come to appreciate his "directness," his "realism" (Jonas Mekas, for example, in his "Movie Journal" in the *Village Voice* reacted to *Me and My Brother* with outrage)—and flung himself into one of his most complicated projects: a truly experimental, erratic, formally mannerist cinema about a handicapped, catatonic young man (Julius Orlovsky, brother of the writer Peter Orlovsky, Frank's friend) who accompanied the Beat poets on their tour and in their hippie life. Frank spent almost four years creating this film: it is without a doubt one of his major works, an opus magnum, far superior to both of his other longer works (*Cocksucker Blues* and *Candy Mountain*) in terms of ambition and substance. Here, for the first time, Frank filmed some sequences in color. Afterwards, he still felt a greater affinity to the black and white of his earlier films. It was only after his switch from film to video material in 1985 that Frank preferred sticking to color when filming.

What *Me and My Brother* engages in for an exhausting ninety-one minutes is self-reflection: it studies the conflict between the real and the imaginary—as well as cinema's more or less mechanical process of exchange between reality and "reality." Frank's first feature gradually intensifies to an artificially blazing, paradoxically only slightly "fictional" film that persistently deals with the medium itself: film staging, projecting and acting. It is also a piece, however, that questions and doubts its own "documentary power." If everything that is filmed (every idea,

every body, every room) is inevitably fiction anyway, Frank seems to say, then one can instantly dismiss realism as a concept—and begin to consider a new, completely different cinema: a cinema of the—only apparently formless—assemblage, which was becoming Frank's new form with *Me and My Brother*.

Subsequent to that film, which also marks an endpoint, only a return to simplicity could take place: *Conversations in Vermont* (1969) is actually the antithesis to *Me and My Brother*—a documentary of the barest kind, an examination of oneself, of the private, with no major formalistic intervention; apparently pure nature, set in the simplest words and images. Frank uses the film to ask his children, Pablo and Andrea, how they feel about the life that they now lead in the countryside (and to document it). Was this normal for them, after they had been in New York City for so long; what is "normal" anyway? *Conversations in Vermont* also emphasizes the artificiality of cinematic representation, no matter how "authentic" it may look. At the beginning of the film, the director is cleaning his camera lens, up close and out of focus. "Let's see," he says, and that sounds appropriate. Afterwards, he presents photos, goes through past moments of his life, or at least the few that he has captured. Frank adapts personal moments that he had once captured in still images, gives them back a measure of time, infuses them with life once again. This film, Frank says, deals with the past. But not only: it also tells of the present—of a present that he preserves with cinematic means, thereby directly making it a thing of the past once again. Frank gropes back through his own history, gazes meditatively at events that occurred nearly two decades prior, reports on his first marriage (to the artist Mary Lockspeiser), on the birth of his children. He shows all of this in pictures, in a consciously casually staged photo/film home movie. It is the first of its kind in Robert Frank's oeuvre— and it proved to be a lasting form: in *True Story* (2004) he still trusts the essayistic combination of motion pictures, still photography and voice-over narration.

But 35 years earlier, Pablo and Andrea were clearly at the center of the conversations. Frank approaches them cautiously, patiently, like a man who has something to clear up with them. Pablo reacts appropriately in the talks that his father wants to have with him: he appears to have retreated into himself, remains mostly reserved. That which is not stated in these conversations seems significantly stronger, more painful than everything that is actually formulated. Even though the distance between Pablo and his father (their "growing apart" that would become Frank's lifelong trauma) is directly addressed and articulated at least once, Frank's self-referentiality here cannot be overlooked—by appearing in front of the camera he makes himself the main topic although the film is actually supposed to be about his children. He has no choice: the author is too strong. "Maybe this film is about growing older," Frank says; a short phase of silence follows.

The filmmaker does not glorify life in and with nature somewhere in far-off Vermont; he views it as though it were something self-evident, lends it no romantic traits. They

work in a dark stable, eat in an untidy room, and live in the circle of an extended family. Frank stages the occurrences before his lens; he gives instructions not only to his children, but by force of habit to everyone else also, and one gets the impression that what is meant to be shown and proven thereby is not so much the authority of the filmmaker, but a small slice of truth. A difficult person casts a critical gaze upon himself. *Conversations in Vermont* requires less than half an hour for the many themes Frank brings up. The filmmaker's great compositional sovereignty, which is obviously not meant to satisfy documentary or narrative film conventions, assures the small wonder of this tightly woven, yet relaxed film. These conversations carry a belief in spontaneity, in the potential of the moment. The film ends with music, a choir, and the credits spoken by the director. Finally he claims, "I call this film *Conversations in Vermont*," then the pictures are cut off.

The years 1968-1970 represented a productive time in the life of the filmmaker Robert Frank. Two new works arose: besides *Liferaft Earth*, the documentation of a public hunger strike, an improvised "starve-in" at a parking lot in Hayward, California, it is mainly with *About Me: A Musical* that Frank achieved a further ironic study of his own inner life, a self-portrait that hides more than it reveals. The slightly absurd film title refers both to the

Conversations in Vermont

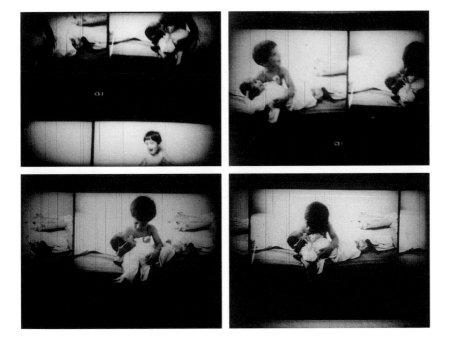

Conversations in Vermont – Robert & Pablo Frank

assignment that Frank took on, as well as to the rejection of this contract: beginning with the idea of making a film about music in America, Frank discards his job from the start, quite explicitly, to then return to what he knows best—himself. He decides to produce a self-portrait that immediately seeks Dadaist rupture: Frank introduces a young actress who is meant to play him. His enjoyment at the audience's and producer's perplexity is obvious. *About Me* demonstrates the filmmaker's pleasure in the fragmentary, the idiosyncratic. His films are personal (this one in particular) simply because Frank does not take his audience into consideration at all, does not answer requests for explanation.

 About Me: A Musical deals (also/again) with its own creation. Rather than autobiography, which the first part of the film title seems to promise, Frank places acting at the center, allowing moments of his psychologically unstable private life to be re-enacted. The artificiality of this venture highlights the lies or stylizations that are inevitably buried in every self-portrait. Again, music is a prime force, and again it leads to a conclusion in an otherwise very open-ended project: hippies recite poetry and make music ecstatically, in a cacophony. A little later, black inmates, dressed in white prison garb, sing gospel in the corridor of the building. Music resumes control and turns Frank's supposed self-portrait into a mini-musical at last (which, along the way, also permits social reflection and concise outsider studies); in the end, music rules over everything: the streets, the prisons and the artists' closets. "Life dances on," someone muses, thereby announcing the title of a film that Frank would shoot ten years later; but that fits as it seems to fit in all of this director's films: life dances on, incessantly, inexorably, while we are seldom able to take notice of it, so persistently involved with ourselves.

 A more explicitly political project than *About Me, Liferaft Earth* is the documentation of a campaign against overpopulation and malnutrition in the Third World. *Liferaft Earth* is not a documentary report in a strict sense, but more of a subjective film: as a political individual, Frank doesn't remove himself from his film; he joins the hippies' hunger

strike. But at first his political activism is not strong enough, he fails in his own good intentions. Frank subjects himself to his camera (once again as if in an act of atonement), recounting how deeply he has understood and felt the issues of the "hunger circus"—and how bad he felt when he had to prematurely leave his colleagues because of heavy rain. "I didn't have the guts," he admits, standing alone in front of the camera. Ruefully, Frank again joins the hard core of the group, which has meanwhile moved its hunger show to the woods near San Francisco. At this point the film becomes a record of hippie rituals: of trance exercises, group humming, howling and shouting. "Are you alive?" becomes the filmmaker's standard ironic question after days of fasting as he gropes his way from person to person in the big house that they all live in together. The film's style is impressionistic, the autumn sun pours into the house and onto the images. Frank continually finds ways to briefly break the apathy that has fallen upon those participating in the action. Some regard the fasting as a game, others choose to see it as a serious political duty; one admits on record that he got "pretty high" from it. At the end there are no less than fifty-two proud strike "survivors." Robert Frank makes the extent to which we should also consider *Liferaft Earth* as agitprop explicit: after a mention of President Richard Nixon, he polemically cuts to a grunting pig.

After 1970 Frank seemed exhausted, finished with film for the time being, looking for new beginnings in his personal life as well. He separated from Mary in 1969 to shortly thereafter begin a new life elsewhere with the artist June Leaf. They moved to Nova

Liferaft Earth

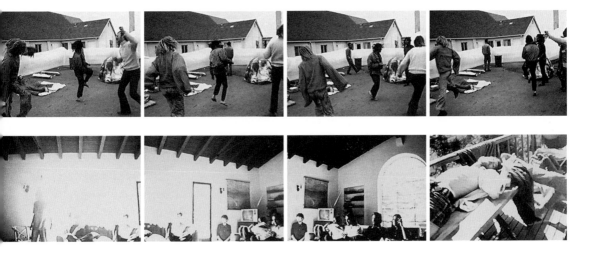

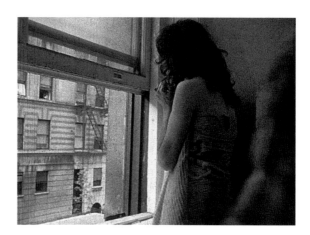

About Me: A Musical

Scotia, Canada, "at the end of a road," as he would later say. June and Robert built a house of their own with an ocean view. "I look out of the window. Often. For a long time. The cameras stay in the cupboard. I wait."

In the 1970s, Frank produced no more than two cinematic works after *About Me*, barely more than two hours of film. *Cocksucker Blues*, the documentation of a rock band's tour, Frank's second feature-length work, developed into a disaster in 1972. The Rolling Stones, whom he accompanied with his camera, did not agree with his vision. Mick Jagger, who had provided the initiative for the film to be shot during the band's North American tour, prohibited public exploitation of the work after it was completed. According to a court order, even today the film can be shown only once a year—and Frank must be present at the screening. It turned into an underground work, accordingly: the film circulated the world as a pirated video copy only, a pale, scratched shadow of itself. We can only speculate on Jagger's reasons for rejecting it: naturally, the pessimism with which Frank views the rock 'n' roll machine is hard to overlook. On the other hand, the band would never have picked him specifically if they had wanted him to create an especially glamorized picture of them. It is unclear what exactly led to the Rolling Stones' objection to a film that shows without compromise, without touching up, the less earth-shaking things that happen around a world-famous rock band on concert tour. Frank's film concentrates on one thing only: loneliness. Happiness is elsewhere. People take drugs, have quick sex on airplanes, but everyone mainly just waits desperately for each new step in the routine of their tour: for the arrival in some new city, for the check-in at some reception desk, which looks like all the others, for the concert to begin, for the night to end.

However, except for the musical parts, everything that happens in *Cocksucker Blues* is presented as fictitious; at least it says so right at the beginning of the film—"No representation of actual persons and events is intended." It seems obvious that we should consider these words an imposition from the producers; none of Frank's other films feature

About Me: A Musical

such a bluntly documentary style as this one; fictional interference with the apparently "authentic," which is not at all rare in the director's creations, is reduced to a minimum in *Cocksucker Blues*. Frank refuses all orientational guidelines; he introduces neither persons nor places, neither well-known nor unknown faces; he works without inserts or narrative, without a pre-formed, user-friendly "documentary" style. What can be seen and heard in *Cocksucker Blues* is often incomprehensible—acoustically and story-wise. No one speaks to the audience here; everyone keeps to themselves, within themselves, withdrawn, and in the end: everyone remains a riddle. Frank's extremely raw visual surfaces, his unattractive images, contribute considerably to the impression of a certain lack of form: a consciously vague, radically contemporary film.

In terms of content, *Cocksucker Blues* delivers things to be expected: Frank shows people at work, at work on music, at rehearsals and concerts; without prejudice he looks at faces, bodies and spaces. *Exile on Main Street*—the cover of which Frank designed—is incidentally the album that the Rolling Stones were promoting on the tour being filmed. Almost none of that can be traced in *Cocksucker Blues*. Frank is not interested in doubling the promotion effects, he is not even interested, for example, in making his clients look good. Frank does not consider the Stones to be stars; as a filmmaker he doesn't privilege them over their entourage; they are part of the world of this rock tour, no more. Thus we do not really learn (or even see) much of value here about the band itself: at one point, Keith Richards falls over unconscious, obviously under the influence—and a very staged sequence, which dimly recalls Nicolas Roeg and Donald Cammell's *Performance* (1970), shows Jagger in bed, touching himself and filming that in a mirror. Despite everything, reputation obliges: Richards throws a hotel TV set out of the window for Frank's camera. In another scene a girl, who is taking a shot of heroin, asks Frank why he is filming everything anyway. He doesn't reply.

The shaky camera circles or peers at the musicians, the technicians, the stagehands and the groupies, but constantly remains "outside," foreign to what it shows. In

marked contrast to *Liferaft Earth*, Frank does not look for involvement or participation; no fraternization between those filming and the ones being filmed takes place here. With *Cocksucker Blues* Frank bids a final adieu to the utopia of the Beat generation: the free space that casual sex and drugs had once promised has been transformed into a series of dreary hotel rooms in which there is nothing left to do or to gain. Boredom reigns, one plays cards, talks, keeps silent or intoxicates oneself (often in precisely this order). *Cocksucker Blues* is a depression piece, populated by the living dead who no longer even spread fear: a zombie film without peaks of suspense, offering no refuge into elaborate dramaturgy or explanatory sideways. Frank's path is direct cinema, in every sense of the word: cinema can't be any more direct. Frank's friend and soundman, Daniel Seymour, who shortly after this film mysteriously disappeared without a trace on one of his long journeys (the filmmaker would recall him with nostalgia in *Life Dances On...* eight years later), is named co-director in *Cocksucker Blues*. In the credits, Frank and Seymour make every effort (maybe under pressure) to cloud the borders between fact and fiction: they assign roles, as is done for actors, to all of those who have made an appearance. It is impossible to miss the sarcasm in this: Keith Richards, for example, is named as "1st TV Repairman."

In 1974, Frank's daughter Andrea, only twenty years old, died in an airplane crash in Tikal, Guatemala. Frank began to travel, to teach, he generated new energy from his marriage with June and their life together on the ice-cold sea—to desperately prove himself. He was not sure how to proceed with cinema. Nonetheless, he tried. For the time being, he stuck to "primitive" filmmaking; in an initial collaboration in 1975 with the screenwriter Rudy Wurlitzer, he began to shoot a small, basic feature film, outside, in the wind and in the sun, near the water, under the sky: they called it *Keep Busy*. Exactly what the film is about is hard to say: several people converge on a small island with a lighthouse, to play absurd theater with one another between wood trash and industrial waste, to improvise a piece before Frank's camera

Cocksucker Blues

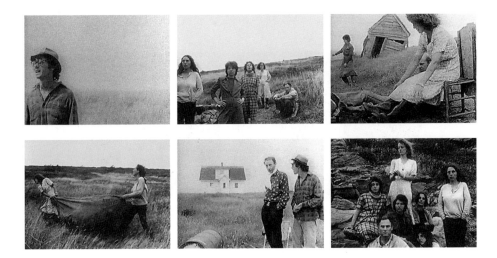

Keep Busy

in obstinate rituals and insistent, emphatically artificial texts. Apparently, a crooked, desolate cabin should be repaired and, later, dismantled. The wooden shack is a recurring motif in Frank's films, from the main setting in *The Sin of Jesus* to the location where Patti Smith and her band play their "Summer Cannibals" as staged by Frank. The image of the bare hut subsumes the basic impression Frank dreams of in his work: a simple life, art of poverty.

In *Keep Busy* people truly do remain busy, occupied; they talk about wind and weather nonstop, they clamber, romp about, and chat incessantly, make free associations, talk rubbish, make no sense. While the performers act like children, Frank also playfully subverts images; what his actors are doing here borders on performance art—for the first time Frank's filmmaking approaches fine art. The artist Richard Serra is among the actors. The style of the staging is agitated; the film is almost unbearable and nihilistic; there is nothing to bring to an end. It breaks off with a few bars of pop music and a radio report about the weather, which constitutes the film's mysterious running gag.

Along with that, Frank's cinema had come to an end also—for a few years at least. At the beginning of the 1970s he had rediscovered photography, the doors of the cupboard at home were wide open. In retrospect, Frank would say: "Since 1972, in the time left over between films or film projects, I have been taking photographs. In black and white or in colour. Sometimes I put several images together to make one. I tell of my hopes, my little hope, my joy. When I can, I put in a bit of humour. I destroy the descriptive elements in the photos so I can show how I am, myself. Before the negatives are fixed, I scratch words on: soup, strength, blind confidence... I try to be honest. Sometimes it's too sad."

Only five years after *Keep Busy* Frank resumed his cinematic work. With *Life Dances On...*, his tenth movie, he re-entered filmmaking in 1980, and this would introduce a phase of consolidation, a new concentration on the essential. Frank has worked (relatively)

Life Dances On...

steadily since 1980. He has completed new films or videos every one or two years since 1985. The commemoration led him back to film: "In memory of my daughter Andrea" can be read in *Life Dances On...*—along with the dates of her brief life: 1954-1974. The remembrance of Andrea (and also Danny Seymour) hovers over the film, but at first Frank seeks not the past, but the very present: a conversation with his son Pablo. Why can't he enjoy life, his father asks him. Pablo answers indirectly, with a wish. He wants to explore Mars, because he doesn't appreciate the Earth's gravity.

 Life Dances On... refers back to *Conversations in Vermont.* Both films center on Frank's two children, one of them now absent. The one who is (still) present turns out to be withdrawn, and, it seems, he has been so for a long time. Pablo calmly whistles, avoids his father's questions and his gaze. *Life Dances On...* sketches out a tragedy, a father's tragedy: the loss of both children. The second part of the film constantly moves away from these familial scenes to anecdotes, episodes that apparently have hardly anything to do with the prior shots. The film deals with people "walking on the edge," as Frank will claim later: A corpulent man empties his pockets in a rundown room that could be a prison. A boy in the street aggressively confronts a man who has directed a camera at him, opening up a debate that seems more like a series of insults. On another street, Frank and his little team stop a few people and half jokingly ask them to name five famous photographers. The name Robert Frank remains unmentioned at first. Only after the film team introduces the name is there someone who has once heard of Frank, vaguely. The art of fragmentation is one of the qualities that make Frank's work so difficult to comprehend and assess. But it is always precisely at the point when one thinks his films are actually falling to pieces that Frank finds his way back to the main thing: the personal. In the case of *Life Dances On...*, he finds his way back to Pablo and Andrea, to mourning, to pictures within pictures and films within the film, to this very special enigmatic mixture of found and staged material.

 Nothing comes about without energy: no life, no art. Frank's next film after *Life Dances On...* reports on energy and its retrieval, or at least that's the title's blunt promise: *Energy and How to Get It* (1981) turned out to be one of the director's most bizarre projects, perhaps

his most perplexing exercise in erasing the borders between fact and fiction. The film is about science and the desire to invent (the incidental phrase "it's science fiction" captures the point of the film), but also about the connection between talent and terrorism, the mechanisms of the (very artificial) crime thriller and life in (very real) solitude. *Energy and How to Get It* tells the story of a brilliant inventor, the constructor of an energy machine, who—at work in a hangar— is threatened by having to sell out on the one hand, and by mental ruin through bureaucratic and industrial hurdles on the other. Frank's old friend William S. Burroughs—who had already worked with the young cameraman Robert Frank on Conrad Rooks' 1966 psychedelic study *Chappaqua*—joins in as the charismatic star (playing mostly himself): as King of Cool, with a raspy voice and, naturally, a gun. In addition, the musician Dr. John makes an appearance (as he would, a few years later, in Frank's *Candy Mountain*), as does a young Canadian actor and filmmaker named Allan Moyle (who with *Pump Up the Volume* would become one of independent cinema's directing hopefuls just one brief decade later). And again, the film is laid out for half an hour, precisely the amount of time that Frank always considered the most suitable for his purposes. (Fifteen of his hitherto twenty-seven audiovisual works are between twenty-three and forty minutes long.)

Frank's transition from film to video took place at the beginning of the 1980s. *Home Improvements*, which arose between 1983 and 1985, was his first major video production, and at the same time one of his most important works. Admittedly, Frank did not completely dive into a new medium; every once in a while he would return to classical film material for single projects or scenes. But his route was laid out. From 1990 on, Frank's central medium would be video: from *C'est vrai! (One Hour)* to *Tunnel* (2005) he has shot all his important films with the little video camera. Before he tackled his very personal *Home Improvements* in

Energy and How to Get It

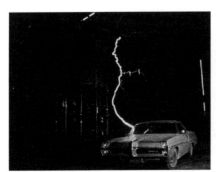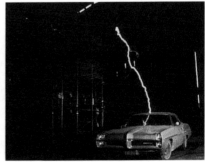

1983, Frank completed a different, less ambitious film. *This Song For Jack* is a secondary work that actually has no more than documentary value: a group of people gather in memory of Jack Kerouac in a lonely house somewhere in Boulder, Colorado, to see each other again, and reminisce. A Beat congregation, which in 1982 reflected on the poetic legacy of their movement, on the occasion of the twenty-fifth anniversary of Kerouac's *On the Road*. From a distance, the (emphatically unglamorously arranged) black-and-white images of bored, hanging-out poets and friends of poets and late hippies naturally recall the Bohemian studies in *Pull My Daisy*, but nowhere does this film even remotely gain the energy which, twenty-three years earlier, Kerouac's recitation alone had radiated.

Frank's distinctive melancholy, the basis of his artistic work, penetrates *Home Improvements*. Conceived as a diary film, *Home Improvements* is fascinating with its consciously sketchy, open form, but also perplexing in its desire to condense, its wealth of detail. Frank returns to dealing with his own life here, far away from urban civilization; he speaks about age, sickness and the torture of his son Pablo's impending death. The calmness in Frank's films is not to be confused with tranquility. Quite fundamentally, they attempt to capture the remarkable range of loneliness (from barren peace to the terror of depression). Frank begins the ballad of his own existence on a day like any other: November 9, 1983. Incidentally it is Frank's fifty-ninth birthday, but that does not play any major role. Frank's wife is sick, possibly seriously. *Home Improvements* is also, quite peripherally, a romantic film, but mainly it is a much further-reaching construction of visual notes and fragments, a film that persistently remains stuck on what is apparently irrelevant: a fly on the window, graffiti in the subway, a piece of paper that dances in the wind on the street. "I like to look at the most banal things," Frank once said, "things which move." Frank's son is in a visibly poor physical and mental state,

Energy and How to Get It

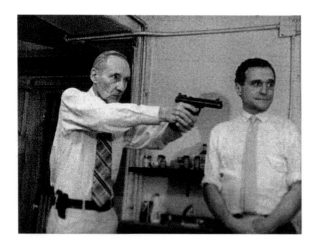

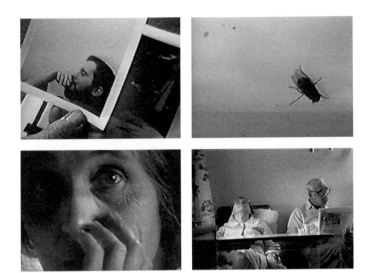

Home Improvements

he is getting lost in cancer and in metaphysics. Frank is shaken by Pablo's suffering, his film depicts his distress. "Let's be more happy, Pablo," he says and it sounds like a plea, despairing, insistent.

Home Improvements is an uncommon film about the common—about the winter in Nova Scotia, about daybreak's red and blue, about the trash that has to be brought down to the street, about waiting and about life: a film with a mixture of moving and still images, old pop hits and trash television images. Thinking, speaking and filming are united here, they take place simultaneously, without favoring one over the other; that which is spoken and thought is instantly filmed and recorded, so the momentary gains undreamed-of space in this intensely direct work. Frank's colors are pale, "everyday," leaning more toward gray and white than all other hues. Frank places no value on eye catchers, his great scenes are provided by little daily occurrences, by unimposing things. "It's a big moment," Frank says, more to himself than to his viewers, ironic and serious, as the garbage truck finally emerges in the early morning on a lonely iced-over country road.

What most people find great gives Robert Frank difficulties. Only in 1986 did he risk another feature-length film; for the first (and very possibly last) time in Frank's creative career, this undertaking was meant to be a "real" feature film, a work that takes narrative conventions into serious consideration; it is arranged (relatively) seamlessly as to be suitable for a mainstream audience. Nonetheless, the director's old pessimism is still evident. Initially the film, which Frank created together with screenwriter Rudy Wurlitzer, was entitled *There Ain't No Candy Mountain*. Later, they would simply call the film *Candy Mountain*, even though that turned the original title into its opposite, to the positive. Linear tales are not Frank's forte, and despite Pio Corradi's handsome photography, this is noticeable. Frank hits the road again with the hero of the film, played by Kevin J. O'Connor—from New York City, the young man travels north to Canada, to Nova Scotia, to find a legendary, unfortunately missing luthier who

could possibly gain him a great deal of money. Frank and Wurlitzer take the thin threads of plot as an occasion to stage a series of more or less motivated guest appearances: on his way, O'Connor meets musicians such as Arto Lindsay, Tom Waits, Joe Strummer and Dr. John, people who again document the filmmaker's interest in the marginal, in subculture. Today, Frank no longer appreciates *Candy Mountain*, he views the film as a defeat, or at least as a lazy compromise; he calls the technical basis of that piece of fiction "heavy machinery," missing spontaneity in it. It is, he says, simply "not necessary to have twenty-five people around me when I make a film." His collaboration with Rudy Wurlitzer ended here also, abruptly, with the third film the two shot together.

And again, Frank slid into a phase of artistic disorientation. His thirty-seven minute TV film *Hunter*, shot in fall 1989 for the German television station WDR, provides ample evidence of the inner uncertainty that enveloped Frank in those years: a film lost between precise documentary work and forced plot, between auteurism and social report. Autumnal Germany, at a time of unrest, somewhere in the Ruhrgebiet: *Hunter* once more is the product of a tight creative collaboration. Together with screenwriter (and main actor) Stephan Balint, Frank sets up a scarcely accessible little road movie about Germany shortly before reunification, a film that touches upon themes such as fascism, music history, prostitution and xenophobia in bold associative leaps. If Balint's monotonous acting is countered by the vitality of several of the passers-by whom Frank questions, the staging itself is a far cry from that vigor.

After that the filmmaker shifted gear: at sixty-five, Frank shot the first of his two music videos; as cover designer and documentarist for the Rolling Stones he was of course no newcomer to the pop industry. In 1989 he designed a clip for the song "Run" by the British band New Order. He fulfilled that contract as though he despised it, like someone who was

Candy Mountain

Hunter

desperately looking for a way to insert unsuitable images and montages. Which is no simple task in music videos; as is well known, almost everything is possible in that genre. Nonetheless, Frank found a solution: the only thing categorically forbidden in pop is being unfashionable. But that is precisely what Frank seemed to be looking for: he juxtaposes a carelessly staged street scene, in which a brooding older man begins to laugh scornfully (presumably about himself), with quite uncharismatic still and live images of the band as well as shots of a group of anonymous people. "Run" thus becomes a three-and-a-half minute anti-clip, ponderous and plain, a blend of incomprehensible associations. It is difficult to imagine that Frank's employers were pleased with the result. Seven years later, Frank's adaptation of Patti Smith's song "Summer Cannibals" fared better; perhaps this work was more fruitful because the singer and songwriter, an American slam poet of the 1970s, felt closer to Frank than New Order's British electronic pop. But admittedly, in the case of *Summer Cannibals*, the director also avoided catering to the MTV mainstream; he did not take great pains to produce hip images, but rather went decidedly for timeless visuals. For the choice of settings, he returns to an old motif, one of Frank's favorites since *The Sin of Jesus*: a rundown dwelling. Frank's protagonists are often at home in barns, wooden huts or shabby apartments. Patti Smith and her band, in this sense, are siblings of the (semi-real, ungraspable) characters who can be seen in *Conversations in Vermont, Keep Busy* and also *Energy and How to Get It*.

If we were to name a time, an era, around which Frank's work constantly orbits, it would be the 1930s. The epoch appears symbolically in his photos, as well as in many of the films, as a remote reference, like a signal. Frank as a visual artist always seems to have belonged to an era of Depression. *Summer Cannibals* is no exception to that—and as a music video, it is much more clearly associated with the rest of Frank's work than *Run*. The aesthetic clarity of his Patti Smith clip—photographed in high-contrast blacks and whites—keeps the enigma of the

Run

recitation and the text. The guttural "eat, eat" that Smith so distinctly repeats in the refrain of her song also seems to recall the hunger show in *Liferaft Earth*—a distant echo from 1969.

In art there's no way to secure "truth," especially in the case of a versatile fact-fiction twister like Robert Frank. A film entitled *C'est vrai!* therefore deserves suspicion. The only thing that is "true" with any certainty in that film is its time: set up as an experiment with cinematic real time, *C'est vrai!* (bearing the logical alternative title *One Hour*) records exactly sixty minutes and an (almost) uncut journey through Lower Manhattan, which the filmmaker acts out as a structuralist road movie with several stations, surprise twists and seemingly documentary overtones. Shot with a video camera, the film unfolds as a movement through the city on a day in July of the year 1990 between 3:45 and 4:45 p.m. The trip that is embarked upon in *C'est vrai!* does not lead especially far in kilometers; one doesn't get much further than a few blocks on New York's busy streets, both walking and driving—yet the journey does not take place in any linear fashion, instead, it is labyrinthine: from the inside to the outside and back inside again (into a diner or into the minivan that the film team uses for transportation)—and finally also from above to below, from the street to a subway station.

The fascinating thing about *C'est vrai!*, created for a multipart television project called *Live* (initiated by the artist Philippe Grandrieux for French TV station La Sept), is its use of preparation and coincidence: after just a few minutes a man appears on the street reciting texts, which he has obviously memorized, into a pay phone. He is *acting*, just like countless other characters in this film—which becomes clear step by step. On the other hand, however, a number of actual passers-by seem to land unprepared in front of Frank's camera. *C'est vrai!* plays out Frank's old project of invalidating common notions like appearance and reality in cinematic representation, however he does so in thoroughly new, surprising ways. *C'est vrai!* thereby becomes a chain of mini-dramas and story fragments; the stressed-out film crew rushing through the streets provides the thread: Kevin O'Connor again plays a starring role, as an ill-tempered character sitting in the back of the team's wagon; he embodies the function of

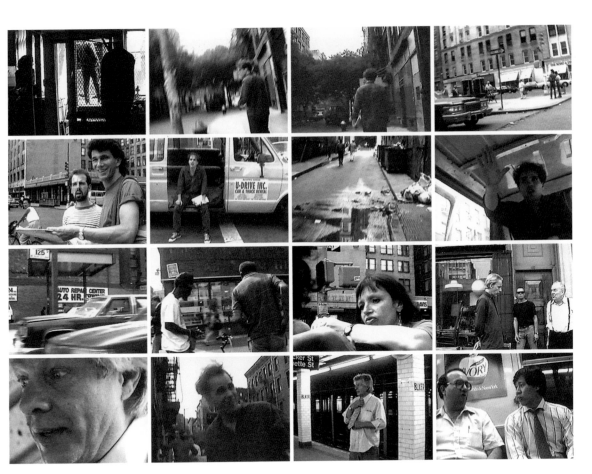

C'est vrai! (One Hour)

the Shakespearian fool—as the only reflective, distanced figure, he repeatedly points to the theatricality of the undertaking. Not only does he incessantly recite films, he also hisses sarcastically, disrespectfully towards the directors ("I didn't mean to interrupt your sixty minutes"), and he visibly enlivens Frank's real-time farce by adding a certain hysteria, assisted by Peter Orlovsky who finally joins in, playing the classical New York maniac, ceaselessly talking and to threatening strangers.

However, *C'est vrai!* differs clearly from Michael Snow's measurement of the concept of time, for example, simply through the "impurity" of the mise-en-scène. The set-ups for Frank's experiment are more extensive, more open. In the middle of the film, suddenly the picture breaks off; only the sound continues until a new camera is switched on. This is how Frank expresses his dislike of pre-arranged concept art and cinematic "artistry": if he's going to shoot a film in one shot, there must be an ironically placed cut, an incision that easily disposes of his own all too "conclusive" concept. Frank's *C'est vrai! (One Hour)* obviously wants to shine less as the virtuoso technical achievement one can definitely see in it than as an absurd

Summer Cannibals

philosophical comedy at the frontier of improvisation and precise planning. The fact that this film is to be classified among Frank's main works is also due to the importance it would have for his future creative work. With *C'est vrai!*, Frank made the decisive step away from classical cinema (that he hardly knew how to operate properly, anyway) towards fine art and video culture. A final work at the interface between feature and documentary film, a production of major logistic effort, evolved in 1991. *Last Supper* revolves around an anticlimax. In a backyard in Harlem, a party takes place, but the writer for whom the party is being thrown doesn't show up. The impoverished Black population in the area seems indifferent to the activities of the White party society. In *Last Supper*, Frank contrasts his very special variety of socio-realist independent film with shaky video work and strongly theatrical interludes. The motif of the Last Supper would also appear, by the way, four years later in *Summer Cannibals*.

The history of Robert Frank's later work, which has kept on developing with remarkable consistency until the present day, thus began around 1991. In the mid-1990s he completed two highly complex video works, radical in their openness (they are open in both senses of the term: limitless and self-revealing). *Moving Pictures*, shot between 1990 and 1994, picks up on Frank's old themes: memory and photography. *The Present*, begun in 1994 and finished in 1996, is more of a diary film in the style of *Home Improvements*, but compared with the older filmit it proves to be (even) more erratic, more elliptic.

The formal brittleness of the sixteen-minute *Moving Pictures*, alienates it from the field that its title actually names: it is more of an exhibition piece than a movie (although, strictly speaking, it is both). It seems more at home in the museum space than in the cinema. The tape is silent, operating only with text inserts, as though created for a video monitor in the framework of an installation. In terms of content, Frank remains personal and with the past. He presents himself at his parents' grave in Zurich, making remembrance once again his prime theme; he shows photos and photo collages, which have already been created on the basis of associative connections and now, for their part, set off a series of reflections (about America,

Last Supper

Jean-Luc Godard, nature, June Leaf's artwork, face and presence), a stream of consciousness that Frank calls "moving pictures" here: a meditation about the essence of the pictorial and the lines of thought that it sets; the work of a taciturn old man who is nonetheless communicative through his art, who takes the liberty of simply showing old friends whenever he wants to—the poet Allen Ginsberg, the sculptor Raoul Hague and the filmmaker Harry Smith briefly appear in *Moving Pictures*.

The Present is even more basic and it declares itself—as an intimate tale—the main topic: what (and how) should one film? What to record? What should—or must—one keep or remember? While already shooting, Frank asks himself decisive questions, primarily concerning the meaning of what he's doing. It is all about finding a story, he says. But that isn't exactly what *The Present* is about; his work proves the opposite. And he finds out that everything he needs is already there in his own untidy room, that a whole world is lying there in front of his eyes: a disheveled bed, a fly on the window, a filmmaker in doubt. In *The Present* Frank, being an artist who is used to being rough on himself, reaches the borders of self-reflection. He thinks about commemoration in order to work on it, almost compulsively, in order to also endure the pain of forgetting, which some of his memories demand. He thinks back to his children, who are no longer with him, thinks about Andrea, who would have been forty on one of the days he is shooting his film; but he also thinks of the small wonders of the world which are offered to him, if he only looked carefully enough. *The Present* shows Frank's fragile, fleeting art in less than half an hour: an autobiographical story made from a thousand individual parts, views and flashes of thought. Towards the end, Frank has the lettering "Memory" arduously scratched away from a plate of glass, as if he wanted to set an example in order to overcome memory. That which remains at the end is only one's self: "Me."

In the aesthetic minimalism that Frank worked on in those years there is also a trace of progressive revocation of the author's "I" in favor of poetic condensation. As usual, Frank carried out this revocation radically, seemed to approach his own self-dissolution in art.

Moving Pictures

 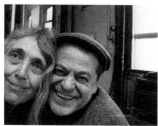

The Present

What I Remember from My Visit (with Stieglitz)

The attempt to reduce his films to the absolute essence also becomes evident in the duration of his works: with two video pieces produced in Canada, *Flamingo* and *What I Remember from My Visit (with Stieglitz)*, both of which he presented in 1997/98, Frank pushed the principle of fleetingness to the extreme. He created these films, each only a few minutes long, almost alone—accompanied only by his cutter Laura Israel (in the case of one) and a young cameraman (in the case of the other); both works appear like cinematic haikus, terse poems that seem to exist completely outside of time.

 Flamingo is done in black and white, in a rapid montage: As usual, Frank fuses still photography with motion pictures, showing a small slide-projection wall and going through photos of landscapes, animals, things—the remains of a memory, supported and awoken by art. One notices Frank's photo inscriptions: drawings and writings, in which terms

such as "blind," "love" and "faith" appear. Miranda Dali reads a lyrical text from off-camera, which only touches upon the visual; that remains the only sound in the production. When the narrator is silent, the pictures are left to themselves; one sees the wind shaking the leaves of a dark tree; workers building a house out in the open nature; a car, on whose snow-covered windshield a date can be read; June, as she walks around the house; June, as she gazes into the camera. "OK, we're done," is stated at the end. And: "paint it black." A man begins to paint the house. At the end it stands there, blackened, in the wide open land. *Flamingo* bears a faint similarity to *Breakfast im Grauen*, one of the dense American avant-garde road movies by the great Austrian filmmaker Kurt Kren. In the other short work, Frank recalls an encounter with the American photographer Alfred Stieglitz, who died in 1946. In cold Mabou, in October 1998, Robert and June, together with Jerome Sother, who handles the camera, reconstruct one of the everyday events that took place during a long-past meeting with Stieglitz and his wife, Georgia O'Keeffe. *What I Remember* is another film about nature, about the engaging, harsh land that has become Frank's home. And again the brief work collects found objects, images of which flash up briefly in the picture, only to disappear immediately. That is the fate of things and people. A photo album being flipped through here is empty.

In his two following films, Frank seems to move away from the extreme point of cinematic solipsism, back to simpler, more accessible documentary forms. *San Yu* (2000) picks up the theme of the commemoration of dead friends and relatives that has formed Frank's creative output for so long. The Chinese painter San Yu, whom Frank met in New York during an apartment exchange in the early 1950s, thus stands in a line with Pablo and Andrea Frank, Danny Seymour, Jack Kerouac and Alfred Stieglitz. (1966, the year of San Yu's premature death

Flamingo

that towards the end of the film can be read on a gravestone, is incorrectly indicated as 1964 at the beginning of the film. It is unclear whether this error stems from the filmmaker's carelessness—or if it rather could be attributed to his idea of gentle fictionalization and "falsification" of real characters.)

An insert in *San Yu* asks, "Is this a requiem?"—and actually, that is a good question. Frank travels to Paris, where his friend San Yu created the majority of his works, to reconstruct the artist's life; but rather than doing this in the style of a requiem, he uses a number of little stories that are just as pertinent to him, Frank, as to San Yu. The film presents a series of letters that led to Frank's trip to Paris, it shows San Yu's wonderfully simple art, but also the physical dealing with his work at exhibitions and at an auction of his paintings. The filmmaker tries to restore the secret of the painter's gaze: how did San Yu look at animals, his favorite topic? In a few pseudo-documentary film recordings in black and white, an actor appears in place of San Yu. Frank has him say, "All my work is a declaration of simplicity." In concise, fragmentary style, *San Yu*, the film, scans the life and art of a stranger—but the hesitant attempts to approach that person in the end is doomed to fail. Frank establishes, in passing, the plain concern of his work: "It's all about memory." Any author can only express the personal, only his own private memory of something—and never the life or the gaze of another man.

San Yu

Paper Route

True Story

It is only consistent that Frank's own gaze is once again featured at the beginning of *Paper Route* (2002), even if this is broken by a woman's voice with Asian-accented English: Frank films a series of his photos, derives history and stories from them—and he shows himself, solitary, waiting for the first light of day. This provides the prologue to *Paper Route*. Only afterwards does the actual protagonist appear: newspaper deliverer Bobby McMillan, whom Frank accompanies on his rounds, on his paper route through the lonesome area in and around Mabou, on March 5, 2002. A night worker at the steering wheel: McMillan delivers 158 editions of the *Herald Tribune* every night. While doing so, he engages in friendly talks with sleepless people in the area already waiting for their morning paper. Frank looks through the cracked windshield of the old car that Bobby drives through the vast wintry nature, towards morning. He eats his breakfast on the road, considering himself lucky, on the journey through a snowy land, in the day's first sun. The final shot belongs to Bobby, this time after work, alone in his living room, at home, in a chair, a vacuum cleaner by his feet. How does it feel to be filmed, Frank asks him. "Good," he answers.

As simple as it may appear, this little road movie is a surprise in the filmmaker's career: a perfect documentary, the portrait of a job, a life, a landscape. "Making the circle, that's what we all do," remarks Frank philosophically in the back seat of Bobby McMillan's car. *Paper Route* is not the sum and not the end of an uncompromising life work, but rather, like almost

True Story

everything Robert Frank endeavors, a new path: the result of the attempt to always take a fresh route each time. As if to counter that, he returned to his past domains with *True Story* (2004): remembrance, autobiography and melancholy. It's all true—at least to the guy behind the camera: "Woke up. Had some tea. Mosquitoes everywhere," Frank says from off-camera, while showing a rundown room, a desolate chair next to a wall. *True Story* begins in Cairo, with "holy Arab music playing" in the distance—but its voyage will ultimately lead into even more unknown territory, into the inner depths of this filmmaker's own continent: Frank's film is a mosaic made of images, lettering and speech, photos and old film clips, accompanied by a fragmentary soundtrack, noisy and buzzing; a complex web of views, performances and cherished "mistakes," a thoroughly impressionist cinema with window curtains softly moved by the wind and pictures of people's faces and bodies. There's work to be done: a tree has to come down, and Frank finds someone to help him; it has to be cut and measured, just like his films. *True Story* is one more compelling remix of Frank's old obsessions: art and life merge inseparably, while an exhausted Robert Frank questions himself as to the meaning of his art, as to his past ("55 years ago. I was 24. One thousand years ago"). Amidst the chaotic lifestyle Frank visibly cultivates, there's plenty of room for his beloved: for Pablo and his paranoid messages, for June working on her paintings and objects, and, above all, for memory.

The four-minute, silent film sketch *Tunnel* (2005), commissioned by the builders of the Lötschberg base tunnel in Switzerland and destined to be presented during the midway celebrations (but never shown there, since Frank did not care to document the construction work at all), is a piece of lesser scope: it is dominated by a documentary sequence depicting men on a meadow trying to catch a cow in order to slaughter and skin it. The somewhat sad account of the animal's fierce resistance while fighting its immediate death is preceded by enigmatic images of pages of an old book, a few art objects and photos showing picturesquely foggy mountains; through a hole in a cracked mirror Frank films wintry landscapes and a dog in the snow. The strange magic of this hardly comprehensible little film is to be traced back to its uncompromising, tough poetry, to its absolute refusal to soften (or explain) the director's very personal world view.

So the work of filmmaker Robert Frank keeps evolving, as if completely independent, freed of the constraints of time, money and space. It's there, for everyone to see. It is. That's enough. When Frank was asked in the mid-1980s to come up with a list of the essential events of his life, he recalled the journey through America which he began in 1955 for his famous photo book with those words: "I work all the time. I don't speak much. I try not to be seen."

Tunnel

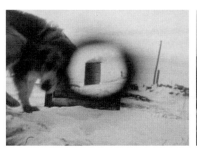
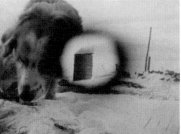
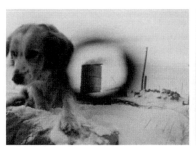

List of film stills

2	Energy and How to Get It
4/5	Me and My Brother
8	Hunter
18	Energy and How to Get It
	Me and My Brother
52/53	Energy and How to Get It
54	Me and My Brother
64	Paper Route
74	Moving Pictures
82	Candy Mountain
92	Flamingo
	The Present
100	Me and My Brother
113	Hunter
115	What I Remember from My Visit (with Stieglitz)
116	Pull My Daisy
117	The Sin of Jesus
118/119	Energy and How to Get It
121	OK End Here
122/123	Conversations in Vermont
125–127	Energy and How to Get It
128–135	Me and My Brother
136–139	Hunter
140	Moving Pictures
141	Run
142–153	Last Supper
152/153	Moving Pictures
154–157	Paper Route
159	Tunnel
160	Me and My Brother
162/163	About Me: A Musical
164	Last Supper
166/167	About Me: A Musical
169	Conversations in Vermont
170/171	Candy Mountain
173	Flamingo
174/175	The Present
176–181	About Me: A Musical
182	Me and My Brother
183/184	Energy and How to Get It
185	Hunter
186	About Me: A Musical
187	Hunter
188/189	The Present
191	Last Supper
192/193	Conversations in Vermont
194–197	True Story
198–202	Tunnel
268/269	Me and My Brother
272	Me and My Brother

frank films
the film and video work of robert frank

The first edition of this book was published on the occasion of the Diagonale Special
"Robert Frank – Retrospective of the films and videos"
in the framework of Graz as 2003 European capital of culture,
in kiz – kino im augarten, Graz, September 11 – 21, 2003.
This publication was supported by Graz 2003 European capital of culture,
and Pro Helvetia, the Arts Council of Switzerland.
Idea: Diagonale – Festival of Austrian Films
Editors: Brigitta Burger-Utzer, Stefan Grissemann

Production: Diagonale (Viktoria Salcher, Constantin Wulff)
in collaboration with sixpackfilm (Brigitta Burger-Utzer)
Design: Karl Ulbl
Editorial assistant: Christa Auderlitzky
Editing English: Steve Wilder, Lisa Rosenblatt
Translations: Christiane Eckler, Barbara Pichler, Bert Rebhandl, Lisa Rosenblatt, Steve Wilder
Video stills & film stills: Brigitta Burger-Utzer, Karl Ulbl

Printing and production: Steidl, Göttingen

Steidl
Düstere Str. 4 / 37073 Göttingen, Germany
Phone + 49 551 – 49 60 60 / Fax + 49 551 – 49 60 649
mail@steidl.de
www.steidlville.com
www.steidl.de

ISBN 978-3-86521-815-5
Printed in Germany

Cover: *Tunnel*

Robert Frank: The Complete Film Works – published by Steidl –
consists of 10 volumes of DVDs which together encompass Robert Frank's
entire œuvre in film and video in chronological sequence.
Information and orders: www.steidl.de www.steidlville.com

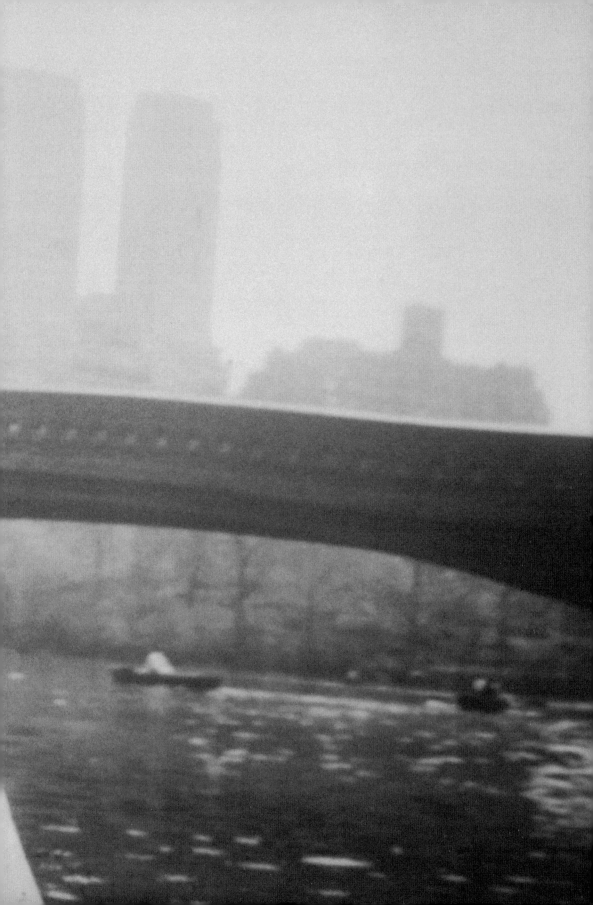

Michael Loebenstein Born in 1974. Studies in film history and film theory. Writer, researcher and DVD author since 2000, film critic of the Viennese weekly *Falter* 2000-2004. Co-editor of the film periodical *kolik.film*. Concept and editing for multimedia projects, curator of film retrospectives, lecturer. 2004–2008 head of the Research & Education Dept. at Austrian Film Museum, Vienna. He works as a researcher for the Ludwig Boltzmann Institute for History and Society in Vienna. Latest publications include *Film Curatorship* (with Paolo Cherchi Usai, David Francis and Alexander Horwath, 2008) and *Gustav Deutsch* (with Wilbirg Brainin-Donnenberg, 2009).

Thomas Mießgang Born in 1955 in Bregenz. German and Romance languages and literature in Vienna. Works as a journalist for *Falter, profil, Die Zeit,* ORF radio. From 1994–1996 advisor for Vienna's city cultural councillor Ursula Pasterk. Since 2000 he works as curator of the Kunsthalle Wien, since 2007 he is Head of Exhibitions and Displays there. Book publications include: *Semantics* (Wolke, 1991), *Der Gesang der Sehnsucht – Die Geschichte des Buena Vista Social Club* (Kiepenheuer + Witsch, 2000), *Fidel Castro – Vaterland oder Tod* (Fackelträger 2007).

Pia Neumann Dr. phil., academic training in American Studies and Photography. Earned her Ph.D. with a thesis on American photography of the 1960s (*Metaphern des Mißlingens: Amerikanische sozialdoku-mentarische Fotografie der sechziger Jahre zwischen Konzeptkunst und Gesellschaftskritik,* Frankfurt, 1995). Worked at the Museum für Moderne Kunst, Frankfurt, at the George Eastman House at Rochester/USA and taught photo history and theory at various German Universities. Currently works as freelance photo curator.

Klaus Nüchtern Born in 1961 in Linz. Studied German and English. Cultural journalist since 1990 for the Viennese weekly *Falter* and deputy chief editor there since 1998. Literary critic for Austrian radio, published articles in *Die Zeit, Weltwoche, Tagesanzeiger, TAZ,* etc. The fourth volume of his collected satirical columns has just appeared in Falter Verlag.

Bert Rebhandl Born in 1964. Studied German literature, Philosophy and Catholic Theology in Vienna and Berlin. Freelance journalist, critic, writer, translator and lecturer in Berlin. Has published a book on Orson Welles and edited an anthology on the Western. Cofounder and -editor of the magazine *CARGO Film Medien Kultur* and the website www.cargo-film.de.

Isabella Reicher Born in 1967. Theater, film and television studies in Vienna, Berlin and Amsterdam. Since 1994 she has mainly worked as a film critic *(Falter, Der Standard)* and film journalist. Co-curator and publisher (together with Andrea Pollach and Tanja Widmann) of *Singen und Tanzen im Film* (Vienna, Zsolnay 2003; retrospective in the Austrian Film Museum, May 2003) and of the book *Claire Denis. Trouble Every Day* (FilmmuseumSynemaPublikationen 2005, together with Michael Omasta). Since 2004 she is editor of *kolik.film.*

Jonathan Rosenbaum was film critic for the *Chicago Reader* from 1987 through early 2008. His books include, among others, *Moving Places, Midnight Movies* (with J. Hoberman), *Placing Movies, Movies as Politics, Greed, Dead Man, Movie Wars, Abbas Kiarostami* (with Mehrnaz Saeed-Vafa), *Essential Cinema,* and *Discovering Orson Welles.* His web site is at www.jonathanrosenbaum.com

Nina Schedlmayer Born in 1976. Studied art history in Vienna and Hamburg. Master thesis about Dada artist Hannah Höch. She has been working as art educator and exhibition curator. Art critic and journalist since 2003 (for *artmagazine.cc, Eikon, profil, spike – art quarterly*), editor-in-chief of *Kunstgeschichte aktuell* since 2007. Lives and works in Vienna.

Amy Taubin is a contributing editor to *Film Comment* and *Sight and Sound* magazines and a regular writer for *Artforum.* Her book, *Taxi Driver,* is part of the British Film Institute's Film Classics series. She was a critic for fourteen years for the *Village Voice.* She has made avant-garde films, among them *In the Bag* (1982) and appears in films by Jonas Mekas, Michael Snow and Andy Warhol. She has received the 2007 Logos-Siegfried Kracauer Award from Anthology film Archives and the 2003 Art Historian/Teaching award from the School of Visual Arts, NYC.

Gerald Weber Born in 1965. Studied history, geography, and philosophy in Vienna. Film and media scientist. Founding member of *Projektor – Diskussions-forum Film & neue Medien.* Staff member at sixpackfilm. Various lectures and journalistic contributions.

Michael Barchet Dr. phil., academic training in Film and American Studies at the Universities of Berkeley/California and Frankfurt/Germany. Earned his Ph. D. with a thesis on American Documentary film and taught Media and American Studies at the Universities of Frankfurt and Jena. Numerous publications on documentary film, early cinema, video art and American television. Currently working as freelance author, editor and lecturer.

Christa Blümlinger Dr. habil., teaches as Maître de conférences in film studies at the University Sorbonne Nouvelle (Paris 3). Guest professorship at the Free University Berlin. Numerous curatorial and critical activities in Vienna, Berlin and Paris. Her publications include the edition of writings of Harun Farocki (in french) and of Serge Daney (in german) and books about essay film and film theory. Her most recent publication is: *Kino aus Zweiter Hand. Zur Ästhetik materieller Aneignung im Film und in der Medienkunst*, Berlin: Vorwerk 8, 2009.

Philip Brookman is Chief Curator and Head of Research at the Corcoran Gallery of Art, Washington. He has organized major exhibitions for other museums including the Tate Modern, London, the National Gallery of Art, Washington, and The Museum of Fine Arts, Houston. He is also a writer, filmmaker, and photographer. His projects about Robert Frank include *Storylines*, *London/Wales, Moving Out*, and *New York to Nova Scotia*. Brookman is currently working on a retrospective exhibition and book about Eadweard Muybridge.

Brigitta Burger-Utzer Born in 1960 in Vienna; Studies in theater, photography and Cultural Management. Co-founder of sixpackfilm in 1990; since 1992 managing director of sixpackfilm (association for lending and distribution of Austrian art films and videos); concept and/or organisation of numerous film series in Vienna; since 1994 in charge of the series "IN PERSON: International film&videoartists bring their work up for discussion." In 2004 she founded the DVD-Label INDEX (with Medienwerkstatt Wien).

Ralph Eue Born in 1953 in Blankenburg. Studied in Marburg, Paris and Frankfurt/Main. 1983–89: production designer in German film and television. 1989–96: head of marketing and publicity for Tobis Filmkunst. Since 1996 freelance author, translator, curator. Since 2007 visiting professor at Universität der Künste Berlin. Editor of *Recherche Film und Fernsehen*.

His books include, among others, *Marcel Ophüls. Widerreden und andere Liebeserklärungen* (ed. with Constantin Wulff), *Aki Kaurismäki* (ed. with Linda Soeffker), *Jean Epstein. Bonjour Cinéma* (ed. with Nicole Brenez).

Birgit Flos Born in 1944. Studied literature at the City University of New York. Has worked on various documentary and film projects. Guest professor at the HdK and unemployed in Berlin (1980s). Since 1988, lecturer in film history at the Wiener Filmakademie. Exhibition concepts: (1995/96 medien, apparate kunst at the MAK, Vienna, among others); member of the editorial board of the film journal *Meteor*. Director of the Graz Diagonale, 2005–2008. Texts on art and film for radio and print media.

Stefan Grissemann Born in 1964. Head of the arts section of *profil* magazine in Vienna, Austria. He has published books on B-picture-legend Edgar G. Ulmer, and on Michael Haneke's adaptation of Elfriede Jelinek's *The Piano Teacher*. A film critic since 1988 in various international publications, he also teaches film and journalism. His latest publication is a study of Ulrich Seidl's life and career, a volume called *Sündenfall (Original Sin)*.

Isabella Heugl Born 1966. Studied Romance languages and literature and journalism in Vienna. Master's thesis on Michelangelo Antonioni. Founded H2-arts&acts. Collaboration and head of production for various theater projects.

Christoph Huber Born in 1973 in Vöcklabruck, childhood in Attnang-Puchheim. Studied technical physics in Vienna. Engineering degree. Since 1999 film critic and journalist for diverse websites. Since 2000, film and music critic for the daily paper *Die Presse*. Publications in *Senses of Cinema*, *Schnitt*, and *RAY*, among others. Writes film program texts for the Austrian Film Museum. Lives and works in Vienna.

Kent Jones is a film critic, programmer and filmmaker. He is the editor-at-large of *Film Comment* and a regular contributor to that magazine, as well as many others. He is the author of the BFI Modern Classics book on *L'Argent*, and more recently he published a collection of his essays entitled *Physical Evidence: Selected Film Criticism*. He is the co-writer of the documentary *Il mio Viaggio in Italia* by Martin Scorsese and directed a film on producer Val Lewton. He lives in Brooklyn, New York.

Lifson, Ben: **Robert Frank and the Realm of Method**, Village Voice 24, 8, Febr. 1979, pp. 75.

MacDonald, Scott: **An Interview with Amos Vogel**, in Cinema 16 – Document Toward a History of the Film Society. Temple University 2002, pp. 55, 364.

Martiradonna, Sabino: **Robert Frank.** Catalog on the occasion of Mostra Int. Riminicinema, Rimini 1990.

Meier, Marco: **Robert Frank. Part Two.** Du. Die Zeitschrift der Kultur, no. 731, Zurich, November 2002.

Mekas, Jonas: **Cinema of the New Generation**, Film Culture 21, Sommer 1960, pp. 1-20.

Myles, Eileen: **Reunion**, Parkett, issue 38, 2008, pp. 45-53.

Perret, Jean; Biamonte, Francesco: **Robert Frank: atelier**, in Catalog of Visions du Réel No. 5, Nyon 1999, pp. 158-177.

Noll Brinckmann, Christine: **Vom filmischen Alltag der Beats. Pull My Daisy (Robert Frank und Alfred Leslie, USA 1959)**, Cinema 30: Bild für Bild – Photographie und Film, Chronos, 1997.

Rotzler, Willy: **Robert Frank**. Du. Kulturelle Monatsschrift, volume 22, Zurich January 1962.

Alex Rühle: **Beim wichtigsten Fotografen der Welt. Bilder einer Einstellung**, Süddeutsche Zeitung, July 26-27, 2008.

Sargeant, Jack: **The Naked Lens. An Illustrated History of Beat Cinema**. Creation Cinema Collection #7. Creation Books 1997, reprinted 2001.

Schaub, Martin: **Postkarten von überall und innere Narben. Porträt des sechzigjährigen Fotografen und Filmemachers Robert Frank...**, Tagesanzeiger Magazin 44, 3 November 1984, pp. 8-13, 15-16.

Searle, Leroy: **Symposium: Poems, Pictures and Conceptions of >Language<**, Afterimage 3, May/June 1975, pp. 33-39.

Stahel, Urs; Gasser, Martin; Seelig, Thomas; Pfrunder, Peter: **essays über robert frank**. Published by Steidl Verlag, 2005.

Tucker, Ann Wilkes; Philip Brookman: **Robert Frank: New York to Novia Scotia**. Exhibition catalog Museum of Fine Arts Houston, Boston, 1986.

Tyler, Parker: **For Shadows, Against Pull My Daisy**, Film Culture #24, spring 1962, p. 29.

Watson, Steven: **Die Beat Generation. Visionäre, Rebellen und Hipsters, 1944–1960.** Hannibal, St. Andrä-Wördern, 1997.
English edition: **The birth of the beat generation – visionaries, rebels, and hipsters 1944–1960.** Pantheon Books, a division of Random House, Inc., New York 1995.

Ziegler, Ulf Erdmann: **Der disparate Blick**, Die Zeit, 16 June 1995, pp. 50.

(Based on the film *Pull My Daisy*). Edition by Steidl Publishers, 2008.

Frank, Robert: **Robert Frank. The Aperture History of Photography Series. no. 2**. Introduction by Rudolph Wurlitzer. Millerton, New York: Aperture, 1976. Published simultaneously in London by Gordon Fraser Gallery, Ltd. and in Paris by Nouvel Observateur/Delpire.

frank, robert: **story lines**. Published by Steidl Verlag, 2004

Frank, Robert: **Texts by Robert Frank**. Thames and Hudson Ltd, London, 1991. Originally published in France by Centre National de la Photographie, Paris, 1983.

Frank, Robert; Grazda, Ed: **Thank You**. For the 10th anniversary of Pace MacGill Gallery. Scalo, Zurich – Berlin – New York, 1996.

Frank, Robert: **Transcript from the lecture of his presentation on 7. Symposium for photography at Steirischer Herbst**, on October 5, 1985, Forum Stadtpark Graz, Camera Austria 22, 1987, pp. 17-23.

Frank, Robert: **Zero Mostel Reads a Book**, commission for a photo-book from the New York Times in 1963. Published by Steidl Verlag, 2008.

Interviews with Robert Frank (selection)

Bertrand, Anne: **Robert Frank de passage / Passing Through**, Art Press 207, November 1995, pp. 39-43.

Garel, Alain: **Robert Frank: Entretien: Images en mouvement**, La Revue du Cinéma 435, February 1988, pp. 49-52.

Glicksman, Marlaine: **Highway 61 Revisited**, Film Comment 23, 4, July / August 1987, pp. 32-39.

Johnson, William: **The Pictures are a Necessity: Robert Frank in Rochester, NY 1988**, Rochester Film and Photo Consortium Occasional Papers no.2, Jan. 1989.

Schaub, Martin: **FotoFilmFotoFilm: Eine Spirale: Robert Franks Suche nach den Augenblicken der wahren Empfindung**, Cinema: unabhängige Schweizer Filmzeitschrift 30, November 1984, pp. 75-94.

Sargeant, Jack: **An Interview with Robert Frank**, in The Naked Lens. An Illustrated History of Beat Cinema. Creation Cinema Collection #7. Creation Books 1997, reprinted 2001. pp. 38-53.

Wallis, Brian: **Robert Frank: American Visions**, Art in America 84, 3, 1996, pp. 74-79.

Publications about Robert Frank (selection)

Alexander, Stuart: **Robert Frank: A Bibliography, Filmography and Exhibition Chronology 1946–1985**. Center for Creative Photography, University of Arizona, Tucson, in association with Museum of Fine Arts Houston, Tucson, 1986.

Bertrand, Anne: **Le Présent de Robert Frank**, Trafic. Revue de Cinema 21, spring 1997, pp. 50-57.

Dean, Tacita: **You Can't Go Home**, Parkett, issue 38, 2008, pp. 62-65.

Eskildsen, Ute: **Robert Frank: HOLD STILL _ keep going**. Exhibition catalog, Museum Folkwang, Essen 2000.

Gasser, Martin: **... really more like Russia in feeling and look ...: Robert Frank in Amerika**, in Beat Schläpfer: Swiss Made, Zurich, 1998, pp. 79-92.

Gosgrove, Gillian: **On the Road with the Rolling Stones – The Film That Can't Be Shown**, The Montreal Star, 12 September 1977, C-2.

Greenough, Sarah; Brookman, Philip: **Robert Frank: Moving Out**. Exhibition catalog, National Gallery of Art, Washington 1994. German edition: National Gallery of Art, Washington, Scalo, Zurich 1995.

Hagen, Charles: **Robert Frank: Seeing Through the Pain**, Afterimage 1, February 5, 1973, pp. 1, 4-5.

Hall, Lars; Knape, Gunilla: **Robert Frank. Flamingo**. The Hasselblad Award 1996, exhibition catalog Hasselblad Center, Goteborg 1997.

Hanhardt, John: **A Movement Toward the Real. Pull My Daisy and the American Independent Film, 1950–65**, in Lisa Philipps: Beat Culture and the New America: 1950-1965. Exhibition catalog, Whitney Museum of American Art, New York in association with Flammarion, Paris, New York 1995.

Hoberman, Jim: **On the Road Again**, April 2007 issue of Artforum.

Horak, Jan-Christopher: **Robert Frank: Daddy Searching for the Truth**, in Making Images Move. Photographers and Avant-Garde Cinema. Washington, London 1997, pp. 161-190.

LeDuff, Charlie: **Robert Frank's Unsentimental Journey**, Vanity Fair, April 2008.

Lee, Pamela M.: **Fifty Years Down the Road**, Parkett, issue 38, 2008, pp. 30-36.

Bibliography

2005 "Robert Frank – Storylines". Touring venues: Museu d'Art Contemporani de Barcelona and Fotomuseum Winterthur (& Fotostiftung Schweiz).

The Festival Internacional de Cine Independiente in Buenos Aires shows his films and videos.

R. F. accepts an order for the video *Tunnel* which is finally censored for the breakthrough celebration of the Lötschberg Tunnel in the Swiss Alps.

2007 "Robert Frank: Films and Videos": Retrospective at the Centre Georges Pompidou in Paris.

Travels to China as a guest of the Pingyao International Photography Festival.

2008 "Mapping a Journey: The Films & Videos of Robert Frank": Retrospective at Anthology Film Archives in New York.

Exhibition in Milano entitled "Lo straniero americano".

The exhibition "Robert Frank. Paris" is reassembled by Ute Eskildsen and Robert Frank for the Folkwang Museum in Essen. Touring venues: Museo di Fotografia Contemporanea, Cinisello Balsamo, Province Milano; Jeu de Paume, Paris 2009; Nederlands Fotomuseum, Rotterdam 2009

2009 "Looking In: Robert Frank's The Americans": exhibition at the National Gallery of Art, Washington DC. Touring venues: San Francisco Museum of Modern Art; The Metropolitan Museum of Art, New York

"Robert Frank. Die Filme 1959-2005": exhibition and symposion at C/O Berlin. Center for Visual Dialogues, curator: Felix Hofmann.

This biography is based partly on the chronology by Paul Roth in "Robert Frank: Moving Out," ed. by Sarah Greenough and Philip Brookman, and the chronology in "New York to Nova Scotia," ed. by Anne W. Tucker and Philip Brookman. Additional information and revisions were provided by Stuart Alexander and Pace/MacGill Gallery.

Publications by Robert Frank (selection)

Frank, Robert: **Les Américains**, Photographies de Robert Frank. Selection of texts and edited by Alain Bosquet, Encylopédie Essentielle, no. 5, Série Histoire, no. 3. Robert Delpire, Paris, 1958.

Frank, Robert: **The Americans**, Photographs by Robert Frank. Introduction by Jack Kerouac. Grove Press, New York, 1959. Revised edition. Published by Steidl Verlag, 2008 German edition: **Die Amerikaner**. Introduction by Jack Kerouac. Scalo Verlag, Zurich – Berlin – New York, 1993.

Frank, Robert: **Black White and Things**, National Gallery of Art Washington/Scalo, Washington, Zurich 1993 (concept from 1952).

Frank, Robert: **Come again**. Published by Steidl Verlag, 2006.

Frank, Robert: **Films: Entertainment Shaked Up With Art**, Artsmagazine 41, 5 March 1967, p. 23.

Frank, Robert: **It's all true**, LimeLight – Cinéma 57, February 1997, p. 32-36.

Frank, Robert: **The Lines of My Hand**. Parkett / Der Alltag, Zurich, 1989. First published in Japan by Kazuhiko Motomura, Tokyo, 1971.

Frank, Robert: **London / Wales**. Edited by Philip Brookman. Scalo, Zurich – Berlin – New York, 2003.

Frank, Robert: **Me and My Brother**, book and DVD. Published by Steidl Verlag, 2007

Frank, Robert: **New York Is**. Photographs by Robert Frank. Introduction by Gillbert Millstein. The New York Times, New York 1959

Frank, Robert: **New York to Nova Scotia**. Edition by Steidl Publishers, 2005

Frank, Robert: **One Hour**. Published by Steidl Verlag, 2007

Eskildsen, Ute and Frank, Robert: **Paris.** Published by Steidl Verlag, 2008

Frank, Robert: **Peru**. Published by Steidl Verlag, 2008

Frank, Robert: **Polaroids**. Seven small albums housed in a slipcase (China, Early Europe / Red Lake, Flies / Pools, Objects, Objects / Photos, People Story, Story Rooms / Windows). Published by Steidl Verlag, 2009

Frank, Robert: **Pull My Daisy**. Text ad-libbed by Jack Kerouac for the film of Robert Frank and Alfred Leslie. Introduction by Jerry Tallmer. Grove Press, New York, 1961.

1993 Travels to Hokkaido in the north of Japan with Kazume Kurigami.

A book entitled **Black White and Things**, first created in 1952 in three handmade copies, is published in paperback by The National Gallery of Art and Scalo.

1994 Retrospective entitled "Robert Frank: Moving Out," National Gallery of Art, Washington, DC, curated by Sarah Greenough and Philip Brookman.

Frank's son Pablo dies in November in Allentown, Pennsylvania.

1995 "Robert Frank: Moving Out" travels to Zurich's Kunsthaus, Stedelijk Museum in Amsterdam, the Whitney Museum of American Art in New York, and Yokohama Museum of Art, Japan.

Frank establishes Andrea Frank Foundation in New York.

Exhibition entitled, "Robert Frank: Flower is...," Mole Gallery, Tokyo.

1996 Receives the International Photography Award from the Hasselblad Foundation, Göteborg.

Completion of the film *The Present* with editor Laura Israel.

Pull My Daisy is named by the Library of Congress to its National Film Registry.

Exhibition entitled "Robert Frank: Photographies de 1941 à 1994" at the Centre Culturel Suisse, Paris.

1997 Visits Allen Ginsberg the evening before the poet's death.

Travels to Taiwan and Copenhagen.

Exhibition entitled "Flamingo" at the Hasselblad Center in Göteborg.

Exhibition entitled "Robert Frank: Flower is...Paris" at the Pace/MacGill Gallery, New York.

Restoration and sale of paintings by San Yu.

1998 Travels to Madrid and visits Vicente Todoli. Car accident in Spain.

Begins working on the film *San Yu.*

Persistence of Vision award from the San Francisco International Film Festival, where the re-edited version of *Me and My Brother* premiered.

1999 Exhibition entitled "From the Canadian Side" at the Pace/MacGill Gallery, New York.

Frank receives an honorary PhD from the University of Göteborg.

Takes photographs for the newspaper Libération.

2000 Frank receives the first Cornell Capa Award from the International Center of Photography, New York.

2000-01 Exhibition and catalog entitled **Robert Frank. HOLD STILL_keep going** at Museum Folkwang, Essen, Germany. The exhibition travels to Museo Nacional Centro de Arte Reina Sofia, Madrid and Centro Cultural de Belém, Lisbon.

2002 Robert Frank personally presents his new video *Paper Route*, which was commissioned for the Expo.02 in Switzerland.

Frank receives the MacDowell Colony award.

2002/03 Exhibition "What Am I Looking At" at The Art Institute of Chicago.

2003 Exhibition "Robert Frank: London/Wales," at the Corcoran Gallery of Art, Washington, curated by Philip Brookman and accompanied by the book of the same title.

"Robert Frank Filmmaker": Retrospective of the films and videos at the Austrian Film Museum in Vienna

2004 Exhibition "Robert Frank" at the Kim Young Seop Photogallery in Seoul.

Gerald Fox presents his TV documentary *Leaving Home, Coming Home – A Portrait of Robert Frank* (86 min.) at the Int. Film Festival Rotterdam and many other festivals.

2004/05 "Robert Frank – Storylines": Exhibition and film series at Tate Modern, London (curated by Philip Brookman and Vicente Todoli). Premiere of *True Story.*

1975 Marries June Leaf in Reno on the way to California, where he teaches filmmaking for two months.

Takes photographs with a disposable camera. **Robert Frank** is published as part of the **Aperture History of Photography Monographs** series with an introduction by Rudy Wurlitzer.

1976 Begins to use a professional Mode 195 Polaroid pack film camera with Type 665 Positive/Negative film. Makes collages with text from these negatives.

1978 Retrospective in Ottawa, curated by Lorraine Monk of the National Film Board of Canada; also shown at Harvard University's Fogg Museum in Cambridge, Massachusetts.

1979 Exhibition "Robert Frank: Photographer / Filmmaker, Works from 1945–1979," curated by Philip Brookman, at the Long Beach Museum of Art in California.

1980 Retrospective "The New American Filmmakers Series: Robert Frank" in New York, curated by John Hanhardt, at the Whitney Museum of American Art.

Dedicates his film *Life Dances On...* to his daughter Andrea and his friend Danny Seymour.

1981 Frank's films are screened at the Rotterdam film festival.

Frank travels to Israel to teach at the Camera Obscura School for three weeks.

1982 Robert Delpire publishes **Robert Frank** as part of the "Photo Poche" collection with an introduction by Rudy Wurlitzer.

A special edition of **Les Cahiers de la Photographie**, edited by Gilles Mora, is dedicated to Frank.

Starts working on the video *Home Improvements* (1985).

1985 "Robert Frank: Fotografias/Films 1948–1984": exhibition and catalog for the Salla Parpallo in Valencia, Spain, curated by Vicente Todoli.

Frank receives the German Photography Society's Erich Salomon Prize in Berlin.

1986 Works on the screenplay *Candy Mountain* with Rudy Wurlitzer.

A new edition of **The Americans** appears.

Exhibition and catalog entitled **Robert Frank: New York to Nova Scotia** at the Museum of Fine Arts in Houston, curated by Anne Wilkes Tucker and Philip Brookman. This exhibition later travels to Museum Folkwang, Essen, Germany in 1987.

Philip Brookman and Amy Brookman direct the documentary *Fire in the East: A Portrait of Robert Frank* (28 min.), produced by The Museum of Fine Arts, Houston and KUHT-Public Television. Interviews with Allen Ginsberg, Emile de Antonio, Jonas Mekas, and Rudy Wurlitzer. Frank's current thoughts on his life and art are also revealed.

1987 The Friends of Photography, San Francisco gives Frank the Peer Award for Distinguished Career in Photography.

Retrospective entitled "In the Margins of Fiction: The Films of Robert Frank" at the American Film Institute, John F. Kennedy Center for the Performing Arts, Washington, D.C.

Exhibition entitled "The Lines of My Hand" at the Museum für Gestaltung, Zurich.

1988 Directs music video *Run* for New Order.

Goes to the Ruhrgebiet to shoot *Hunter* together with Stephan Balint from the Squat Theater, New York.

1990 The National Gallery of Art, Washington D.C. establishes the Robert Frank Collection. Frank donates negatives, contact sheets, work and exhibition prints.

Video entitled *C'est vrai! (One Hour)* is produced for the French television broadcaster La Sept.

1991 Frank produces a short film for fashion designer Romeo Gigli in Florence.

Takes photographs in Beirut and around Lebanon for a project organized by Dominique Eddé.

1992 Frank travels to Egypt. Begins making a film with Dominique Eddé and Dina Haidar which is never completed.

Travels to Lake Baikal with June.

Biography of Robert Frank

1924 Born in Zurich (Nov. 9)

1941–44 Brief apprenticeship and employment as a photographer's assistant in Switzerland (including with Hermann Segesser and Michael Wolgensinger).

1946 Makes first book, **40 Fotos**, with original photographs.

1947 Emigrates to New York.

 Alexey Brodovitch hires Frank to work for Harper's Bazaar as a fashion photographer.

1948 Trips to Peru and Bolivia. The resulting photographs are first published in Robert Delpire's revue Neuf in 1952 and later in a book entitled **Indiens pas morts** in 1956.

1949 Trip to Europe (France, Italy, Switzerland and Spain). Produces a book with 74 original photographs of Paris for artist Mary Lockspeiser.

1950 Marries Mary Lockspeiser.

 Edward Steichen includes Frank's photographs in a group show entitled "51 American Photographers" at New York's Museum of Modern Art.

1951 Son Pablo is born in New York.

1952–53 Lives and works in Europe, primarily Paris; trips to Spain, London, Wales, and Switzerland. Gives up fashion photography and begins working as a freelance photojournalist.

1954 Daughter Andrea is born in New York.

1955–56 Frank is the first European photographer to receive a one-year Guggenheim Fellowship.

 Travels across United States; fellowship is extended for a second year.

1958 Robert Delpire publishes **Les Américains** in Paris; Grove Press later publishes it in the United States in 1959.

 Frank travels to Florida with Jack Kerouac.

 Works for advertising department of New York Times. Rides buses throughout New York including 42nd Street to create **Bus Series**.

1959 Co-directs *Pull My Daisy* with Alfred Leslie.

1961 Travels to Europe, takes photographs at Venice film festival.

Hugh Edwards curates Frank's first one-man show, "Robert Frank: Photographer," in the spring at The Art Institute of Chicago.

1962 Exhibition at New York's Museum of Modern Art: "Photographs by Harry Callahan and Robert Frank," curated by Edward Steichen.

 The Swiss magazine Du dedicates an issue to Frank's photographs.

1963 Directs the film *OK End Here.*

1964 George Eastman House purchases twenty-five of the photographs which appeared in "The Americans" for a traveling show.

1964–66 Frank travels throughout France, Mexico, India, Sri Lanka, England, Jamaica and America with director and producer Conrad Rooks and shoots the film *Chappaqua*. They win the Silver Lion at Venice in 1967.

1965 Begins his first feature, *Me and My Brother,* which is finished in 1968.

1969 Seperates from Mary and later divorces.

 Lives with artist June Leaf in New York's Bowery.

 Frank writes five monthly columns for London's Creative Camera magazine. Produces and directs his first autobiographical film, *Conversations in Vermont*, and the documentary *Liferaft Earth*.

1970–71 Frank buys land and a house in Nova Scotia with June Leaf.

 Teaches at several American colleges and universities.

 Receives funding from the American Film Institute to produce *About Me: A Musical.*

1971 Kazuhiko Motomura publishes **The Lines of My Hand** in Tokyo; this book is later published in the USA by Lustrum Press.

1972 Begins to use a Polaroid Land Pack film camera.

1974 Frank's photographs are shown in a retrospective at Zurich's Kunsthaus, curated by Rosselina Bischof.

 In December, his daughter Andrea dies in a plane crash in Guatemala.

the interaction between the object and the images' creator, illustrates his authorship of the visual scenario. A moment later we see his wife June with one of her objects that catch the air; she too seems to be focused in the hole of the black shadow mask. Only then does the narrowing of our gaze through this mask's tunnel, the tunnel in the camera's viewfinder, become distinct.

As if Frank wanted to say "Forget about the visual games, and get back to reality," we witness a cow being slaughtered. This is not an easy job for the four farmers who struggle to catch the animal before shooting it. A moving aspect of this scene is the fact that the cow does not struggle so much, or defend itself, it merely tries to escape until it is finally tugged into position. At the film's end: two of Frank's photographs of the hanging animal cadaver—in color. The men posing for the camera have done their job, just like the man behind it. Morals have no place here. We see and take note. That is Robert Frank's system.
Brigitta Burger-Utzer

2005

Tunnel

CH/USA 2005, video, color and black & white, 4 min.
directed by: Robert Frank
cinematography: Robert Frank
editing: Laura Israel

We See and Take Note

This film was supposed to premiere at the breakthrough celebration for the third-longest tunnel in the world, Lötschberg Tunnel in Switzerland, but in the end the clients did not include it in the program. There is no indication of this fact in the film itself. The tunnel, as a brutish architectural achievement in the conquest of the mountains, was merely Robert Frank's starting point for a meditation about his own production of art. Sounds of old-fashioned trains accompany the initial pan over a field of colored postcards with mountain scenes, which is then abruptly replaced by the yellowed page of a dictionary with the words "father" and "husband" among others with two syllables. Frank leafs on to the monosyllabic words, to word fragments that have no meaning in isolation and are useful only as building blocks. The filmmaker is aware of the fact that the lens, as a kind of telescope, can capture only details but never everything. Robert Frank inscribes these images in his body: we hear heavy breathing, see his hand on the pages. The philosopher Paul Virilio wrote: "Vision machines make the artist's body superfluous, just as light produces images." Frank's personal works represent a vehement contradiction to this claim. The following sequence of images—each of which possesses great poetic power—reveals what he is capable of as a film magician: through a shadow mask we see a snowy evergreen forest pass by, while in the foreground a solitary dog trots through the snow. We would like to lose ourselves in these "beautiful" images—but are then torn from these dreams by a closeup of his wife's eye, seen through a magnifying glass, which has a reflection of Frank himself. Once again the artist points out

so many of whom have died; his art and the questions about the act of making pictures; his sadness when thinking about his parents and his son's illness; his love of New York and the trees he planted in front of his house in Mabou (one of them must be propped up so that a heavy branch doesn't break); anonymous street scenes; his gratitude for the people who have helped him become a recognized artist, and those who have helped him deal with everyday life; the beauty of fields swaying in the wind and at the same time anger at nature because it doesn't provide any answers; his desire for uncompleted journeys and his physical aches and pains as an old man. All of that enjoys the same significance in this video, all of that is part of his life. Thomas Bernhard, the Austrian writer (Frank has read all his books, and Bernhard inspired him greatly), once said in an interview: "The actual story is completely secondary in my opinion." Frank's *True Story* takes its richness not so much from the story, but more importantly from the expression in sound, language and image, and everything that resonates in-between.
Brigitta Burger-Utzer

2004

True Story

USA 2004, video, color and black & white, 26 min.
directed by: Robert Frank
cinematography: Robert Frank, Yuichi Hibi
editing: Laura Israel
sound mix: Laki Fotopoulos
online: Steve Covello
cast: Robert Frank, June Leaf, Pablo Frank, Albano Pereira (voice), Nancy Fish (voice), etc.

The Story Is Secondary

The title refers to the expectation that Robert Frank has been playing with for a long time now: while he has always identified the search for truth as the engine driving his artistic work, he now adds the truth itself, so to speak. At the same time he's aware of the impossibility of telling a strictly "true" story in art. And so, this recent film self-portrait develops on the basis of a number of fragmentary short episodes: excerpts from previous films are checked for their current relevance, old photos or elements from photographic cycles are shown, June Leaf (Frank's wife) and her art are presented in detail, but filmmaking itself is also explained ironically: "Video is electronic and film is black and white?", he has his wife ask, and he answers coolly, "Yeah." In another scene she asks a question, "Why do you make these pictures?", and he immediately switches to the next one, starts playing a song and leaves the question unanswered. While projecting a film onto the wall, he says tersely: "What the hell, it's always running, the light is on...." On the beach at Mabou Frank finds a lightbulb and holds it in front of the camera, then sees a crab's claw and asks, "What is this hand saying?" He yawns and says, "Let's look at this instead!", then shows us his left foot against the sky, "Hallo, then let's look at this instead!"—and we see his son at the beach. Frank talks in an unbearable child's voice that takes the desire for screen sensations to an absurd degree.

What's important to show seems to be the major theme of *True Story*, and to be honest, this is the filmmaker who is remembering himself; the people who are close to him—

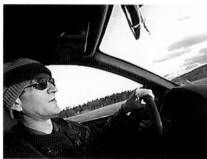

humorous and wholly unpretentious survey of the spatial and temporal parameters in the life of a man who "does his work at night" (Frank). "No big deal," says Bobby, "a good job." Both men laugh when they realize that the paper route takes them in a circle: "Circles—that's all we do," grumbles Frank, "that's all we do, when it comes to the end!"

At the conclusion, the sun is up and the music has changed; Pink rather than Jennifer Garner. One of the last customers is already waiting at his stairway. Then Bobby is back in his own living room, sitting next to his vacuum cleaner. "What was it like being filmed?" asks Frank, this time about the quality of *his* work. "Good," answers Bobby. Story A, Story B.

Significantly, *Paper Route* was presented on a ship, the *Arteplage mobile de Jura*, in August 2002 as part of an installation of Frank's video and photographic works. A beautiful venue for a tale about a "life on the move," without a fixed location, on the way from A to B, endlessly moving in circles. *Michael Loebenstein*

Paper Route

CAN / CH 2002, video, color, 23 Min.
commissioned by the Expo project Le Cafard
directed by: Robert Frank
editing: Laura Israel
production: Vega Film, Zurich; Robert Frank
cast: Bobby McMillan

Nothing but Circles

Paper Route, which was commissioned for the 2002 Expo in Switzerland, is a short, laconic video film about departures and returns, about cyclical movement in nature and the equally circular movement of a journey. Both the starting point and destination are shown in the first scene. Frank's video camera skims over a collage of photographs and notes, typed and handwritten, hotel stationery. "Leaving Home" is visible, and "Coming Home"; a woman's voice from off-camera —"Story A," "Story B" continues this bisection. "The voyage of an ordinary man with important memories."

Fade-in, crows cawing, a garden fence in the snow: Nova Scotia, Canada. Robert Frank films himself in a mirror, waiting for the sun to come up. "I wonder about the paper route... getting the news..." As is so often the case in Frank's works, a casual question, a passing remark about the world before one's own doorstep, is the starting point for a photographic meditation. How is the daily newspaper delivered to remote, snowed-in houses? The filmmaker once again sets off on a journey, this time a paper route: he accompanies Bobby McMillan, a wiry, high-spirited paperboy, on his evening route around Mabou, Nova Scotia. One hundred fifty-eight subscribers, each with a name and a story, and Bobby knows every one of them.

At the beginning it is still pitch black; snowflakes swirl and easy-listening hits for early risers, from "The Time of My Life" to Rod Stewart, play on the radio. Frank's camera alternates between Bobby's profile and the view through the windshield. *Paper Route* is a

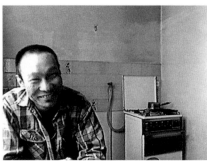

and me, and not just his pictures," said Frank in an interview.[1] Significant for this approach is a question posed by a journalist: "What do you want to tell San Yu?" In response, Frank addresses the painter himself, who is lying on the Paris studio's floor with the camera: "The sun is shining on your tree. No more paintings. So this would be your story about the few moments I remember."[2]

In black-and-white footage set apart from the rest of the film Frank combines real, fictitious, and autobiographical elements.[3] In Paris, the city where San Yu lived, an actor playing the role of the artist talks about creative work, history, dreaming, and love. The issue of this character's authenticity remains open. *San Yu* is therefore not only an examination of the modes of talking of art and artists, but also about the authenticity of documentary depictions. *Nina Schedlmayer*

[1] Interview with Ute Eskildsen, Eskildsen, eds., *HOLD STILL_keep going,* exhib. cat., Museum Folkwang, Essen, Scalo, Zurich, Berlin, New York, p. 111.
[2] "By questioning the veracity of photographic images and by proposing to eliminate the camera that stands between experience and documentation, Frank declares that memories of an experience are more real than photographs of it." Philip Brookman, "Windows on Another Time: Issues of Autobiography," in *Robert Frank: Moving Out*, eds. Sarah Greenough, Brookman, exhib. cat., National Gallery of Art, Washington, Scalo, Zurich, 1995, p. 153.
[3] See also Philip Brookman on *Last Supper*, Brookman, op. cit., p. 143.

San Yu

CH / F 2000, video/35 mm, color & black and white, 27 min.
directed by: Robert Frank
cinematography: Robert Frank, Paolo Nozzolino
editing: Laura Israel
production: Vega Film, Zurich, Paris; Yves Riou, Didier Fouquier
cast: Nikolaï Boldaïen, etc.

A Requiem?

In Paris and Taiwan, Robert Frank sets off on a search for traces of a friend, the painter San Yu, who died in 1966 at the age of sixty-five. This search documents itself: San Yu's birthplace has supposedly been marked on a map of China, arrows on the street and street signs indicate the film's procedural and self-reflexive nature. There is "no clear direction or substance of what I will be trying to say and to show," admits Frank, and then asks himself, "Is this a requiem?" Frank met San Yu in the 1960s and briefly traded his studio in New York for the latter's in Paris. Thirty years after the painter's death, Frank was contacted by the art historian Rita Wong, who asked him about sculptures left with him.

Dispensing with a spectacular dramatic structure, organized solely by means of inserts, Frank's film documents the story of its own production. Correspondence with San Yu's widow, auction houses and journalists appear occasionally. Frank tells us not only about his friend San Yu, but about himself also, showing his careful and almost tender interaction with the other man's works. In contrast to other documentaries about artists, he did not simply shoot footage of drawings, paintings and sculptures; they appear within their contexts exclusively, as lots at an auction or as exhibits at a show as it is being set up.

In a way similar to *Last Supper*, Frank has made a report on San Yu, his descent into poverty (thoroughly clichéd), the painter's œuvre and its posthumous discovery on the basis of third-party statements. The artist himself is shown infrequently—once quite significantly in a photograph with the filmmaker. "I wanted to show something between him

Nova Scotia was successful. The ghosts of memory no longer plague him; the family albums are empty; there are no pictures from the past. It seems somehow sad, this absence of images, though this might be no more than the product of Frank's distaste for the sellout of his icons, his loathing to repeat himself. "And I'm thinking of Kerouac when he said, 'Being famous is like old newspapers, blowing down Bleecker Street,'" says Robert Frank in *Home Improvements*. Such a dismissive statement seems unnecessary in *What I Remember*; the role of a creative personality who combines life and art, external reality and autobiography is playful to play. Frank becomes the old man with a camera who is on the lookout for motifs, someone who chops wood, puts on his steel-toed shoes to go shopping, and caresses his wife's wrinkled cheek with a rough hand.

It is almost as if Frank had come to enjoy this role of an old master, able to present art and domestic life as a repetitive interplay of rituals. Spontaneity still comes naturally to him; he is always ready for "more photographs."

At the same time one thing is certain: it is nothing more than a game. Life's scars have no place in a portrait motivated by admiration. *Brigitta Burger-Utzer*

1998

What I Remember from My Visit (with Stieglitz)

CAN 1998, video, color, 7 min.
directed by: Robert Frank
cinematography: Jerome Sother
editing: Laura Israel
production: Robert Frank
cast: Robert Frank, June Leaf, Jerome Sother

The End of Images

The video's title is repeated by a voice with a French accent, suggesting the beginning of a personal narration. The home-movie touch underlines this impression. A naked light bulb hangs from the ceiling; the hand of an unseen person switches the lamp on. The main attraction—the cinematic observation—can begin, though with the most basic means available. "What I remember from my visit with Stieglitz: the hospitality, the wood stove in the kitchen, chicken for lunch, Stieglitz, waiting for the sun to appear through the clouds...."

The man behind the camera is also the narrator: Jerome Sother, a young filmmaker invited by Robert Frank to make a short film during his visit in Mabou. As was the case in his films *Me and My Brother, About Me: A Musical, Candy Mountain,* and *Last Supper,* this project provided Frank once again with an opportunity to question his role as a photographer and filmmaker through the alter ego of a real or fictitious artist. No less a personality than the great American photographer Alfred Stieglitz, whose fame was based in part on the portraits of his wife, painter Georgia O'Keeffe, represents a "grand old man" in this film work. The similarity to Frank's life story—he had been married twice, to two different artists—is another one of the details that evoke his own biography, private life and work as a photographer. Frank plays the role of Stieglitz, his wife June Leaf plays Georgia, "who comes from her studio in the rain." But some of the elements employed in earlier self-referential works are missing: the children, having passed away long before, are no longer able to offer resistance. The retreat from his fans and other members of the art industry into the rough landscape of

transforming them into memories, allowing them to enter a joint context. The walls form an inner refuge where Frank can retire with his wife to contemplate the progress of civilization through nature; like Philemon and Baucis, the lines "You, on shores of breaking foam, / See, a garden lies completed" in Goethe's *Faust* refer to the couple's seaside retreat where they are spending their golden years. The picture of Buddha has no particular significance in *Flamingo*; it appears only briefly in a series of equally important images. But this could also provide a key to the film's organization, like the beginning of a Zen meditation: consciousness is bombarded by sensory stimuli from all directions and liberates itself only gradually from them. When construction vehicles finally clear the field, a house is left behind for final insulating. "Paint it black."

Flamingo is dated like a painting, but the signature, rather than certification, is written in the snow—another reference to a present which does not exist on film.
Bert Rebhandl

1996

Flamingo

CAN 1996, video, black and white, 5 min.
made for the presentation of the Hasselblad Award
directed by: Robert Frank
cinematography: Robert Frank
editing: Laura Israel
narrator: Miranda Dali
production: Robert Frank

Structures of Residential Buildings

A house high above the sea. A ray of light falls on some old photographs.
A voice names the things we see. *Flamingo* closely resembles *What I Remember from My Visit
(with Stieglitz)*, yet it develops in a completely different way, because Frank himself is visible
only briefly in this black-and-white report on the elementary structures of residential buildings.
Miranda Dali's commentary sounds objective, her voice dislocated from the images like in
an art installation intended to fill a space (*Flamingo*'s theme). Dali names what is visible in the
picture: the silhouette of a huge excavator (in a photograph); and souvenirs, specifically a statue
of Buddha and a postcard with the Empire State Building. Laborers arrive to work on the house
in Nova Scotia where Frank lives with his wife June. An addition to the house is planned to
provide an even better view of the ocean. In Frank's film, routine movements, the precision and
speed with which they work, become organic shapes and processes, similar to a stack of paper
fluttering in the wind. The snow, the retreating snake, various landscapes, the wooden walls,
and the sea—everything together provides latitude for associations, as defined by Miranda Dali,
even when she conspicuously stops talking and the indistinct images show the workers going
about their business. The "all-patient house" has a dual structure in *Flamingo*, both material
and biographical. It consists of four walls and the fragments of someone's life (which are
repeatedly projected onto or attached to the walls). "This is the time to say a few words: about
building a house, about projecting slides." The Biblical tone at the beginning of this statement
is employed in a reflection on media archeology—at first the house reflects the images,

Frank's images intuitively follow the song's rhythm, and a high speed playful web of associations is created. At the beginning, the camera glides along the ceiling as if it were being pulled by an invisible current. This is followed by a 360-degree pan which has a rather disorienting effect in its attempt to capture the entire scene (just like the contradictory phrase "descending into air"). A little later the viewer is witness to an amusingly macabre mystery play acted out by Smith and band (at one point she whispers something into a musician's ear). Frank participated occasionally by inserting irritating closeups which tended to add sensuousness rather than meaning. At times, Christian symbols such as an engraving of the Last Supper seem to demand reinterpretation of the lyrics' heathen metaphors, but this is misleading: when Smith takes some objects out of her pocket the first thing to appear is a rosary—and then some coins. This seems to happen more out of coincidence rather than as commentary on the related topics of religion, pop, and economics. Or maybe not: Things and actions in *Summer Cannibals* are simultaneously inexplicable and provocatively concrete. Maybe it is a horror movie after all: a story of the unpleasant secrets lurking beyond the palpable. *Christoph Huber*

1996

Summer Cannibals

USA 1996, 35 mm, black and white, 5 min.
music film for Patti Smith's song "Summer Cannibals"
directed by: Robert Frank
cinematography: Kevin Kerslake
editing: Laura Israel
music: Patti Smith
production: Cascando Studios
producer: Michael Shamberg
cast: Patti Smith & Band

Horror Movie

"I went down to Georgia / Nothing was as real / As the street beneath my feet / Descending into air." The growling timbre of Patti Smith, the woman who only allows herself to be photographed with black-and-white film, accompanies the introduction of a cryptic text, apparently about a witch's Sabbath, vampirism, and a mystic communion ceremony in a world where all the rules have been turned upside down. The song is entitled "Summer Cannibals," the same as a chapter in James G. Ballard's experimental novel *The Atrocity Exhibition*, which is most probably not a coincidence. In it there is no difference between the outer and inner worlds—the line dividing the overwrought, fragmented psyche of the protagonist(s) and the omnipresent stimuli from a media-obsessed society have been obliterated. And in Smith's music and its driving rhythm, the lyric self overcomes an archaic vision beginning in the second line, which addresses "the darker side of being a rock musician," as Smith later remarked.

This would be ideal material for a horror movie, but Frank's lighthearted, energetic short film made to accompany *Summer Cannibals* dispenses with logical illustrative images to the extent they fail to serve Patti Smith's performance for the camera: For example, at the lines "The viscous air / Pressed against my face" at the song's climax she theatrically presses her hands to her face; after a thundering, guttural cry of "Eat!" leads to the lashing refrain, she bites herself in the crook of her arm. *Summer Cannibals* makes use of a typical, in fact banal music-video situation: Smith and her band put on a make-believe concert in a sparsely furnished room. Oddly enough though, Frank's film has an aura of the inexplicable.

about life...." What that could be, a film about life, is not dealt with. But in the same breath, because *The Present* does not say anything about a subject, it represents a part of feeling one's way in daily life, as Frank's work (and art) has marked the realization of this possibly (probably) impossible film.

There are repeated moments of saying farewell, departure, separation. Something (someone) is left behind, and someone else begins a journey. A friend in Switzerland dies: "I am almost sure I will not see him again." The next scene shows a sign at Zurich's main train station: "Another 1,347 days until the year 2000." Back in the filmmaker's house on the Nova Scotia coast, the word "memory" has been written on a wall. Off-camera, the writer/filmmaker grumbles: "Today I'm going to ask Luigi to erase the word 'Memory.' " Frank watches as the young man scrapes the letters away with difficulty, beginning at the end of the word and working back until only "me" is left. Putting down roots and ripping them up—the two acts are connected. Working on that is painful. At one point, Luigi takes a look at the wall, and then says into the camera, "It's kind of sad."

At the very end of the film, a friend plays against himself. He has taken a pair of dice from a large jar that is filled with many of them. First he rolls a ten as his first self, then a seven as his second self. "I've lost," says one self. "But so what?" answers the other. "That's the question." *Ralph Eue*

1996

The Present

CH 1996, video/35 mm, color, 27 min.
directed by: Robert Frank
cinematography: Robert Frank, Paulo Nozzolino
editing: Laura Israel
sound: Robert Frank
production: Vega Film, Zurich, Ruth Waldburger

Life as a Craft

One Monday… The semblance of a diary: the sweeping gaze of a video camera.
Everyday surroundings in the screenwriter's house. And his off-camera voice: "I'm glad I have
found my camera. Now I can film. But I don't know what. I don't know what story I would like
to tell. But looking around this room, I should be able to find something. Don't you think so?
Don't we know? Isn't it all there?" The filmmaker talks to himself in an associative monolog
at the moment of filming. In doing so, he creates a communicative space between I and you,
you all and we. Then, roughly two minutes later, the picture focuses clearly on a piece of
cardboard on the floor. What is hiding behind it? On the one hand, the plot: "I'm gonna begin
this film with this picture. What's behind this board?" On the other, there are the flies on the
windows, his friend Fernando, his life together with June Leaf, his memories of his daughter
Andrea, his deceased son Pablo, the apartment in New York, his brother in Switzerland, and
the crows in the winter...

An attempt to connect with the things, people, animals, with events in front of
the camera—and with the film's potential viewers.

A diary which Frank presumably started some Monday between 1994 and 1996:
what might it be about? The craft of his life during those years; the combined, parallel and
chaotic onslaughts of memory, constant attempts to order his private affairs, the presence of
animals in front of the house's windows, of trips, and unfinished projects. At one point Frank
reads a melancholy sentence from a letter he received: "We should go on making this film

covered with flowers captioned "Pour la Fille" (a reference to his daughter Andrea, who died at the age of 20). These quite sad images are counteracted by honest feelings of aggression directed at death and aging, such as the reaction of Frank's old friend Harry Smith when asked how he felt about having a birthday: he makes a dismissive gesture and bellows, "It sucks!"

Photos of empty spaces seem to complement the stillness of this film, and they are employed as punctuation—a deserted beach, sterile landscapes of apartment buildings, a large parking lot, an empty asphalt surface, an abandoned street in an industrial district. All these places were once inhabited but are no longer: a temporary state of emptiness, of silence. The last scene shows a group of women dragging a sack across a field with the caption "Keep busy." The emptiness and the silence represent a needed pause in a constant flow of images, thoughts and memories, like the blank pages in Frank's photo albums. Or, as the title of one of Frank's photographs says: "HOLD STILL keep going." *Nina Schedlmayer*

[1] Sarah Greenough, "Fragments That Make a Whole: Meaning in Photographic Sequences," in *Robert Frank: Moving Out*, eds. Greenough, Philip Brookman, exhib. cat., National Gallery of Art, Washington, Scalo, Zurich, 1995, p. 97.

1994

Moving Pictures

USA 1994, video, color & black and white, silent, 16 min. 30 sec.
directed by: Robert Frank
cinematography: Robert Frank
editing: Laura Israel
production: Vega Film, Zurich
cast: Allen Ginsberg, Raoul Hague, Harry Smith, June Leaf, Jean-Luc Godard, etc.

Blank Pages

"I have a faible for fragments which reveal and hide truth," announces a text in capital letters. But the word "memory," written several times on a sheet of paper in a typewriter, appears at the beginning of *Moving Pictures*. The fragmentary nature of memory is made up newly in an associative sequence parallel to the fragmentary nature of the photographic image.

This silent work deals once again with Robert Frank's transition from photography to film and his search for a "solid form of expression."[1] Frank assembled his own photographs in temporal and spatial sequences: one is laid atop another, photo albums are flipped through; strips of prints are filmed with a slow and probing gaze.

Ever since the 1950s, Frank had regarded the solitary iconic image with a critical eye, developing strategies to counteract its claims to absolutism. In *Moving Pictures* the borders between photography, found footage, projected film footage and filmed reality blur in long zooms to details of photographs, in veils of dust or windowpanes, and washed-out colors with a few brighter contrasts. To this end, Frank mostly employed material he had already shot for his artworks. The way in which these images pass by parallels the title's dual meaning. *Moving Pictures* refers firstly to a moment in the viewer's action, in this case that of the filmmaker himself, namely the movement of images (as objects), and secondly to the nature of film as opposed to photography and painting.

Moving Pictures also deals with death. The headstone of Frank's parents is the first image we see, then the photos of Raoul Hague and Jack Kerouac on their deathbeds, a meadow

by a camera, have on a controlled, staged scene? Strictly speaking, is not *every* camera shot documentary in nature? And what about the various modes of portrayal by actors? The Waiter watching over the buffet is played by Bill Rice, who has appeared in a number of independent productions. How could one categorize his interaction with the guests, whose acting is more or less professional? And the amateurs? When do they first sense the presence of the virtually hidden camera, when does their natural behavior turn into a forced performance?

A great deal of autobiographical elements from Robert Frank's life were used in this work, such as the son who does not want to be exploited for his father's art, and the father/husband who wants to disappear and feels a need to escape "art discourse." This film's texture is reminiscent of Buñuel; the beating wings of the *Exterminating Angel* are apparent: The bourgeois guests are trapped in their arena of small talk and art talk. Why do they not leave the party? Even the evening meal supplies film references, such as to the beggar's banquet in Buñuel's *Viridiana*. In the latter film, people also sit at a table which has been set, one that was not set for them, enjoying the meal in a manner differing from that of the "authorized" group. They too are acting out the Biblical Last Supper. But are these people on display? Are they being exploited for the film?

Robert Frank's radical questions directed at images also run the risk of losing their voice: in the black frame. *Birgit Flos*

1992

Last Supper

CH / GB 1992, 16 mm, color, 50 min.
directed by: Robert Frank
script: Robert Frank, Sam North, Michal Rovner
cinematography: Kevin Kerslake, Mustapha Barat (video), Robert Frank (video)
editing: Jay Rabinowitz
art director: Tom Jarmusch
production: Vega Film, Zurich; World Wide International Television, BBC;
Ruth Waldburger, Martin Rosenbaum
cast: Zohra Lampert, Bill Youmans, Bill Rice, Taylor Mead, John Larkin, Odessa Taft, etc.

Exterminating Angel

Parts of *Last Supper* resemble an educational film with directions for its use.
It deals with the impossibility of depicting something. Is it about the impossibility of depicting something? What is real? What is staged? What can be staged by coincidence? And which reality does a video camera record?

Guests arrive at a vacant lot in New York, which is surrounded by rundown apartment buildings. The host is a writer, and he intends to celebrate the publication of his latest book with his friends and acquaintances. A buffet has been laid out. Waiting for the writer. Waiting for Godot. He fails to show up. This level of the film is constructed in the same way as a theatrical work. The dialogues seem holographic: almost every quotable phrase reflects the meaning of the entire statement.

But the film begins with a video image of this empty lot, and with an indication of the date: 9-18-91. The irregular series of similar shots gives structure to the staged events. The dates vary; it turns out that the story is not being told in chronological order. The video picture shows what happened and indicates time and place. There is the group of actors: white, middle-class. The actual residents of this neighborhood walk across the lot and enter the picture, and the film. They are African-Americans. Some of them simply walk past the scene; others hesitate or turn around to leave.

The exciting aspect of this complex film text plays out in the transitions. What kinds of effects can a real environment and its incidental details, randomly captured

Then I encountered the closest thing *One Hour* has to a skeleton key—a tiny book issued by Hanuman Books in 1992, comprising mainly a transcription of the dialogue heard (over 74 pages), but also two pages of credits: half a dozen production or crew workers and 27 actors. Plus an acknowledgement that the film has a script (by Frank and his assistant, Michal Rovner), that a conversation heard in a diner was written by Mika Moses, and that the lines of Peter Orlovsky (intercepted by Frank roughly halfway through the hour, in front of the Angelika Cinema on Houston Street)—who gradually wrests the film's apparent center away from O'Connor—are "total improvisation."

 Here's where the mysteries truly begin. How much of Frank's apparently random drift is precisely plotted, how many seemingly chance encounters are staged and intricately coordinated, how much of what we see and hear is extemporaneous? The volatile, unstable mixtures of chance and control can never be entirely sorted out. In short, how much this is a tossed-off home movie about Frank's neighborhood and how much it's a contrived board game spread out over several city blocks ultimately becomes a metaphysical question. So perhaps Frank isn't so far away from Ruiz after all. *Jonathan Rosenbaum*

1990

C'est vrai! (One Hour)

F 1990, video, color, 60 min.
directed by: Robert Frank
script: Robert Frank, Michal Rovner
cinematography: Robert Frank
production: La Sept (TV), Prony Production, Paris; Philippe Grandrieux
cast: Kevin O'Connor, Peter Orlovsky, Taylor Mead, Willoughby Sharp,
Bill Rice, Tom Jarmusch, Zsigmond Kirschen, Sid Kaplan, Odessa Taft,
Sarah Penn, Margo Grip, etc.

Metaphysica

"I've seen *La chouette aveugle* seven times," Luc Moullet once wrote of Raúl Ruiz's intractable masterpiece, "and I know a little less about the film with each viewing." I can't say *One Hour* has anything in common with the Ruiz film, yet what also makes it a masterpiece and intractable is the same paradox: the closer I come to understanding it, the more mysterious it gets. My first look at this single-take account of Frank and actor Kevin O'Connor either walking or riding in the back of a mini-van through a few blocks of Manhattan's Lower East Side—shot between 3:45 and 4:45 pm on July 26, 1990—led me to interpret it as a spatial event capturing the somewhat uncanny coziness and intimacy of New York street life, the curious experience of eavesdropping involuntarily on strangers that seems an essential part of being in Manhattan, an island where so many people are crammed together that the existential challenge of everyday coexistence between them seems central to the city's energy and excitement.

But this was just a first impression. A second look highlighted the degree to which Frank's rambling itinerary seems to recapitulate a tradition of North American experimental cinema harping on the perpetual motion of protagonist and/or camera, encompassing such varied works as *At Land, Dog Star Man* and Michael Snow's camera movement trilogy, in which narrative becomes a kind of stream of consciousness as well as a sort of journey, even if the journey (as in Snow's) proceeds mechanically and in successive jerky zooms or pendulum-like arcs or circles, retracing the same patterns and/or spaces.

and somewhat later, "What the hell is happening / I can't think of everything / I don't know what day it is / Or who I'm talking to."

Without any obvious reason a child, a girl, begins to dance in the street in front of the man as he sits there, at his table. Mechanically, as if she were a wind-up toy, she completes her dance—an enigmatic miniature Madonna. Somewhere else a few people at a low wall or embankment gaze into the distance, possibly at a stage. A series of faces, both in film footage and photographs, the latter black and white, move briefly into the picture. The idea of formlessness, the associative patchwork, permeates Frank's first promotional video. It looks quite different than the one he would make for Patti Smith a few years later; his clip for New Order resembles the work of an amateur, a desperate attempt to create alternative "images" for an industry no longer able to take the main factors—the music, the image—into account in its constant attempts to outdo itself. Frank's *Run* is a plea for deceleration, for the awkward, the everyday. With that short work, Robert Frank took a step behind everything defining the field in which he was working, the result being the most modest music video ever made.
Stefan Grissemann

1989

Run

USA 1989, video, color & black and white, 3 min. 35 sec.
music film for New Order's song "Run"
directed by: Robert Frank
cinematography: Robert Frank
editing: Laura Israel
music: New Order
producer: Michael Shamberg
cast: New Order, etc.

What the Hell Is Happening?

Whenever there are aesthetic rules in force, Robert Frank ignores them. While making a music video for famous British band New Order in 1989 he simply refused to follow the basic guidelines. Although Frank did produce a three-minute, thirty-second film as called for in his contract, thereby providing visuals for New Order's song "Run," he created images which contrasted starkly with the industry's claims and pretensions. The type of film he made was what the industry has the least possible use for: an anti-clip.

The images Frank produced to accompany the band's melancholy pop are unattractive, cheap and "poor"—Arte Povera. Rather than telling a story, they confuse matters, remaining little more than fragments, impressions of a rock industry which has seen better days. The band itself is visible only occasionally, on a misty stage, disappearing in the dry-ice fog. In fact, the musicians play a secondary role in this work. Frank's clip features a skeletal plot instead, a piece of fiction characterized by resignation and solitude. An elderly man paces an empty street, apparently with some indecision, finally sitting down at a table in front of a drink. He ponders something, then begins laughing to himself as if hilarity were the only possible reaction to the absurdity of the world.

Frank's underlying pessimism seems to be reflected in the song's lyrics, in the words which confront the strangely meaningless images with some remnant of sense: "Answer me / Why won't you answer me / I can't recall the day that I last heard from you,"

curiosities and the general vibrations in the months shortly before the fall of the Berlin Wall. Its scenes serve as bare stages for a naïve self-presentation of the German people. A young foreigner tells us his idea of the relationship between modern xenophobia and past anti-Semitism: like foreigners in today's Germany, Jews always got a higher class of women, which made other Germans angry. At the conclusion he says, "I speak their language perfectly. But I'm not German. I was born in Spain. I'm Moroccan and want to stay Moroccan. I'm not going to change my citizenship." (An insert appears: "History / His Story"— a demonstration of reverence for Godard which is not really necessary.) Then there is an elderly woman in a souvenir shop who, indifferently, sells delicate statuettes of Hitler, Elvis and other personalities. And a bakery clerk at the window in a pedestrian zone enthusiastically reporting on her customers' buying habits: "What most people want in Germany today is this whole-grain bread."

 P. S. In one sense *Hunter* and *Allemagne Neuf Zero* reach the same conclusion regarding Germany. They identify an underlying theme extending from Romanticism through two centuries to the present day: solitude. In his film Godard operates on multiple levels with the word "solitude," virtually putting it on display. *Hunter* ends with a shaky pan of some graffiti on a firewall: "We're always alone … until we die!!" *Ralph Eue*

1989

Hunter

D 1989, 16 mm, color & black and white, 37 min.
directed by: Robert Frank
script: Stephan Balint
cinematography: Clemens Steiger, Bernhard Lehner, Robert Frank (Video)
editing: Jolie Gorchov
sound: Gerhard Metz
production: Kulturstiftung Ruhr (Kinemathek im Ruhrgebiet), Essen;
Westdeutscher Rundfunk
cast: Stephan Balint, Gunter Burchart, Sabine Ahlborn-Gockel,
Laurenz Berges, Fosco Dubini, Topuz family, etc.

Stranger Than Paradise

An American in Germany's Ruhrgebiet. His name is Hunter, and he's touring the area around Duisburg. A travelogue? Maybe. Somewhere between the Rhine and Ruhr rivers, in the country's industrialized midwest, he meets some locals. An ethnological project? Possibly. His attempts to establish contact with the people there are unsuccessful. But he keeps trying to understand how someone can live in this area and cope with it. An essay? That too.

Stephan Balint, who also wrote the film's script, plays the role of Hunter, the story's mediator. We experience the locations in this travelogue through him. He speaks American English, but with a strong Eastern European accent. (Balint was one of the founders of Squat Theatre, a Hungarian theater troupe in New York. His sister, Eszter Balint, was the female lead in Jim Jarmusch's *Stranger Than Paradise*.)

Hunter is a play on foreignness and the attempt to overcome it, or how this state enables insights and certain experiences which would have been otherwise inaccessible. In other words: controlled communication breakdowns. It is not certain whether the many encounters, which are characterized by an absurd excess of language barriers and misunderstandings, are unsuccessful attempts at interviewing passers-by or boldly staged scenes, whether they were captured or planned. *Hunter* is an amusing film, though at the same time it is imbued with wonderful shades of sadness, like the lingering taste of an excellent wine.

Hunter was made late in the summer of 1989—one year before Godard shot *Allemagne Neuf Zero* on the opposite side of the country. It can now be read as a record of

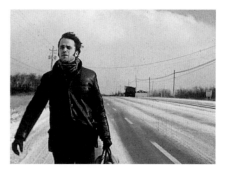

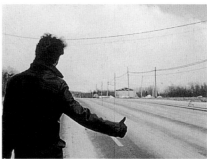

at least possibly. The longer he follows Silk's trail, in a meandering and tragicomic way, the closer he comes to discovering the other man's motivation for disappearing. But only after finding Silk (an impressive Harris Yulin) shortly before the film's end he is able to fully understand the decision. "The whole deal went up in flames" is Julius' comment on the surreal finale. He is then prepared to move on.

Candy Mountain has its assets: Robert Frank's feeling for photographic composition, for example, and a thankfully unpretentious approach to the popular genre of the road movie, which in this case—despite numerous memorable guest appearances and equally good music (Dr. John, Tom Waits, Joe Strummer, etc.)—seems entirely free of 1980s independent hipsterdom, thanks to Wurlitzer's brief, often bitingly funny and always critical view of myths and their artificial magic (once, wearing his sunglasses and his hands on the steering wheel, O'Connor resembles Warren Oates' desperately sad dreamer GTO in the self-destructive road-movie apotheosis *Two Lane Blacktop*, which Wurlitzer co-wrote): "Life ain't no candy mountain, you know," says a driver who, near the film's beginning, gives Julius a ride after he had been abandoned at a gas station. The driver then charges Julius fifty dollars for taking him. *Christoph Huber*

1987

Candy Mountain

CH / F / CAN 1987, 35 mm, color, 91 min.
directed by: Robert Frank, Rudy Wurlitzer
script: Rudy Wurlitzer
cinematography: Pio Corradi
editing: Jennifer Auge
sound: Daniel Joliat
production: Xanadu Films, Ruth Waldburger; Les Films Plain-Chant, Philip Diaz;
les Films Vision 4 Inc., Claude Bonim, Suzanne Héncurt
cast: Kevin O'Connor, Harris Yulin, Tom Waits, Bulle Ogier, Roberts Blossom, Leon Redbone,
Dr. John, Laurie Metcalf, Rita MacNeil, Joe Strummer, Jane Eastwood, Kazuko Oshima;
and the musicians Joey Barron, Greg Cohen, Arto Lindsay, Marc Ribot, Fernando Saunders,
John Scofield

The Whole Deal

Wanderlust from the very beginning: the camera sweeps from New York's skyline to the interior of a loft which is under construction. Julius (Kevin J. O'Connor) abandons his work and leaves the room. "You don't come back," shouts his boss angrily. "Right," is the other man's self-assured answer. Julius then marches through the city's streets and has his first puzzling encounter: he laughs in the face of a hotel doorman as the man struggles with a banana.

Candy Mountain is about travelling, both in a physical and mythical sense, and about music. Julius hears about legendary guitar maker Elmore Silk, who disappeared some time before. He pretends to be acquainted with the man and is set off to search for him. Julius' efforts will supposedly be rewarded with a career, and the client will get Silk's precious guitars. There is much discussion of integrity—showbiz talk—and of a "walk down rock-'n'-roll memory lane," but the real issue around which everything revolves is business. "You're telling me he disappeared," says an arrogant rock-'n'-roller (David Johansen) about Silk, "It's as if he signed with William Morris or something."

Julius follows Silk's trail to Canada, and his journey becomes a repetition of history as farce: "He came with very little, he left the same way," says Silk's former lover (Bulle Ogier). Wherever Julius goes, he comes away with even less. One of *Candy Mountain*'s running gags is that Julius repeatedly trades one bad car for an even worse one—often in an absurd situation—and his expense account disappears rapidly. At the same time he gains insight, or

Hampl, "[seem to free] memoir film from the sovereignty of the image." At the same time, the voice in these works takes on great power and significance, "a voice that assembles its pictures" and belongs to a narrator who has become "more eye than I."

The filmmaker therefore assumes a strangely equivocal position in this constellation. Although close to his family, he remains behind the camera, alone with his perception. (ALONE: this word, in large letters, has been written on a piece of paper. It becomes noticeable when the camera glides over some handwritten notes which are never legible in their entirety.) And he changes sides only infrequently: once June Leaf films the man she loves. Frank smiles at the camera, somewhat embarrassed. The long self-portrait near the film's conclusion shows the man with the camera reflected in a window pane. A permeable dividing wall and a picture which corresponds to Frank's self-image: "I'm always doing the same images. I'm always looking outside trying to look inside, trying to tell something that's true. But maybe nothing is really true, except: what's out there, and what's out there is always different." *Isabella Reicher*

[1] John Berger, "Mother," Berger, "Keeping a Rendezvous." New York: Vintage, 1992, pp. 43-52.
[2] Patricia Hampl, "Memory's Movies," in *Beyond Document. Essays on Nonfiction Film*, ed. Charles Warren, Hanover: Wesleyan University Press, 1996, pp. 51-79.

1985

Home Improvements

USA 1985, video, color, 29 min.
directed by: Robert Frank
cinematography: Robert Frank, June Leaf
editing: Michael Bianchi, Sam Edwards
sound: Robert Frank
production: Robert Frank
cast: Pablo Frank, June Leaf, Robert Frank, Gunther Moses

"Autobiography begins with a sense of being alone. It is an orphan form."
(John Berger[1])

Telling Something That's True

Home Improvements, made in 1983 and 1984, is a kind of film diary. Sequences
resembling home movies tell the story of how Frank's wife June Leaf becomes ill and has to
have surgery. With mixed feelings, Frank sets off to visit his son Pablo in a psychiatric clinic.
His thoughts and actions all revolve around the past and his attempts to free himself of its
remnants. These events, which define his days, are shot through with associations and objets
trouvés such as a photograph taken in a subway car. It combines a detail of a poster
("SYMPTOMS") and some graffiti ("it was dark") to form a puzzling statement.

In contrast to Frank's photographic works, of which not only this moment is a
reminder, the film contains two further decisive elements: motion and sound, the latter
dominated by Frank's voice. Sound accompanies the images, often questioning their status and
presenting a contrast to their presumable statement, for example with a quote or a meticulous
log of sequences. This interplay resembles Patricia Hampl's[2] thoughts on the genre of film
memoirs. The simple means with which "memory's movies" often (or must) operate, wrote

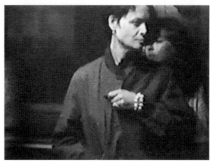

snail's pace, but when he begins to speak of Kerouac in his oddly tinny, rasping voice, a little life comes into the film: literary life, one might add.

In an aesthetic sense *This Song for Jack* has nothing extraordinary to offer; but that was apparently not Frank's goal, even less so than in other secondary projects: the documentation itself is the object rather than its value as an artwork; as a record of the gathering of old Beat poets, this film remains valuable even if it lacks a precise dramatic or visual structure. Frank's old friends, contemporaries of Kerouac like himself, are there— Gregory Corso, Peter Orlovsky—and Allen Ginsberg speaks of the "angel of death" which has spared the rest of them so far.

When the eponymous Song for Jack plays near the film's conclusion, it sounds sad, a swan song like the film itself—anything but a celebration. *Stefan Grissemann*

1 further titles under which the film was screened:
Twenty-five Years Since the Publication of On the Road, Dedicated to Jack Kerouac, This Song for You Jack

1983

This Song for Jack

USA 1983, 16 mm, black and white, 26 min.
Shot at On the Road: The Jack Kerouac Conference
(July 23– August 1, 1982, Naropa Institute, Boulder, Colorado)
directed by: Robert Frank
cinematography: Robert Frank
editing: Sam Edwards
sound: Jay Markel
production: Robert Frank
cast: Allen Ginsberg, Gregory Corso, William S. Burroughs, David Amram,
Gary Snyder, Carolyn Cassady, Lawrence Ferlinghetti, etc.

Swan Song

The sadness in Robert Frank's film images cannot be overlooked. In *This Song for Jack*,[1] a gathering takes place in the rain: someone reads from Jack Kerouac's *On the Road* for a group of six listeners. Art—so Frank demonstrates—is something for small circles. And it always seems, regardless of the specific situation, an act of mourning.

The focus of *This Song for Jack* is therefore not that reading, but art and mourning. In 1982, a number of people travelled to Boulder, Colorado, for a conference held at the Naropa Institute, a house in the country. The meeting honored the memory of a man who was lonely his entire life, a self-destructive genius: Jack Kerouac. The conference's actual occasion was the twenty-fifth anniversary of *On the Road*'s publication. Both friends and strangers can be seen there, chatting and waiting, on the porch and in their rooms: old hippies, friends, and fans of a writer who had left them thirteen years ago. Robert Frank was asked to document this meeting on film, presumably because he was the only one who owned a camera.

In the process he created a document, and in doing so, he shot from the hip: the goal of Frank's searching, probing camera, as is true for so many of this artist's works, was not "good filmmaking" but capturing something, preserving the past, those irretrievable little moments called life which are rarely seen in film. As a defender of truth in art, Frank insisted to not only show the happy occasion of the conference but, more importantly, his protagonists' and colleagues' perplexity (including his own) and the boredom they felt, having been left alone together. But then William Burroughs arrives. Walking with the aid of a cane, he moves at a

Numerous weird and wonderful moments accompany the (extremely fragmentary) plot, such as William Burroughs playing an energy czar—one of Golka's opponents—in his customarily laconic manner. A fragile old lady by the name of Agnes Moon, identified in the opening credits as Golka's "companion and witness," also adds unusual and individualistic glamour to the story. The (rather wooden) performance of an odious and successful young go-getter, who has masterminded absurd plans for the global marketing of Golka's work broadens the film's social criticism to the extreme for a few moments.

Golka's downfall is escorted by improvised music: "Lightnin' Boogie," performed on the piano by Dr. John, accompanies the hapless "Lightnin' Bob," as Golka is dubbed, on his way into a pool of cynicism—and into his defiant announcement that he would rather build (and lay) bombs under *these* circumstances. In Golka's huge laboratory, a lightning spectacularly strikes a car before a tracking shot takes us outside, into solitude, into a wide and unfathomable America. *Stefan Grissemann*

1981

Energy and How to Get It

USA 1981, 16 mm, black and white, 30 min.
directed by: Robert Frank, Rudy Wurlitzer, Gary Hill
script: Rudy Wurlitzer
cinematography: Robert Frank, Gary Hill
editing: Gary Hill
music: Dr. John, Libby Titus
sound: Leanne Ungar, John Knoop
production: Robert Frank, Rudy Wurlitzer, Gary Hill
cast: Robert Golka, Agnes Moon, Rudy Wurlitzer, William S. Burroughs, John Giorno, Robert Downey, Lynne Adams, Allan Moyle

Mad Scientist

How to obtain energy: This film's artistic creed is already revealed in its title. The creative trio behind *Energy and How to Get It*—Gary Hill and Rudy Wurlitzer together with Robert Frank—demonstrate what can be done in a low-budget narrative film in less than thirty minutes. The result might be called, for example, a baffling reflection on "truth," or a boldly related mini-drama offering plenty of room for documentary and fictional elements, satire, science, and performance art (among other things).

It is said that Frank's original idea was to make a documentary about the somewhat tragic existence of inventor Robert Golka, who had experimented with ball lightning in an abandoned hangar, intending to use it as a practical source of energy. Frank, who already had made photo portraits of Golka in the late 1970s, Hill and screenwriter Wurlitzer fictionalized the real story of Golka's life, thereby creating—in the framework of a *fake documentary*—the tale a man who had to face numerous obstacles presented by the American government, various authorities and profiteers: a surprising variation on the motif of the mad scientist, in this case apparently the administrator of Nikola Tesla's legacy.

The provisional nature of Frank's œuvre remains evident in this film, as does the familiar contradiction between supposed artlessness (jumpy black-and-white images, stream-of-consciousness narration) and the high degree of photographic quality in a number of shots. Golka himself is presented as a true antihero, a quiet and obsessive man who even gets tangled in his attempt to explain the terms "fusion" and "fission."

than autobiography. This is demonstrated by the apparently casual nature of the events captured on film. For example, in a black-and-white image taken from the filmmaker's personal archive for *Life Dances On...*, the camera pans suddenly from a static self-portrait in a small mirror on the wall to Frank's sleeping wife, then zooms back briefly and traverses the apartment. A boiling kettle on the stove, a view out a window in New York, a radio program on a Sunday morning, then the woman again: "Why are you filming this?" Frank fails to offer the answer, which can be found only in the way the film brings a motionless image to life.

For Frank, photographs arranged to form assemblages and images taken from film footage, altered and collaged, are objects whose material nature is tied to their function as vehicles of memory. When placed in new surroundings, their timestamp is made clearer. Frank was also skilled at creating new temporal contexts by means of acoustic bridges. The sentence "Do you remember the footage I showed you in New York?" put an entire color sequence into the past perfect tense, as if it were something which had already been remembered within the family. We see Frank's second wife June at Nova Scotia's coast as she attempts to show a blind man how to photograph the wind with a pinhole camera. *Life Dances On...* is in the final analysis about the limits of what photography can depict. *Christa Blümlinger*

[1] Robert Frank, "J'aimerais faire un film...," *Robert Frank*, coll. Photo Poche, Paris: Centre National de la Photographie, 1983.
[2] Jean-Paul Fargier, "La Force faible," *Cahiers du Cinéma*, no. 380, February 1986, pp. 35-39.

1980

Life Dances On...

USA 1980, 16 mm, color & black and white, 30 min.
directed by: Robert Frank
cinematography: Robert Frank, Gary Hill, David Seymour
editing: Gary Hill
sound: Robert Frank, David Seymour, Gary Hill
production: Robert Frank
cast: Pablo Frank, Sandy Strawbridge, Marty Greenbaum, Billy, Finley Fryer, June Leaf

A Film in the Subjunctive

A slim book with photographs by Robert Frank, published in Paris in 1983, begins with a text written by the artist. In it he seems to be describing *Life Dances On...* as a film in production. This text, given the emblematic title "I Would Like to Make a Film...,"[1] deals with nothing less than the relationship between photography, film, and life itself. Frank voices his desire to unite private and public life, including everyday coincidences, in film. Photographs in films, he explained, should function as pauses and windows which show other times and other places.

Frank does not place a great deal of importance on "perfect" images, which Jean-Paul Fargier[2] described as his "weak strength." When Frank operates a camera, he is active and normally intervenes on several different levels simultaneously. He once introduced himself, microphone in hand, to a few amateur photographers in New York, revealing himself to be the film's subject. Another time his arm appeared from behind the camera, replacing the clapboard with a snap of the fingers, and Frank continued asking questions in a voice-over. At times, when his efforts reached the limits of words' capabilities because the interviewee refused to answer, he even provided instructions.

Life Dances On... is dedicated to Frank's deceased daughter Andrea and the memory of his friend Danny Seymour. Though it makes use of outtakes and footage from earlier works, the purpose is not to convey mourning in narrative form. Frank's fragmentary, metaphorical and associative representational style has more in common with self-portraiture

A plot can be loosely identified: a small group of people live on a remote island near Cape Breton; the sole link to the outside world is the radio owned by the local lighthouse keeper. The other residents put great stock in everything he says, whether it harks back to old sayings ("When the wind is in the west, the weather's always best") or presents a totally incomprehensible mantra such as the one he utters at the beginning, "Richard on the fire!" This statement undergoes constant variation in the course of the film. Similarly enigmatic is the behavior of the other characters (two of them stand around for a while for no apparent reason, apparently holding up a house). The atmosphere is somewhat reminiscent of Beckett's abstractly unsettling grotesques. The focus could be the unchallenged power which the lighthouse keeper automatically exercises over the others (the lighthouse, in the most beautiful of the dazzling black-and-white images, juts symbolically on the hazy horizon). He reinforces this view with a claim made near the film's end: "Once you're up here, you're all alone. You run the show."

Or it's all just about the show, which is manifested here—in the interweaving of documentary and fictitious elements—as a buzz of activity. What absurd things some people do so they have something to do. Just keeping busy. *Christoph Huber*

1975

Keep Busy

CAN 1975, 16 mm, black and white, 38 min.
directed by: Robert Frank, Rudy Wurlitzer
script: Rudy Wurlitzer
cinematography: Robert Frank
editing: Robert Frank
sound: Charles Dean
production: Canada Council (support), Robert Frank.
cast: June Leaf, Joan Jonas, Richard Serra, Joanne Akalaitis, Joe Dan MacPherson

An Unsettling Grotesque

"It's important not to neglect the outside in favor of the inside." This is one of the statements, cryptic at first glance (most of which remain so), which constitute the greater part of the prattling dialogue in *Keep Busy*. At the same time, these dialogues may provide a clue as to how the film was produced. Neither director Robert Frank nor screenwriter Rudy Wurlitzer ever really offered any clarification of this equally fascinating and incomprehensible thirty-eight-minute improvisation, their first joint production—except that it was made spontaneously and almost "by itself." "I am filming the outside in order to look inside," Frank once said about his aesthetics. In *Keep Busy* his chosen home of Nova Scotia serves for the first time as the "outside" in a possible examination of the "inside."

Everything else is a matter of interpretation; Frank and Wurlitzer do not bother with explanations of any sort. In contrast to Frank's previous work, *Cocksucker Blues*, for this film one cannot even count on the occasional presence of stars (sculptor Richard Serra, however, is recognizable in the jumble of actors) or the organizing principle of "daily life on tour." The only thing to do is to follow the protagonists' astounding verbal gymnastics and often incomprehensible interactions. In its occasional tendency to descend into nonsense, and with the syncopated rhythm of its action and dialogue, this film is reminiscent of the playful and parodying elements of the Beat fantasy *Pull My Daisy*, but *Keep Busy* does not even permit a guess as to whether it was intended to represent a strange sort of idyll or a post-apocalyptic scenario.

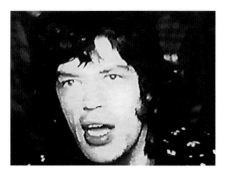

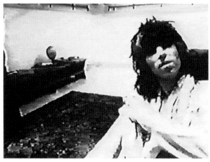

rooms, during preparations and periods of waiting. After a few minutes the viewer might think: I can't stand this trashy handheld camera anymore. It circles the subjects, tolerating all kinds of intrusions. Rather than lying in wait for the stars, it makes them disappear, forgets them completely and then returns them to the picture, seemingly in passing: pure cinematic movement. Almost every movement is initiated by the camera; it infects the picture, and it alone creates the unbelievable filmic energy.

I saw a video copy of *Cocksucker Blues* in which the contrast had been washed out by its being copied so many times. The soundtrack had suffered in similar fashion: What resulted was a collage in which solely snatches of songs were recognizable or parts of sentences could be understood before they go under in the general noise. A magnificent work in progress. No software could produce this kind of wear and tear which gives this film an almost haptic quality: The Stones Rolling (as an insert in Godard's *One Plus One* once put it).

Before the handwritten title appears, a statement is made: "Except for the musical numbers the events depicted in this film are fictitious. No representation of actual persons and events are intended." This sounds like a typical Frank statement: Documentation has been combined with fictitious, staged reality. But the film's entire text is in this case a song. Film music. As a result everything is authentic (or getting there). On the road. *Birgit Flos*

1972

Cocksucker Blues

USA 1972, 16 mm, color & black and white, 90 min.
this film was made during the US tour of the Rolling Stones in 1972
ordered by the Rolling Stones
directed by: Robert Frank
cinematography: Robert Frank, Danny Seymour
editing: Robert Frank, Paul Justmann, Susan Steinberg
sound: Danny Seymour, "Flex"
music: The Rolling Stones
production: Rolling Stones Presentation, Marshall Chess
cast: Mick Jagger, Keith Richards, Bill Wyman, Mick Taylor, Charlie Watts, Danny Seymour,
Andy Warhol, Dick Cavett, Lee Radizwell, Truman Capote, Tina Turner, etc.

Camera? Rolling: Images in Motion

What did the Rolling Stones expect when they hired Frank to make a film about their 1972 tour of Canada and the U.S.? One of Frank's photographs from 1950 was used for the cover of "Exile on Main Street": Maybe they expected an avant-garde homage. Anyway, the band was so dissatisfied with the final product, *Cocksucker Blues*, that they blocked its distribution, though Frank managed to repurchase the rights later. For years, solely bootleg copies of *Cocksucker Blues* have been available, and public showings are supposedly permitted only once a year and in Frank's presence.

All this resulted in certain expectations: Yes, there are scenes in the Stones' private jet in which minor figures have sex with various groupies. There is snorting of cocaine and shooting of heroin. Yes, there is an autoerotic scene in which Jagger reveals himself to be the cameraman in a reflected image. Frank put this hot scene near the beginning of the film, possibly to quickly dampen expectations. It could be assumed that Frank's experiences with artists of the Beat Generation such as Kerouac, Ginsberg and Burroughs were more anarchistic than those with the Stones.

In his 1968 *One plus One*, Godard depicted the Stones as workaholics; they recorded their "Sympathy for the Devil" while neatly separated behind dividing walls. In *Gimme Shelter* by the Maysles brothers they examine footage of the catastrophic concert at Altamont, including the fatal stabbing, earnestly and with shock. *Cocksucker Blues* contains only about fifteen minutes of concert footage. Everything else is set in practice studios, hotel

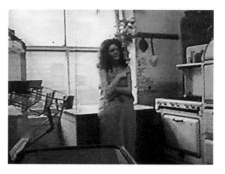

loft in New York's Bowery with the words "It's great, but who gives a shit?"— "Well, I do." The scars left by life are implied. While his skeptical view of photography is virulent, it is refracted in a picture of his parents' apartment, filled with other pictures among which his blind mother walks. "That's me," says Frank when an old-fashioned film projector shows him as a small child. Interviews with passers-by complete the circle: "If you had a camera and some film, what would you shoot?" Something about the country's problems—that's naturally the most common reply, and once again Frank sees himself isolated in his self-referentiality, curbed by issues of representation. Then a street musician answers, "About myself," and starts playing a classic song. "Those were the days, my friend." This is an explicit echo of the scene in which the actress playing Frank throws a stack of photographs onto the bed and says with disgust, "That's my past." Works and days long gone. *Bert Rebhandl*

1971

About Me: A Musical

USA 1971, 16 mm, black and white, 30 min.
directed by: Robert Frank
script: Robert Frank
cinematography: Danny Seymour, Robert Frank
editing: Robert Frank
sound: Robert McNamara
production: American Film Institute (support), Robert Frank
cast: Lynn Reyner, Jaime deCarlo Lotts, Robert Schlee, Sheila Pavlo, Bill Hart,
Vera Cochran, Sid Kaplan, June Leaf, Allen Ginsberg, Danny Lyon, Peter Orlovsky

An Exposition of the Subject

Robert Frank's self-portrait is born out of his failure to adequately develop a
certain theme, and he assumes personal responsibility for its random nature: "My project was
to make a film about music in America." And then, with marvelous disdain: "Well, fuck the
music. I just decided to make a film about myself." In spite of that he goes on creating a film
about music that repeatedly poses questions concerning artistic expression and presents the
function of memory similar to a kaleidoscope. The most interesting revelation came from an
actress named Lynn Reyner, whom Frank himself introduces as "the young lady that's playing
me." She appears in several colored and visually distorted scenes, and rehearses an interview
in which she speaks for Frank, relating some of the important events in his life. One political
question remains unanswered, and the theatrical nature of those scenes makes them reminiscent
of a workshop. The counterculture of the late 1960s is definitely present, though not explicitly.
Collectivity is the norm; there is no "I" outside the author's reflexive world. Frank is being
encyclopedic; the role played by temple musicians in Benares, India, is equally important in
his *About Me* as that of "hope freaks" in New Mexico or, in an especially intense scene, Black
inmates in a Texas prison. They sing a "soulful piece" in an extraordinarily melancholic
chorus, after which each individual reveals his sentence: "life," "a hundred years." Frank, the
immigrant, regards his story as a collective one. He disregards himself (the first scene with the
actress who plays him is an outtake) to the same extent that he narcissistically relates everything
to himself. He comments on the presence of his wife who plays a violin at the window of their

The boom in the marketing of images from Woodstock (August 15-17, 1969) overpowered Frank's quiet, direct gaze at these modern nomads. The unpretentious manner in which the camera is used in a strategy of precise documentation is striking. These voluntary outsiders of consumer society hold their protest with a great deal of sincerity. Of course, we are aware of the fact that seven days of fasting does not represent any danger to normally well-fed individuals—and this idea of fasting against hunger is also somehow naïve. Frank gives the protestors an opportunity to justify this aspect on camera.

The strikers lie on sleeping bags and blankets. The handheld camera circles them in long shots. Associations with key images of our civilization occur: refugee camps, prisoners, survivors of the great catastrophe—the installations of Ilya Kabakov and Christian Boltanski also come to mind. On the last day, as the protestors' movements slow down, the camera gives them additional time. They stare directly into it with enduring gazes.

With her most friendly smile a woman says, "You fucking media whores," and then: "I can't stand up much longer." *Birgit Flos*

1969

Liferaft Earth

USA 1969, 16 mm, color & black and white, 37 min.
directed by: Robert Frank
cinematography: Robert Frank
editing: Susan Obenhaus
sound: Danny Lyon
production: Sweeney Productions; Portola Institute, Robert Frank
cast: Robert Frank, Danny Lyon, Hugh Romney, Stewart Brand,
participants in The Hunger Show

Fasting for the Whole Earth

Liferaft Earth begins with a newspaper report from Hayward, California:
"Sandwiched between a restaurant and supermarket, 100 antipopulation protesters spent their
second starving day in a plastic enclosure. ... The so-called Hunger Show, a week-long starve-in
aimed at dramatizing man's future in an overpopulated, underfed world. ..." This film
accompanies the people on this "life raft earth" from October 11-18, 1969. Right after the first
shots of the participants (who are doing yoga and meditating), Robert Frank is shown standing
in front of his camera: uncertain, barely recognizable in the backlighting. He declares how
important it is to him to make this film for Stewart Brand. Part of this statement is used again
later: Frank feels bad because he left the raft when the weather turned foul, but then he decided
to get back on.
Steward Brand is—it is said—considered the least recognized but most important
visionary thinker in America: he was a co-founder of the "bible of the alternative community,"
the *CoEvolution Quarterly*; publisher of the bestselling *Whole Earth Catalog* (1968-85; an
encyclopedic guide to tools and ideas) and in 1985 co-founder and architect of the Whole
Earth Lectronic Link (WELL), the legendary Internet site for electronic communication which
predated the advent of the WWW era. In 1968, Brand launched a media campaign to search
for a photograph of the entire Earth. One of the first pictures of the planet, provided by NASA
from its Apollo program, became the *Whole Earth Catalog*'s logo. A number of Brand fans are
convinced that this logo represented the conceptual foundation of the ecological movement.

those asking and those being asked. "The meat is fresh," says the daughter with some annoyance, after her father at first refuses an invitation to stay for dinner. Then, "I've had movie cameras in front of me before."

 In the photographs—and the film—there is continuous overlap of professional and personal interests ("I think we made a good take with Pablo"), private and publicized history. All talk eventually revolves around what the pictures failed to capture—or what they reveal only after a second look. And the camera is running the entire time. Despite everything, the father has remained a creator of images, some of them resembling stolen snapshots which preserve precious moments without comment, such as boy and girl shoveling out a stable together. Heavy dust swirling, backlit by the sun. Routine hand motions. All that, too, will be recalled some time in the future. *Isabella Reicher*

1969

Conversations in Vermont

USA 1969, 16 mm, black and white, 26 min.
part of a twelve-part TV serial for KQED-TV in San Francisco
directed by: Robert Frank
cinematography: Ralph Gibson
editing: Robert Frank
sound: Robert Frank
production: Dilexi Foundation, Robert Frank
world premiere: TV Los Angeles
cast: Robert, Pablo and Andrea Frank

Family Album

"This film is about the past, which goes back nineteen years when Mary and I got married. ... As I said—this film is about the past and the present. The present comes back in actual film footage which I took where my children now go to school. That means they left New York and they live in a different place now. ... Maybe this film is about growing older ... some kind of a family album. I don't know ... it's about ..."

Conversations in Vermont, produced in 1969, is considered Robert Frank's first autobiographical film. If defining a theme for it were necessary, one could say it tells the story of a father's relationship with his two teenaged children. It describes the father's attempt to communicate with them by means of a shared history, to open up a space for joint memory. And it shows the fragility of such an undertaking, which is intimated in the prologue quoted above. The children have long since found their own past and now lead their own lives. The records of the family's history are apparently quite complete. Accompanied by Frank's voice, the camera is trained on a number of photographs at the film's beginning: family pictures enter the scene along with other (world-famous) stills. Some of these photographs are in Frank's luggage when, resembling a bashful visitor, he later arrives along with his cameraman Ralph Gibson, at the alternative boarding school where his children Andrea and Pablo live.

But these photos possess only limited value as means of communication. That is another theme dealt with by this film, which barely distinguishes between seeing, being seen, and talking. Questions hang in the air, unanswered. There is uncertainty perceptible in both

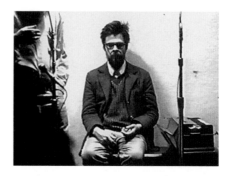

Brother skillfully weaves together opposites, plays counterfeits against the authentic, pornography against poetry, acting against being, Beat cynicism against hippie romanticism, colorless against colored: radical overgrowth is this film's program, the potential simultaneity of various narrative levels being its formal basis. Cinema is dissected for study purposes, "de-composed," surrounded by life as it rots. Frank's first feature-length film work celebrates the return of the poetic essay as assemblage, the affirmation of the underground as a wild cinematic analysis in the form of a collage.

There is a method to this film's confusion: it is so rich in text, quotes, music and associations that keeping up with it through the underbrush of psyche, cinema, and urbanity is barely possible. But that is necessary; anything else would be nothing more than a compromise: if film were to take storytelling seriously, it would have to leave its consumers behind. No admittance. An illuminated sign shining through a black night, somewhere in a big city, announces at the very beginning the (ironic) creed of this working hypothesis: "Stop," it announces, and "Do not enter." *Stefan Grissemann*

1965-1968

Me and My Brother

USA 1965-1968, 35 mm, color & black and white, 91 min. (re-edited to 85 min.)
directed by: Robert Frank
script: Robert Frank, Sam Shepard
poetry: Allen Ginsberg, Peter Orlovsky
cinematography: Robert Frank
editing: Robert Frank, Helen Silverstein, Bob Easton, Lynn Ratener
production: Two Faces Company, Helen Silverstein
world premiere: September 1, 1968, Venice Film Festival
cast: Julius Orlovsky, Joseph Chaikin, John Coe, Allen Ginsberg, Peter Orlovsky,
Virginia Kiser, Nancy Fisher, Cynthia McAdams, Roscoe Lee Browne, Christopher Walken,
Seth Allen, Maria Tucci, Jack Greenbaum, Otis Young, Lou Waldon, etc.

Chaos Theory

The key to explaining the Möbius strip of docu-fiction in Robert Frank's work comprehensively must be searched for here—there is no getting around *Me and My Brother*. None of this artist's films allow a more varied (and, typically, complicated) report on the constantly multiplying problems which accompany the narrowing of the "real" in the filmic. This film fails to achieve such clarification (because its maker is smart enough to know that such failure is inevitable), but its failure is realized by means of extraordinary ideas, with great formal aplomb and a high degree of visual energy.

Someone who makes films exposes him or herself to self-examination. Frank fictionalizes his own life (both here and in other works) to obtain, via fiction, certainty about himself. Everything which had defined Frank's art up to that point turns up in this film, newly configured: the look at America, "from the outside"; the poetic libertinage of the Beats; the marginal in a central role (represented by the "real" figure of Julius, Peter Orlovsky's catatonic brother who accompanies the band of poets on tour in the film and through life). The story contains bizarre twists and turns: What *Me and My Brother* seems to be is revealed early on as a—rather artless—film-within-a-film being shown at a rundown movie theater. An actor who fails to resemble Julius in the slightest, later assumes his role without being able to drive the "real" Julius (just playing himself, of course) from the scene or the film.

At the same time, Frank emulates urban reality formally, playing with the impossibility of concentrating on a single subject for more than a few seconds. *Me and My*

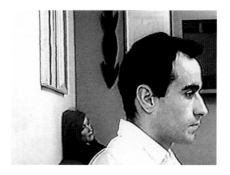

This "documentary" aspect becomes even more obvious near the end when the two meet friends in a restaurant. While the openly expressed emotions in a lover's farewell letter read aloud are lost in the background noise, the camera reflects the general lack of interest and turns away from the speaker, as do the others at the table, paying more and more attention to the other diners. Greetings, hand movements, glances: these cinematic snapshots of urban life are very much in the style of Robert Frank's well-known volume of photographs *The Americans*, which was made in the 1950s.

Even the shots showing the protagonists on their way through the city from their apartment to the restaurant are composed photographically. Empty spaces with prominent cubic structures and isolated arcades with straight lines of columns are characterized by almost geometric rigidity. In Antonioni's films, such (urban) landscapes are normally employed to visualize the protagonists' emotions. In *OK End Here,* the path through architectural structures is the first element to introduce some clarity into the main characters' learning process. At the film's end it will be expressed, although without demonstrating any kind of consistency: "I don't love you. I love what is familiar. You are not familiar to me."
Isabella Heugl, Gerald Weber

1963

OK End Here

USA 1963, 35 mm, black and white, 32 min.
directed by: Robert Frank
script: Marion Magid
cinematography: Gert Berliner
editing: Aram Avakian
production: September 20 Productions, Edwin Gregson
world premiere: September 1963, Bergamo Filmfestival, Italy,
September 14, 1963 First New York Film Festival, Lincoln Center
cast: Martino La Salle, Sue Ungaro, Sudie Bond, Anita Ellis, Joseph Bird, etc.

On Sundays Your Eyes Are Grey

A Sunday mood. A young, well-to-do couple aimlessly wiles away their day, bored with each other and their surroundings. Gestures and movements that come to nothing. Nothing to say, nothing to talk about. Attempts are made to bridge the gaping space, after which they drift apart again. She: "Talk to me." He: "When a woman says to a man: Talk to me, it's like saying: Do you still love me?" A visitor arrives. Little jealous squabbles without any grand emotional gestures. A walk through the streets. Dinner at a restaurant that evening. Return to their apartment.

Robert Frank's 1963 short film about inertia in a modern relationship seems to have been directly influenced by the French Nouvelle Vague and Michelangelo Antonioni's films with regard to narrative style and aesthetics. It alternates between semi-documentary scenes and shots composed with rigid formality. In the apartment, the camera goes from one main character to the other. Similar to Antonioni's characters, they are often only partially visible, usually at the edge of the frame, are physically separated by walls, doors, reflections, or furniture.

The camera moves through the protagonists' world in the same way that they spend their day, with neither rhyme nor reason. At times it even abandons the persons to survey the room or skim over pieces of furniture or other objects, a roaming gaze, which seems to lose itself in things of little importance, at the same time capturing the dominant atmosphere of routine, alienation, and apathy.

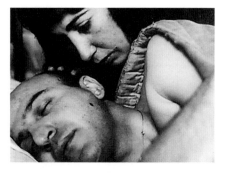

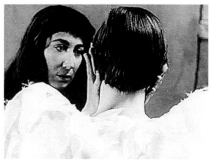

with several 360-degree pans. The solitude (of a psychotic woman? a hysterical woman?) is overwhelming, it justifies her regarding her situation in terms of a genre, as a religious drama in which the story of salvation ("Look at this man," it is said about Jesus according to the Bible) and the story of human disaster ("Look at me," cries the woman) are compared. By resisting the audacity of men and rebelling against their (innocent caused) absence, the woman develops a sense of her own personal existence: "I don't wanna know," she shouts at no one in particular; for the first time she is not "beside herself" but back at her accustomed place, the chicken farm. The fact that Jesus appears to her once again, this time as a "simple God" who asks for forgiveness, is only the epilogue in a drama of autonomy which goes beyond any and all psychological chasms. The theodicy, God's justification for his creation, is omitted because this creature has just begun to regard itself as being whole through the loss of self. This idea contains a trace of the Christian doctrine of salvation, its secularization in *The Sin of Jesus* provoked by the discomfort plaguing male-and-female relations. *Bert Rebhandl*

1961

The Sin of Jesus

USA 1961, 35 mm, black and white, 37 min.
directed by: Robert Frank
script: Howard Shulman, Mimi Arscher, based on the story by Isaac Babel
cinematography: Gert Berliner
editing: Robert Frank, Ken Collins
music: Morton Feldman
sound: Philip Sterling
production: Off-Broadway Productions, Jerry Michaels, Walter Gutman
world premiere: June 19, 1961, Spoleto Film Festival,
USA: December 10, 1961, Cinema 16, Murray Hill Theatre New York
cast: Julie Bovasso, John Coe, Roberts Blossom, St. George Brian,
Telly Savalas, Mary Frank, Jonas Mekas

Drama of Autonomy

Psychology and theodicy, based on a story by Isaac Babel. A woman on a chicken farm spends her days working at the egg-sorting machine. "I'm the only woman here." She is pregnant, her husband spends his days lying in bed, and his friend encourages him to go out with him. The woman talks to herself as she works, in a cadence resembling the hermetic music of Morton Feldman, simultaneously introverted and permeable, lost in the monotony of human existence ("feeding, cleaning, soiling—it doesn't matter"). She counts the passing days in the same way she counts eggs. Even extraordinary events go under in the stream of this melancholy solipsism. The appearance of Jesus Christ in the barn is a reaction to a guilty conscience looking for some place to file a countersuit.

"I'm troubled," says the woman. The barn seems to her like a church, the farm is her world, the ploughed field and the trees represent the cosmos. The hens' cackling outside never ceases, but angels appear to her inside. "I'm alone," she says to Jesus. "Is that how you made me?" She turns herself into an object with this question, distancing herself from her own actions. She is searching for a counterpart who can liberate her from herself. Jesus promises her an angel in whose presence her solitude will be as happiness. The fragile wings, their feathers wafting to the ground, are all that is left of everyday existence in this phantasm, and they also represent the motif with which death returns. The woman smothers Alfred the angel, she turns to her Creator again with her misfortune: "Who made my body a burden? Who made my soul lonely and stupid?" This creature is caught in a hopeless situation, as Frank emphasizes

is "a painter"; in other words, in addition to running the household she is clearly the one responsible for artistic matters, as opposed to her husband, railway worker Milo (played by painter Larry Rivers). At the same time she functions throughout the film as a contrast to the Bohemian world of the Beat poets, to which Milo's friends belong.

Due to his "real-life" position as buddy and fellow writer of Allen (Ginsberg), Gregory (Corso) and Peter (Orlovsky), Kerouac is unable to be objective. Enjoying almost unlimited authority in the film, he is an omniscient narrator (whose words always anticipate what the images show), commentator, dubbing speaker and improviser whose cascades of lyricism compete with jazz composer David Amram's soundtrack. But regardless of the Beat boy band's heroic efforts—"struggling to be poets"—at removing the barrier between life and art, it remains intact. Just after Milo's wife gives her husband a firm smack, a pan through the apartment begins, the banal furnishings jazzed up poetically and mythologically by Kerouac's off-camera voice. The sanctification of the secular in Allen's questions—"Is the world holy? Is baseball holy?" (an obvious reference to Ginsberg's "Footnote to Howl," written four years previously)—remains a precarious undertaking. Quite conventionally, the boy band moves out of the apartment presided over by the quarrelsome and nagging woman at the film's end. Milo gives the rocking chair a kick and follows his buddies' call. *Klaus Nüchtern*

1959

Pull My Daisy

USA 1959, 16 mm, black and white, 28 min.
directed by: Robert Frank, Alfred Leslie
script: based on the third act of the play *The Beat Generation* by Jack Kerouac
cinematography: Robert Frank
editing: Leon Prochnik, Robert Frank, Alfred Leslie
music composed by: David Amram
musicians: David Amram, Sahib Shahab, etc.
"The Crazy Daisy" sung by: Anita Ellis, lyrics by: Allen Ginsberg, Jack Kerouac
production: G-String Enterprises, Walter Gutman
world premiere: November 11, 1959, Cinema 16, New York
cast: Mooney Peebles (Richard Bellamy), Allen Ginsberg, Peter Orlovsky, Gregory Corso,
Larry Rivers, Delphine Seyrig, David Amram, Alice Neel, Sally Gross, Denise Parker, Pablo Frank

Everyday Space

In 1958, Robert Frank began to photograph life in the anonymity of New York City through bus windows. One year after that, his photos started to move and the window was opened. But first the camera slowly pans over walls, a picture, a cupboard and a refrigerator, one view from above shows a table and some chairs. For the next thirty minutes that apartment becomes a stage and venue. Then a door opens, and the adjoining room is flooded with sunlight from the window.

This visual overture is followed by a verbal one which includes a colossal zoom: "Early morning in the universe" are the first words spoken by Jack Kerouac, as if the camera showed a scene from a different galaxy. But the viewer is promptly brought back into the domestic concretion—"The wife is getting up. Opening the windows"—and is given the coordinates of an earthly existence in a Bowery loft on New York's Lower East Side. This power dive from space into the everyday has no correspondence in film—but at the same time it defines the poles providing Frank's first cinematic work with the tension from which it lives. *Pull My Daisy* is a domestic drama which takes its pathos and irony from the circumstance that this domesticity, in all its banality, also exists "in the universe" at the same time: the stars one reaches for in lust and lunacy are on the one hand infinitely far away, and on the other they lie just beyond the door.

The decisive aspect is that this film presents the opposites of profanity and poetry as being analogous to the polarity of the sexes. "The wife," played by actress Delphine Seyrig,

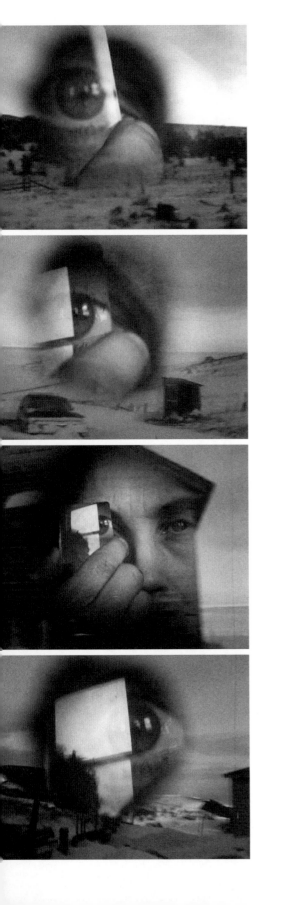

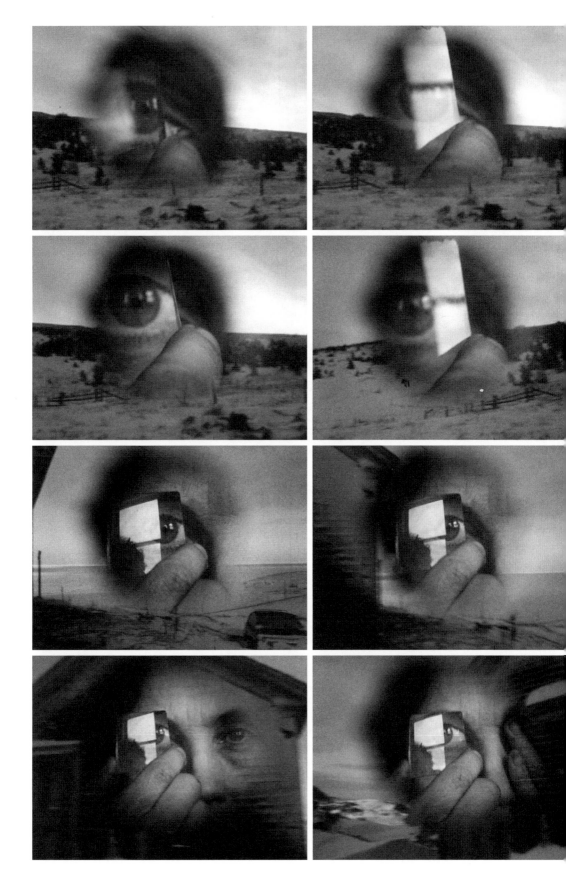

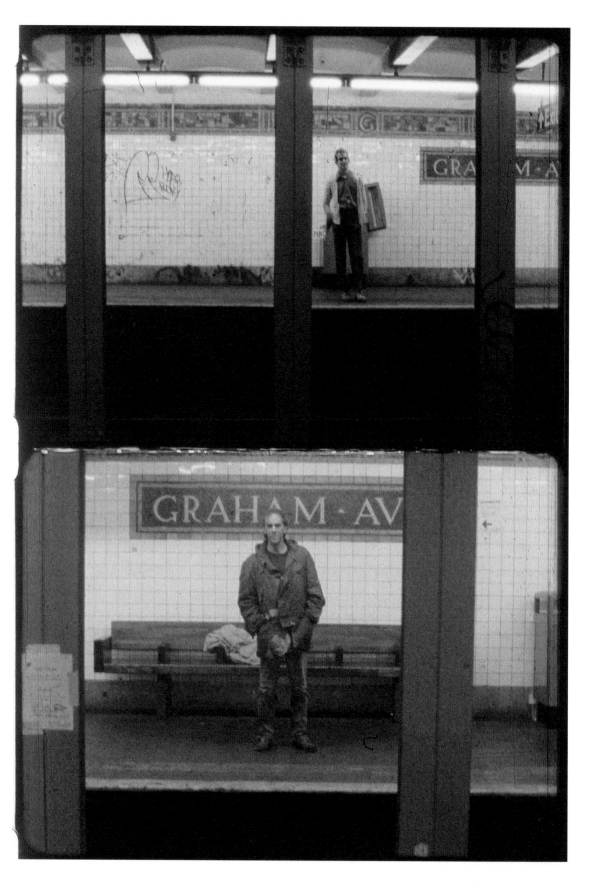

183

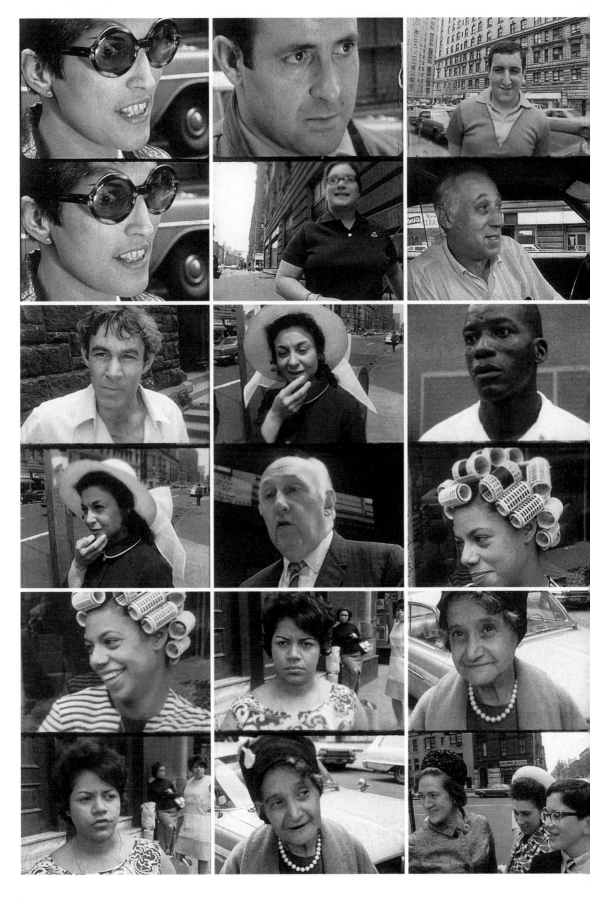

A LOT HAS CHANGED SINCE I ASSISTED WALKER ON HIS TOOLS SERIES. BACK THEN, I ADMIRED HIS ABILITY TO ACHIEVE THIS EXTRAORDINARY PRECISION WITH VERY BASIC TECHNICAL EQUIPMENT (SHAKY TRIPOD AND SO ON). IT WAS IMPRESSIVE, BUT THERE WAS A COLDNESS TO IT. WALKER EVANS CHOSE HIS TOOLS WITH THE EXPERIENCE AND THE TASTE OF THE ELITE. IN MY ROOM IN MABOU, FAMILIAR OBJECTS ARE JUST LYING AROUND, AND I JUST HAVE TO WAIT FOR THE RIGHT LIGHT. THAT'S ENOUGH FOR ME.

(UTE ESKILDSEN, "IN CONVERSATION WITH ROBERT FRANK;" IN: "HOLD STILL_KEEP GOING," 2000)

THE FILMS I HAVE MADE ARE THE MAP OF MY
JOURNEY THRU ALL THIS... LIVING. IT STARTS OUT
AS „SCRAP BOOK FOOTAGE." THERE IS NO
SCRIPT, THERE IS PLENTY OF INTUITION. IT
GETS CONFUSING TO PIECE TOGETHER THESE
MOMENTS OF REHEARSED BANALITIES,
EMBARRASSED DOCUMENTATION, FEAR OF
TELLING THE TRUTH AND SOMEWHERE THE
FEARFUL TRUTH SEEMS TO ENDURE. I WANT
YOU TO SEE THE SHADOW OF LIFE AND DEATH
FLICKERING ON THAT SCREEN. JUNE ASKS ME:
WHY DO YOU TAKE THESE PICTURES?
BECAUSE I AM ALIVE... (ROBERT FRANK, SEPT. 1980)

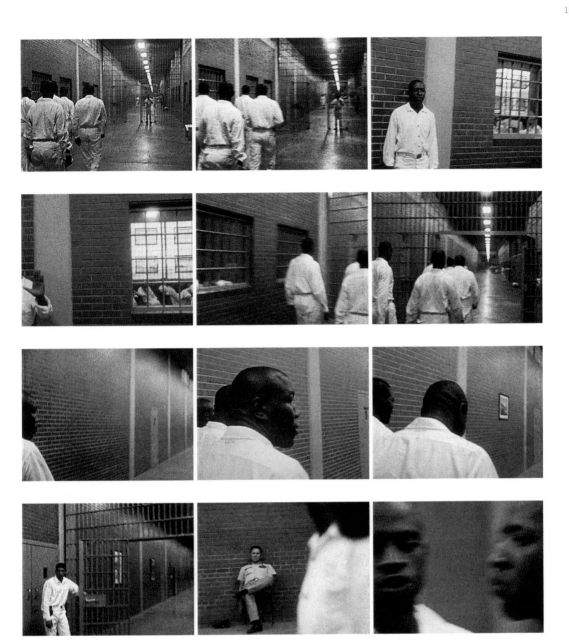

THE ONLY THING I'M INTERESTED IN THESE DAYS
IS WHAT I DID LAST. IF SOMEONE TALKS ABOUT
MY PAST, I DON'T LIKE TO GO ALONG WITH IT.
I DON'T CORRECT EITHER, WHATEVER PEOPLE
MIGHT SAY ABOUT INFLUENCES AND
DEVELOPMENTS. IT DRAWS YOU BACK IN THE
SAME OLD WATERS THAT YOU HAVE ALREADY
CROSSED. (ROBERT FRANK IN "CINEMA: BILD FÜR BILD," ZURICH 1984)

IN MAKING FILMS I CONTINUE TO LOOK AROUND ME, BUT I AM NO LONGER THE SOLITARY OBSERVER TURNING AWAY AFTER THE CLICK OF THE SHUTTER. INSTEAD I'M TRYING TO RECAPTURE WHAT I SAW, WHAT I HEARD AND WHAT I FEEL. WHAT I KNOW! THERE IS NO DECISIVE MOMENT, IT'S GOT TO BE CREATED. I'VE GOT TO DO EVERYTHING TO MAKE IT HAPPEN IN FRONT OF THE LENS: SEARCHING_ EXPLAINING_ DIGGING_ WATCHING_ JUDGING_ ERASING_ PRETENDING_ DISTORTING_ LYING_ JUDGING_ RECORDING_ TRYING_ TRYING_ TRYING_ RUNNING_ TELLING A TRUTH_ RUNNING_ CRAWLING_ WORKING TOWARDS THE TRUTH_ UNTIL IT IS DONE (ROBERT FRANK, THE LINES OF MY HAND, 1971)

Yes it's later now... T
The boats will be out

ng up, the water will be
will look green again.

w ... The ice is breaki
e out there. The hills

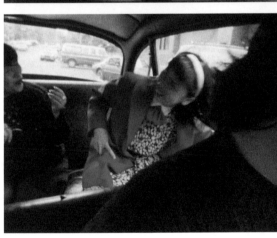

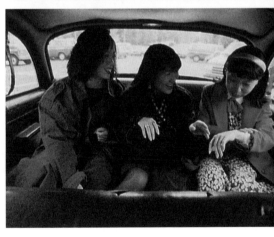

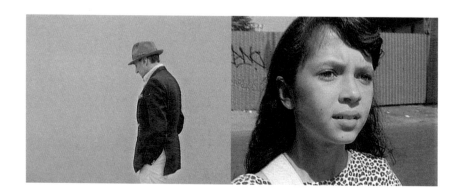

AT A PARKING LOT
FOOD & DRUGS

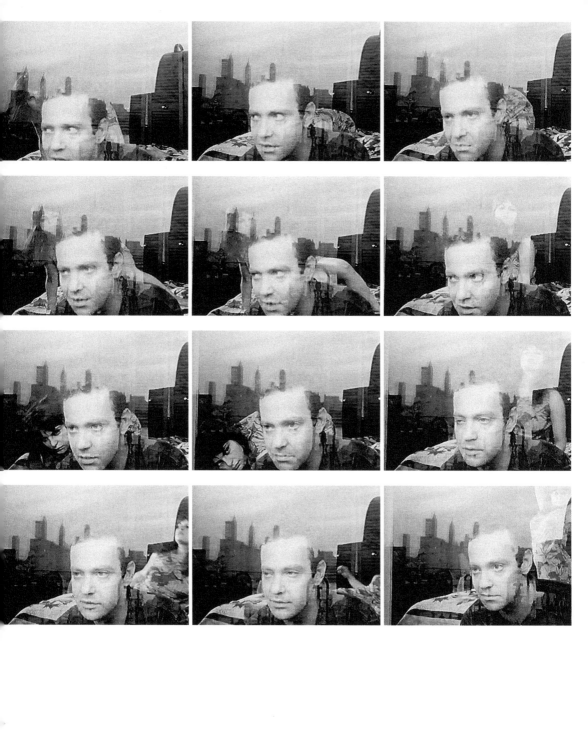

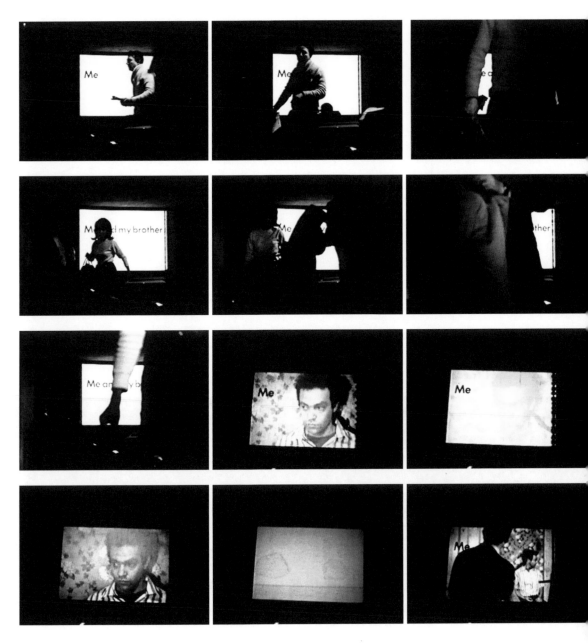

STOP

DO NOT

THE TRUTH IS SOMEWHERE BETWEEN THE DOCUMENTARY AND THE FICTIONAL, AND THAT IS WHAT I TRY TO SHOW. WHAT IS REAL ONE MOMENT HAS BECOME IMAGINARY THE NEXT. YOU BELIEVE WHAT YOU SEE NOW, AND THE NEXT SECOND YOU DON'T ANYMORE.

(ROBERT FRANK, SCRIPTBOOK: ME AND MY BROTHER)

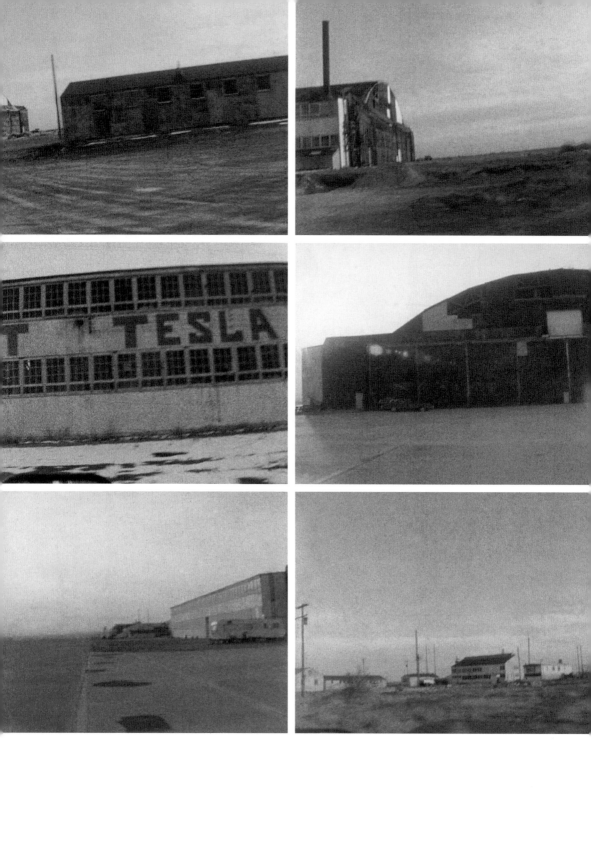

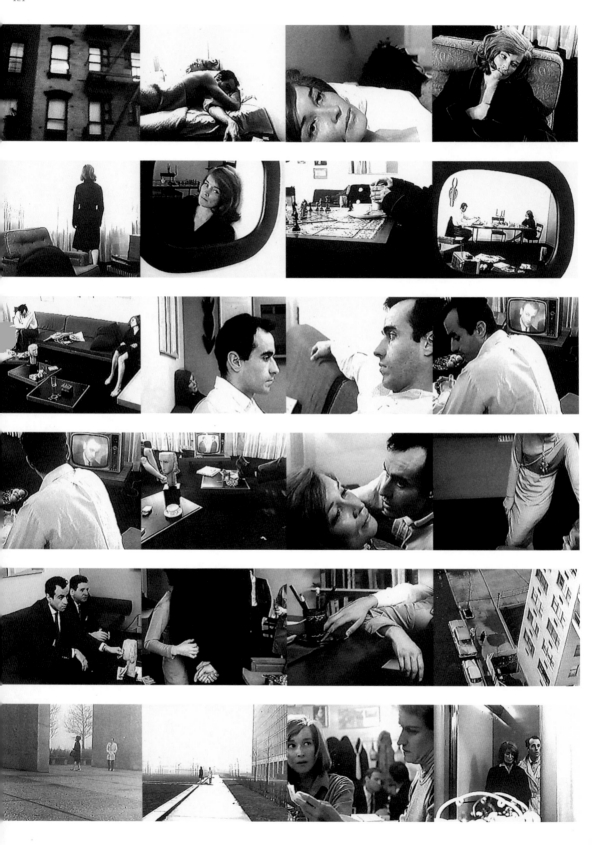

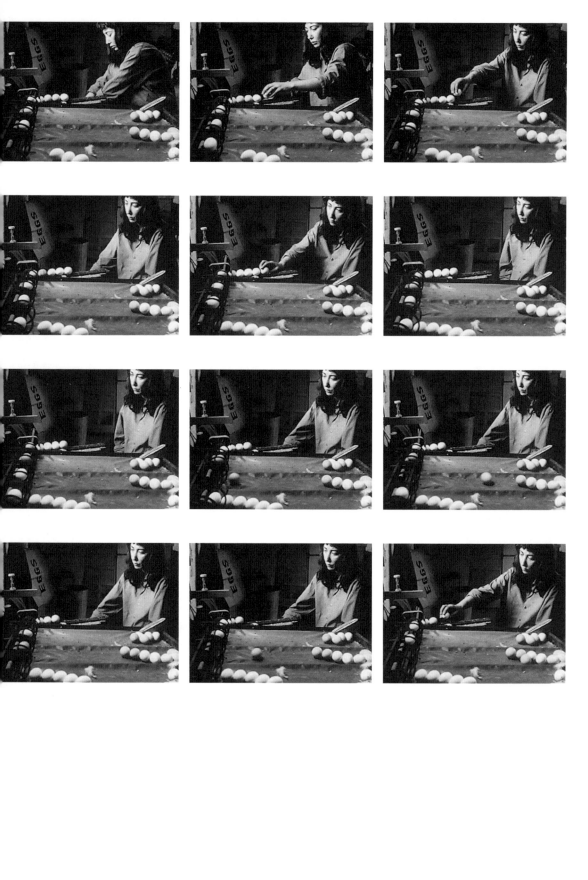

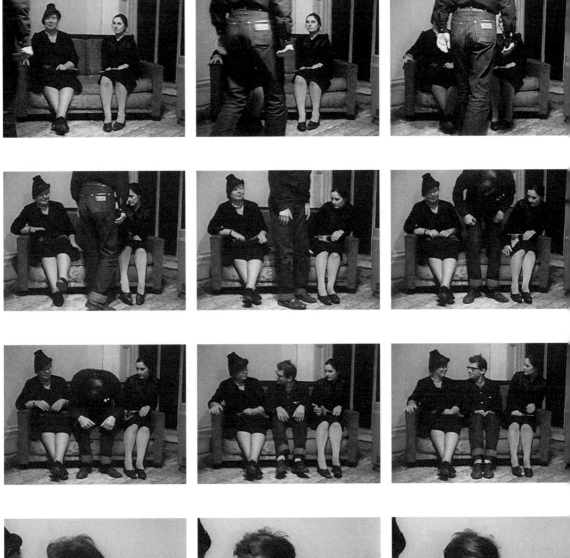
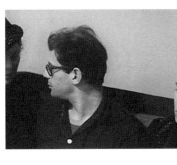
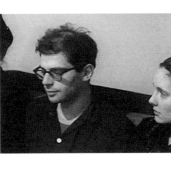
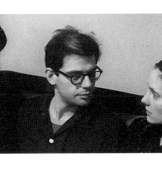

I HAVE COME HOME AND I'M LOOKING THROUGH THE WINDOW, OUTSIDE IT'S SNOWING, NO WAVES AT ALL. THE BEACH IS WHITE, THE FENCE POSTS ARE GREY. I AM LOOKING BACK INTO A WORLD GONE FOREVER. THINKING OF A TIME THAT WILL NEVER RETURN. A BOOK OF PHOTOGRAPHS IS LOOKING AT ME. TWENTY-FIVE YEARS OF LOOKING FOR THE RIGHT ROAD. POST CARDS FROM EVERYWHERE. IF THERE ARE ANY ANSWERS I HAVE LOST THEM. THE BEST WOULD BE NOT WRITING AT ALL. (ROBERT FRANK, THE LINES OF MY HANDS, 1971)

plausibility of its version of picture making for others: the character previously so endlessly orbited in the party scene—the father, husband, artist, famous man, friend, employer—whose absence and refusal to show himself become the negative of an insatiable longing, a longing for a praxis without the compulsion of expression, which becomes absorbed in the function of the apparatus and therefore knows, demands, and legitimates clear rules such as recognition, identification, technical norms, professionalism and craftwork. The longing is thus for a practice of making pictures outside of art, constituted solely through the desire of use, and whose power over the symbols is freed of the compulsion for expression, because it is concerned solely with preserving, securing, and overcoming transience.

1 Robert Frank in *Home Improvements.*
2 Philip Brookman, "Fenster auf eine andere Zeit. Autobiographische Fragen," in *Robert Frank: Moving Out,* Zurich, 1995, p. 42.
3 John Hanhardt, "Kenner des Chaos. Die Filme und Videos," in *Moving Out,* Zurich, 1995.
4 Paul Arthur, "Gilding the Ashes. Toward a Documentary Aesthetics of Failure," *Motion Picture* 6/1 (1991): 24-27, 24.
5 See, i.e., Alain Resnais, *Nuit et Brouillard,* which thematizes the fundamental failure of a documentary grasp of history in the representation of the Holocaust, or Luis Buñuel's *Land without Bread,* whose documentary gaze at the living conditions in a Spanish mountain village is revealed as a grotesque exaggeration of social documentary discussion of the victim.
6 "I'm filming my Life in Order to Have a Life to Film," Ross McElwee in *Sherman's March.* Cf. Arthur, 24.
7 Here as well, it is difficult not to follow the path of "double occupation" as Frank's dramaturgical strategy. There is also this doubling of a character in *Me and My Brother,* and even the parody of the speaking and gesture of the absent father in *Last Supper* could be read as an act of replacement and doubling.

Last Supper

by an actor. The rhetoric of the request, however, that can be found in the speaker's attempts to set Julius in motion, to talk him into coming along, into participating, or at least to even watch are a clear appeal to the viewer at the beginning of the film. The promised sex in front of the camera outlines more precisely the enticement of that prohibition that the traffic sign formulates and from which the cinema has lived for as long as it has existed: "The sign says walk"—but over the sound of the words, the seeds of a fiction and the anticipation of the attraction, the writing of the prohibition blinks, both a warning and a temptation.

A great deal speaks for reading this sequence not only as an allegory of the situation in the cinema, but also as a metaphor of the reflexive style of Robert Frank's films. It also contains the attitude that they give rise to in their viewers: follow the promise of the sign, but do not await entry into a world—neither one that is represented with documentary means, nor one constructed with the means of cinematic fiction—because the reality of film can't be deceived. Thus, viewing Frank's films means being challenged to participate in a (usually thoroughly serious) game of being called upon to produce cinematic norms and conventions, whose rules are never fully unified and whose aims remain unclear; it means being a witness to scenes, situations, and plots without receiving information and knowledge about the world. It also means abandoning the cinematically visible and audible elements—the reality of film, with a sense that most of the conventional compensations that cinema has invented are subjected here to a ban on being confused with the emotional truths of fiction or the empirical truths of documentary rhetoric of the world.

The Utopia of Vanishing

Possibly the most touching moment in *Last Supper* is the scene in which an African-American woman holds her child, wrapped in a romper suit, in front of the camera's lens and repeatedly demands the camera man to "[T]ake a picture of my baby." Here as well, the degree of the peaks and falls are decisive: first the plunge of a techno-aesthetic difference. The professionally, richly contoured and layered aesthetic of the cinematic image, the scene of the party which constitutes the main scene of the film, against the washed-out, roughly screened, distorted pictorial surface of the *home video* including date line, on which this scene is shown.

At least related to this difference is the topos of those elementary, cultural and mental functions that are constantly assigned to photography and cinema. The safety, storage and rescue of fleeting truth from its unavoidable decay is a defining narrative in the cultural history of desire of the photo-filmic apparatus. The servant's cinematic authorship, a function without expression, established by the address of the mother, sketches a horizon showing the impossible desire for immortality and duration as the pragmatic truth of the recording medium. This scene is particularly moving because of its triviality, shocking through the

Me and My Brother

Alone the tourist's, or even the journalist's gaze at the real is not sufficient. The brokenness and contingency of the utopia of everyday life can only be had as deviation, marginality and selection; in addition, the tourist as well as the journalist consistently simply reproduce the conditions for the sights. To make these conditions visible and traceable, not to merely question them, but rather to be present at their construction in that they accompany the reception of the film as a permanent question, could be described as one of the most important sources of the pleasure in the text that can be found in Robert Frank's films.

The Prohibition

"The sign says walk," assures the voice from off-camera, but what we see are the red blinking letters of a traffic sign that orders the opposite: "Stop. Do not enter."

It is seldom that Robert Frank's films formulate their program so clearly and boldly as in this sequence from *Me and My Brother*. Previously, the streaks of light from car headlights had sketched ornaments of movement on the dark screen while the noise of starting car motors, screeching tires, and speeding vehicles broke into the silence before the start of the film. Dynamic, energetic promises of escape, movement, possibly adventure, and perhaps even danger are what the film achieves here. The shaky pan of the camera, the hesitant and seemingly indecisive zoom lifts the blinking traffic sign from the dark of the night and displays it before our eyes as booty. For a long time, the camera does not lose sight of this sign, even if the blinking writing often injures the border of the cadre and its legibility fights with the impatience of the handheld camera.

Standing in contrast to the unrest of the images is the control and modulation of the voice from off-camera. The "fidelity" or naturalness with which it is rendered, and its audible efforts to be understood, are constituted by the sound room in the studio, the controlled recording situation and its autonomy from the picture. And it is not only through this that the voice belongs to the sphere of fiction. Additionally, it addresses a film character who is not yet visible and thus introduces a narrated story into the space and speaks to the viewers in the cinema. We will experience Julius, who is spoken to here, in two versions as Peter Orlovsky's brother: as the object of documentary observation—and as a fictional character who is played

Me and My Brother

woman would concentrate on measures to get young people back on track—all answers expressed in the tradition of the social documentary concerned with society's problems or the entirely related gesture of documentary reporting.

The final character that the film lets get a word in plays a Russian folk tune on a type of flute that sounds, however, like a musical saw. Its melody, to which the flute player dances on a street corner, is only able to break through the noise of the traffic with the help of a microphone; before, he states emphatically that naturally he would only make a film about himself: *Life Dances On,* a perfect ending for a musical about the autobiography, perhaps even a happy ending. *About Me* makes clear here that it is possible to rely on chance, on everyday urban life's situational abundance, on the vitality of lived identity, on the potential of the street and on idiosyncrasy. That utopia of transformation in the contingency of true energy and abundance within that which is utterly artificial and overly formed, from which the musical in particular has always survived, but primarily that utopia of the "right moment," which seldom lasts longer than a scene, but which the attentive and culturally flexible camera can nonetheless empower.

Utopias exist in small, cinematic observations of accessible islands in the discourse of alienation, masks and pretensions. The narrowness and circularity of the attempt to evoke them through experimental arrangements, to seek out pornographic situations for filming such as in *Me and My Brother*, the absurd epic theater of *Last Supper*, which is also meant to be understood as a repetition of Beckett's modern *End Game*, even the rampage through the cultural unawareness of the Ruhrgebiet in *Hunter*, are all clearly identified through a rhetoric of necessity, which is almost eye-catching in its violence. "To do what is necessary" is to create situations in which the decisive moment is *not* possible, for it is precisely this, which creates the conditions for its perceptibility.

The necessity of the intervention is legitimated less through the idea that perhaps the pressure of the pro-filmic—and thereby synthetic situation—evinces truths that draw their authenticity from the reflective conditions of their produced state (such as the Cinéma Vérité from Rouch and Morin would have believed), but rather, are there much more to establish the staged situation as the height and the framework of the fall within the film-aesthetic structure, which is what establishes the observation as a difference that makes sense.

a world whose clearly marked discursive parameters were acutely aware of their own range and borders and were thereby also controllable for the viewers, the technical failure of the project formulates the fiction of all criteria for authenticity that rest on technical rules that cannot be deceived. Rules have no existence outside of the contracts that assure that they will be kept. When these contracts are one-sidedly broken, when the demand made of the viewers to subject themselves to the experience of a cinematic concept no longer corresponds with an author's self-restraint to limit possibilities to the guidelines of the concept, then nothing remains other than the fundamental claim that sentences every attempt at "truth in an extra-moral sense" to constitutional failure.

A Score for the Extent of the Dramatic Hero's Fall

It is first in the final two minutes of Frank's *About Me: A Musical* (1971) that there is time for answers. Prior to that, the questioning of "Robert Frank," the fictional character embodied by the actress Lynn Reyner,[7] was somewhat open in terms of results. It is as though precisely the aggressive, inquisition-like tone with which a committee comprised of different persons had confronted the woman named Robert Frank and the stylized nature of the mise-en-scène had again and again merely staged the impossibility of any authentic information. The occasional statements of that male off-camera voice, which speaks in an angry tone about artistic decisions and the living conditions of a man who appears to have control over the diegesis of this film, did not contribute much to the explanation, but instead actually caused additional confusion.

Not until this stage in the film do questions, addresses and references become clear, as the camera leaves the claustrophobic scene of a stimulating, although impenetrable game with unknown rules of diverse performances to enter the aesthetic terrain of the documentary, which is normatively secure because it is so very precisely measured and held away from the linkages to contemporary conventions.

In a rapid montage, we see talking heads answering a question that we have not heard, but which can nonetheless be deduced from the answers. Someone has asked: what would *you* shoot a film about? The answers are valuable as historical documentation, not only because the selection of those asked suggests a cross section of various ethnicities, genders, ages and social classes of New York's population in the early 1970s (in the form of a random sampling), but also because many of the answers can be understood as an echo of a historically contemporary community. A woman with sunglasses and a scarf on her head says that she would film the unrest that has broken out in the country; several people would film New York's descent into chaos; a woman with a pearl necklace and fashionable hat says that she would make a film about Central Park; a young man would make a film about sports, and an older

whose gazes carefully avert the camera, thus characterizing the intervention of the film into the reality of the pro-filmic as a physically created situation for the presentation of everyday life and not as a product of the creative geography of montage. All of this, however, remains an object of a certain diverted or at least doubled attention, since the "truth" that the film carries in the title refers not only to the content of the cinematic scenes, but even more so to the coherent and viewer-monitored realization of the concept. The constant and increasingly furious dissatisfaction with the results of the project, as spoken by a young man who also takes on the logistic function of head of recording, transfers the discussion of the limitation of the range of conceptual unity to the scenario of the film, and the question of its status as a staged, improvised, or spontaneously arising discursive element is depicted in the closed space/time structure of the established sequence.

Approximately two thirds of the way through the film—which until that point keeps strictly to the experiment's arrangements and has again and again, with amazing effectiveness and discipline, spectacularly displayed and been determined by the playing out zof its possibilities—the camera team is once again found in the delivery wagon which serves both as a means of transportation and a dolly. All at once, the screen turns black. On the soundtrack, which continues to run for another few minutes, there is talk of technical problems with the camera, which now must be exchanged for another, and the voice speaking is recognizable through its characteristic inflection, the traces of the Swiss-German dialect in the English, as the voice of Robert Frank. This refusal of the image formulates the break and thereby the failure of the conceptual project. As a result, the second camera begins its own film, forcing a cut—regardless of the fact that we are dealing with an entirely technical insertion and not a sense-producing montage. Between the established sequence shot until that point and the second one inserted here, there could be either seconds or months of pro-filmic time— the aesthetic of virtuosity, which had dominated the visual protocol until now, is devalued, since a conceptual break is the only thing that cannot possibly happen. It reveals the project's failure at the hands of the notoriously treacherous detail of technology and denounces the entire concept as a mechanical procedure that pulls its concept of truth from mere contingent rules, the crossing of which would be coincidental, uncontrolled, and without expression if the technical failure should prove a fake.

The mistrust of the stringently tight concept, which contains clear rules and limited messages, expresses itself here almost menacingly; the *tour de force* has functioned amazingly well, a thoroughly successful form has been violently brought to an end. Even if there is no sign that the unity of the established sequence will be abandoned in what follows, nothing and no one can guarantee that the "technical failure" of the camera was not part of a staged scene planned to culminate precisely in this moment of failure. If previously, coincidence and staging, spontaneous behavior and logistics, observation and improvisation took place in

own state of being, is a further parallel of the performative metaphor of failure. The fact that McElwee formulates his cinematic credo in *Sherman's March* with the point that he would film his life, "in order to have a life to film,"[6] would, additionally, be a perspective of the author persona of Robert Frank that could be further investigated in another study.

For the present context, however, it seems more productive to look into the topos of failure in Robert Frank's films in the dramaturgy of *C'est vrai!*. *C'est vrai!* is laid out as an experimental *tour de force*, which is found in that tradition of experimental film that is situated as closely as possible to the scientific concept of research: the experimental set-up—reflective and precisely defined in terms of its parameters—forms the frame and necessary conditions for an almost empirical questioning of its possibilities. Cinematic experiments have often concentrated on an element of film aesthetics in order to investigate its place in the order of the filmic real in the greatest possible number of declinations. In *C'est vrai! (One Hour)*, this element is the established sequence: a one-hour cinematic sequence, which is not broken by a single cut, which aligns filmic and filmed time, at least at the level of plot duration.

One particularity of this forced reduction to a central concept consists of calling up a specific hermeneutic code in the viewer: for one, a hermeneutics of mistrust that tests every sequence of the running picture and the sound for its consistency with the concept—has there really been no cut made here? Is that really "true"? Another particularity is that everything that is visible and audible registers the declination and becomes an object of amazement because of the cleverly devised logistics of the act of filming. Among other things, this creates the horizon for perceiving observed street life; for apparently aimless journeys with the handheld camera, in which no element worthy of cinematic observation can be found; for obviously staged sequences, such as the everyday conversation of two women during lunch,

About Me: A Musical

projects. McElwee is not even able to start his historical documentary film, which should be about the Civil War march of northern general William Tecumseh Sherman through the American South. Instead, he becomes distracted in the apparently private obsession of film as an autobiographical medium—which becomes the material of his film. Moore is also unable to entice Roger Smith, the head of the automobile manufacturer General Motors to Flint, Michigan for filming, in order to film the meeting of the chairman with the workers whom he fired. Moore's supposed attempts to get Smith in front of the camera, together with a grab bag of seemingly chance digressions, form the material for his grotesque documentary. The defining trick of these films is the doubling of the documentary filmmaker as an author with a personal writing style and a character in the documentary narrative itself, who fails in the pragmatic realization of his project in a more or less insightful way.

This figuration of failure in the feasibility of an enterprise, and also the element of doubling of author and character, appear often in Robert Frank's films. Although hardly comparable with the self-ironic figure of the documentary filmmaker as a daring clown, which Michael Moore has meanwhile developed as a trademark, or with the offensive narcissism which Nick Broomfield attempted to establish as a signature in several films, there are nonetheless structurally analogous constructions in many of Frank's films. Thus his works not only constantly thematize the failure of their experimental arrangements at various levels, but they additionally stage their failure or inability to stick with guidelines as a framing structure. This is particularly clear in *About Me: A Musical* (1971) and *C'est vrai! (One Hour)* (1990).

It is especially obvious in the almost identical construction of the "framing fiction" in Frank's *About Me* and McElwee's *Sherman's March*. The speaker, speaking in *About Me* from the off, an undeclared but obviously rather omnipotent position of control, and whose diction sounds very much like Robert Frank's voice, reports that he should actually be making a film about American music, but has decided instead to make a film about himself. "Fuck the music," he defiantly explains, to then describe how he has recruited an actress named Lynn Reyner to represent him in the film. Equal to the defiance of this gesture as a deviation from and rebellion against the artist's responsibilities in light of normative expectations, is the clarity of its failure as the film proceeds. *About Me* is much more clearly understood as a meditation on American music and, not least, as also being about the genre of the musical, rather than as information about that rather dislocated "I" that speaks here.

Sherman's March begins in a similar way nearly twenty years later with a scene announcing the actual project; however, it introduces, in a much less aggressive yet that much more subversive way, the figure of the indecisive filmmaker, whom the viewer is invited to accompany on his apparently aimless journey through the south. The fact that this film has much more to say about the scars left from historical injuries that constitute the South of the US rather than about the apparently so smug I, which constantly measures the pulse of its

Last Supper

The Aesthetics of Failure

In an influential article, Paul Arthur dubs a rhetorical gesture that he observed in a series of American documentary films of the late 1980s, as the "Aesthetics of Failure." He begins with the situation of a unique historical hybrid of documentary method, embedded in the paradigm of postmodern subject critique, and the feeling of an exhaustion of the style-defining documentary approaches (such as the observational documentary film arising in the 1960s). From this, Arthur records a unique form of the self reflection of documentary representational claims and modus operandi:

"A particular structural gambit has emerged in a group of films including Ross McElwee's *Sherman's March*, Tony Buba's *Lightning Over Braddock*, Michael Moore's *Roger and Me*, and Nick Broomfield's *Driving Me Crazy* ... by which the dramatization of inadequacy or failure to complete a standard documentary project, the cohesive inscription of a given subject, serves as a heightened guarantee of authenticity."[3]

Whereas a documentary project's failure as the subject of a documentary film extends a thin but entirely prominent line of "anti-documentaries,"[5] this performative doubting of the genre is shown in the films presented by Arthur in the gestalt of an unfamiliar diegetic figure: that of the documentary filmmaker whose film becomes the documentation of failure of the project on which the film is based. Presented by the filmmakers and narrated as a contemplative observation of their own modus operandi, figures such as Ross McElwee in *Sherman's March* and Michael Moore in *Roger and Me* personify the failure of their own

constructions, and the obstinacy of improvised performances against each other. Although the weaves of text arising from this method are very loose, ambivalent, and *in principle* remain open, a rhetorical topos continually comes to the fore of a privileged legibility—the cinematic rhetoric of failure. We would like to look into this through a closer investigation of several passages from Robert Frank's films: *Last Supper, About Me: A Musical, C'est vrai!* and *Me and My Brother*.

The reason for doing this is to understand this rhetoric as a condition for the *cinematic* construction of an author persona whose incessantly expressed doubt of their control over the diegesis carries strong traits of fictionalization and from that creates plausible positions of authentic expression. In this, it seems that it is this crossing of "life and work," so often detected in Frank's films, which allows the most distinct signs of fiction to appear there, where they are most closely linked to autobiographical scenarios and where they foreground their reference to the life of the filmmaker.

In this context, concern is less with reproaching relevant film critiques for their steadfast confusion of filmmaker and author. It appears much more important to work out how Frank's films call for this confusion and what it is used for. Thus, the figure of the artist, who in the "search for truth and for a language to express it,"[2] risks "proximity to chaos,"[3] in order to constantly question the conditions of his or her own subjectivity, is so clearly recognizable as the central figure in the romantic concept of art, that he or she must immediately come under suspicion of projection. However, this does not mean understanding this figure as a product of distortion or lies. Much more likely is a tactical reduction of complexity in which the aesthetic idiosyncrasies of Frank's films rescue the concept of the authentic artist for the diegesis of art by having an author figure constantly involved in those scenarios that are characterized by failure in the conditions for artistic articulation.

Home Improvements

Take a Picture of My Baby:
Robert Frank and the Dramaturgy of Failure

Michael Barchet / Pia Neumann

> I'm always looking outside,
> trying to look inside. Trying to say something that's true.
> But maybe nothing is really true.
> Except what's out there.
> And what's out there is always changing.[1]

Robert Frank's films travel through terrain that is difficult to map. Their territory lies at the peripheries of divergent regions of cultural production and perception, which neither border one another nor share a common canon of customs and habits. Present in Frank's films are methods and representational patterns from documentary film, forms of acting from experimental theater, and also narrative forms from feature films and the intimacies of amateur video. Frank's films offer only extremely imprecise, at times even consciously misdirecting maps and road signs for navigation in these highly contradictory media scenarios. Many stylistic and thematic characteristics of his films, though—including the quotation offered here at the beginning from his video *Home Improvements* (1985), which is often cited in the literature about Frank—point out that the concept of "truth," so obsessively tossed around in his works, is not to be understood merely as a metaphor of the fundamental doubt in the possibility of understanding authentic artistic subjectivity; it also fills the cinematic gaze "outward" with a type of desperate hope. This indicates a privileging or at least a centrality of documentary approaches.

Admittedly, in Frank's films these methods for approaching issues are revealed as multiply broken and reflected interrogations of their conditions, which continually and literally wantonly destroy their use as instruments for the cinematic ascertainment of the world. Frank's films seem to use various documentary styles and modes of operation in order to explore their outer limits. It is primarily in the montage of the films that this intuitive and not very systematically carried out research often plays out cinematic observation, controlled narrative

The Present – Andrea Frank

and getting out his own camera to start shooting—did Frank have to do multiple takes to rid him of his self-consciousness, to get that wonderful mixture of determination, boredom, (feigned) nonchalance and intelligence in his gestures and expressions? And let's not forget that horse, standing still, looking guardedly at the camera. Or the dog, fixated on the mythical object out the window.

In a very real way, the life-tested solitude I prize so much in Frank's work is a matter of context. And sequencing. Early on, Frank embraced the idea of sequential as opposed to singular images. So why the beef with Steichen over *The Family of Man*? First of all, because Frank has always been a resolutely anti-cliché artist. But even more than that, the clichés of universal meaning in that show—suffering, hope, endurance, etc, etc, etc.—run against the grain of Frank's art, and what I will presume is his philosophical stance. Namely, that real freedom is an elusive state, available in the far corners of life, far from the madness of the glorious and all-consuming center. And that the minute you start grouping images together according to a Theme, you're lost. Because in Frank the solitude doesn't just belong to the people in the image, or to the shadows in the image, or to the man behind the camera, but finally to the images themselves. The move from the hotel room on a foggy afternoon, that woman brushing her hair, the bed, to a coin placed in a filthy outsretched hand, shadows on a New York sidewalk, the Lower East Side before sunset, to the dice-wielding friend in Nova Scotia, has the same air-filled freedom/intelligence/wisdom as the darkened Salt Lake School of Art, to the smiling lady from South Carolina happily resting in a chair with the sunset and a providential telephone pole behind her, to the starched mourners filing past the body, to the toppled flower arrangement at the fogswept Chinese cemetery in San Francisco, to the Stephenson fan hidden behind his tuba. Each is an image to be sure, allowed to retain its identity as a moment.

Frank leaves me feeling at peace with myself, and for that I feel grateful. I'm sure Andrea and Pablo feel the same. Wherever they are.

I said earlier that I see no difference whatsoever between Frank's photographs, his filmed images, and his video images. Nor between his "fictions," like *Candy Mountain*, and his "documentaries," like *The Present* or *One Hour*. In each case, the image is, or appears to be, happened upon. And there's something else, too. What is it that Frank keeps happening *upon*, again and again, throughout his career, in his memento pieces, his little stories, his landscapes, his impromptu portraits, his moments? It has something to do with the aforementioned solitude. In every Frank image I've ever seen—the animal soon-to-be-named "horse" in *The Present*, O'Connor driving north and sharing the frame with a colorful autumn landscape in the oddest composition in *Candy Mountain*, that gorgeous shot of sunflowers with "Les Filles" scrawled across it, the South Carolina mourners in *The Americans*—there's a fiercely powerful sense of the elemental freedom in aloneness. Often it's reflected in the relationship between Frank himself and the landscape. Take the famous photo from *The Americans* of Highway 285. There's no cliché here—The Freedom of the Open Road, the Terror of the Open Road. It feels too dark for the former, hardly ominous enough for the latter. In one sense, it is a classically composed photograph. In another, more pressing sense, it is a moment of communion with the idea of solitude itself. Frank exposes for the darkness on the horizon, but it's a nice darkness—not sweet, but calm, restful, comforting even. It's about a million miles from the tabloid blackness of Weegee, the suave darknesses of a Callahan or a Minor White, the bewitching blacks of a Weston, or the hard, slatelike range of grays in Evans. The various darknesses of the Butte, Montana billiard table or the Salt Lake City School of Art, surrounding Kerouac's beloved lonely elevator girl or behind the blonde at the Hollywood premiere, strike me as wholly unthreatening and even cozy—just like those black crows in *The Present*. They are spaces in which to repose, to re-gather momentum, perhaps to await oblivion, perhaps to take a few minutes before getting back into the fray, perhaps to contemplate eternity. It's one of the great achievements of *The Americans* that Frank zeroes in on the scary part of America, the religious mania and the deathly political paranoia, the poverty and the exhaustion, but also finds the salvation of potential solitude in its anonymity and famously wide open spaces. And its shadows.

The New York City rodeo rider, hidden behind his Stetson, rolling a cigarette. The blurred Hollywood starlet looking away from her fans. The pregnant woman staring into the dirt in Belle Isle, her arms folded. The plain-faced blonde behind the two old men leaning against the tree somewhere in North Carolina, raising her abstracted gaze toward Frank's camera. And, most touchingly of all to these eyes, that elevator girl staring heavenward as the frame tilts with her and against her fancy passengers. And that beautiful girl in Reno, tightly encircled in her boyfriend/new husband's arms, allowed to resist the scenario of True Love Forever for one precious moment before Frank's camera. There's the same sense of shapely singularity and solitude in Frank's nameless, silent pony-tailed friend in *The Present*, approaching the camera

The Present

every goddamned twig"); a woman brushing her lustrously dark hair, her face out of frame, against a white background (like the crows against the snow); a cut from a hissing wood stove to a poster of the muscular substructure of the human face; the resolution to make a new piece of video every day; a sudden eruption of useless blathering nonsense, for no good reason. "We were celebrating the new jacket," Frank says at one point. Later, near the end of the film: "I've asked my friend Yuichi to come…we'll see what *that* visit will be."

Everything in *The Present* feels at once caught—thus framed and, in a sense, remembered—and happening…in the present. We never know where we will be dropped next, or when—chronology is uncertain, and Frank shifts effortlessly between Nova Scotia, Bleecker Street, Zurich, a hotel room somewhere, a gallery somewhere else. If you pay close attention, you'll find a framing device. "I'm glad I found my camera," he says, the first words in the film, and right away he's in search of a story, lurking somewhere in the dailiness of his house. And it's not so much a story that is found as a touchstone, or a habit. "I look out the window," says Frank, as we look out at the Cape Breton landscape from his window, "and then it's…memory." And when Yuichi comes to visit near the end of the film, Frank asks him to scrub the word "memory" off a piece of glass: it's been there for twenty years, finger-painted in black. Predictably, memory is hard to erase. Are they laughing over this remark because they know this will make a too-tidy ending for the video, or did Frank just decide that it was fitting to make his daily piece of video over a corny and readily available metaphor, and then decide on its placement later?

Is it "memory," or is it "remembering"? Or, is it experience—and in this case, filming is a part of experience—in the process of becoming memory? In a sense, *The Present* could be considered a collection of fragments, but that would be reductive, making Frank into a systems artist. Like his old pals in the Beat generation, the ideas of the automatic, the spontaneous and the intuitive are meaningful only to the extent that they merge the making of art with the process of living: they effaced the model of the meditative, "ivory tower" artist, the better to work within and through experience itself—partly political, partly temperamental, partly spiritual and partly generational. To see the spontaneity—sometimes the *impression* of spontaneity—in Frank's (or Kerouac's) work as an end in itself, as opposed to one aspect of the art, is to misunderstand the work, to pre-judge it according to inapplicable criteriae and thus avoid it altogether.

The Present

achronological structure which suggests rummaging, moseying through an empty house and letting your mind wander, or taking a leisurely journey through the past. Or, just living: we're always borne back into the past, as Fitzgerald said, but where he was addressing a grand, pretentious subject (America!), Frank is working at the local level—of course we're always going to go forward, and of course we're always going to look back. What else can we do? We see Pablo's face in photographs, we hear a remembrance of him read over a lovely image of snow falling on Bleecker Street (another beautifully hand-made juxtaposition), we see his flowers (and his father's photographs of his flowers), we look at the clutter of his apartment (Frank on the track: "How can I sort out my thoughts?"). We read the heartbreaking note his father has written him after he's gone ("I wish that you could see your flowers...From Dad, with a kiss"). And the way Frank and his obviously brilliant editor and partner in crime Laura Israel construct this piece, so seamless and yet so lovably ragged, we have the space to generate associations between moments that are left just untended enough. Earlier in *The Present*, Frank says that it's his daughter Andrea's birthday—also gone, killed in a plane crash over twenty years ago. "I wonder what she's thinking," he wonders. Perhaps Pablo and Andrea are merely dead, but not gone. Not there, but always present. So, in this movie in which death is so ubiquitous, and so real, the sight of three black crows against a white background has a special lilt. It may seem like it's stretching the point to mention the piece's other death—Frank's old friend Werner, the third black crow—but maybe that would please Frank after all. The world has a way of offering metaphors at the most unlikely moments, in the least likely settings.

 "It's gonna be a crows movie!"announces Frank—the moment in question marks one of many appearances of the black birds, and prompts a funny discussion with a neighbour ("You feed them *too?*" asks Frank's wife June). There are other animals—a dog that keeps looking out the window ("What does he *see?*" "I don't *know*, Robert."), a horse ("What kind of animal is this?" asks Frank, trying to pretend he's the first man after the act of creation, or something like that—"This animal is called…" and then a cut), more crows in another snowbound convocation, this time with off-camera animals braying in the distance. Like everything else in *The Present*, these visits to the animal kingdom are events. There is no hierarchy among the events, nothing is more important or urgent than anything else, and they come in all shapes and sizes: a fly dropping dead; a dying tree on Bleecker Street ("I remember

The Present

in reality, apparently happened upon. Secondly, the sense of relaxed, no-sweat, in-the-moment aesthetics extends to the byplay between image and narration, as a nice juxtaposition is set up: Frank is talking about people as he's supposedly looking at crows, getting at something he's cultivated from the beginning of his career, which is an artistic practice wedded to the rhythms and habits of life, not as it's supposed to be lived or as it should be lived, but as it *is* lived. The pause before the crow trio flies away in unison and Frank's thumbs up on people is irresistible, perfectly timed, thrillingly affirmative. On another level, if you're looking at it closely (and I've seen *The Present* many, many times), the calculation, brainwork, and artistry behind the moment has its own charm. Frank may be looking at the crows through a window and thinking out loud, or (more likely) the moment has been perfectly constructed to give the appearance of spontaneously generated reality (what was it that drove the crows away? An offscreen noise? If so, why isn't it on the track?). As has often happened with Frank, the modesty of his viewpoint as an artist (determinedly small-scale, minoritarian, unglamourous) has obscured the fact that he's pioneered many aesthetic practices that have come into vogue over the years. This kind of careful re-constitution of reality now seems to be Kiarostami's domain, but Frank has been taking it through far less lofty realms for years now. Where Kiarostami is looking at Nature, Existence (or is that The Nature of Existence), etc. with his artfully constructed artlessness, Frank is never stepping back to look at the big picture, but putting everything on the level of dailiness, what could be called "practical reality"—he winds up giving us the big picture anyway, but he allows it to piece itself together. Connections are made and metaphors are generated as naturally as breathing, and then we're on to the next thought, the next sensation, the next realization, the next instant of forgetting, dreaming, free-associating. Or remembering.

There are other reasons to love this moment, and they have to do with the fact that it is part of this particular piece. If you've seen *The Present*, you will know that it is, in one sense, a lament. I won't call it a work of mourning, because that would be to tag it with a bullshit, precision-tooled cliché. But Frank's son Pablo, dead before his father started making this video (a photo on a gallery wall, glimpsed in one of *The Present*'s many fragments: Frank's son, framed by the words "Pablo...Gone" and followed by a country song on the track—"Well, goodbye Mr. Reporter, I'm sorry for what I done"), keeps coming back. *The Present* has an

come away with images and sensations: a lonely encounter with a loveable old Hank Snow fan, the Northway from New York to Canada in blazing autumn color, the seascapes of Nova Scotia, homey diners and bars. Few movies have ever given such presence to people and places, incorporating them into a barebones narrative in a jokey, no-sweat fashion that suggests vaudeville, the better to leave them alone, very much as they are. This practice of grafting a suitably flexible narrative structure onto the Real World was a key Wenders strategy in the early and mid-1970s, when he was doing his best work. But the completely unsentimental Frank is a world away from the historically troubled, ultra-sensitive auteur of *Im Lauf der Zeit* or *Der Amerikanische Freund*. Whereas Wenders is following in the path of Godard and Straub (Commandment #1: Thou shalt alter reality as little as possible), for Frank it feels like a matter of temperament. *Candy Mountain* may have been co-authored with Rudy Wurlitzer (like Alfred Leslie, another stormy partnership that ended badly), but it feels like Frank through and through. From the long view, life does indeed suck. From the right here and now, it's always beautiful, mysterious, lively. When Kevin O'Connor's crummy anti-hero gets to the end of the road in *Candy Mountain*, he might find an antidote to his discouragement just around the corner from the end of his movie (right there in Nova Scotia, come to think of it). Easy to imagine him running into Frank's dice-throwing friend who closes *The Present*. "I lost. But so what? That's the question."

A breathtaking moment: cut to three black crows pecking at something betweeen blades of grass and weeds sticking up through the snow. Sounds of outdoor life in mid-winter. "I think every day I should have some footage," says Robert Frank in his deadpan, Swiss-accented voice. "But it will be better...to have footage...of people," he adds. "Every day, I want to make a little piece of video. And I find that people..." A pause, and the crows suddenly fly out of the frame, all at once "...are very good..." Zoom out to reveal a snowy, nicely disshevelled landscape, with an old tire lying in the corner of the frame. "...and very expressive." Cut to a man in a plaid shirt, sitting by a Nova Scotia window, discussing the local dogs.

Why does this little vignette move me so? First of all, because of Frank's unfailing eye—limpid, quick, calm. The laid-back black crows are grouped in a nice triangle formation against the white snow, and the unpicturesque brown grass dilutes the potential preciousness: as always with Frank, the image is strictly present tense, fused to the moment of its occurrence

Presence

Kent Jones

How to approach a "piece of video" as movingly direct as *The Present*...
Ticking off its various strategies and properties seems like a paltry response to a work of such
unsentimental force and simplicity. Simplicity most of all. Absolutely nothing in the entire
twenty-seven minutes feels assumed or cooked up for the occasion. Every choice, every move,
feels *arrived* at, resulting from a hard-working effort to get at an impossible subject. Namely:
what it feels like to be alive.

Robert Frank's always been pretty good at that. If it's impossible to break his
photographs/films/videos down into separate categories, it's because they all seem to flow
from the same source, the same impulse. There's a remarkable balance between great care and
(stubbornly) imperturbable ease that runs throughout Frank's body of work, the strong sense
of the artist as human being rather than maestro, demiurge or philosopher king. In *The
Americans*, the stance is neither affectionate nor critical, not inquisitive, and not voyeuristic.
Rather, there's the feeling of an artist simply being there. It's never a matter of getting a sharp,
encapsulating image in the manner of Evans or Lange, or hitting on the "right moment"
à la Cartier-Bresson. Frank is simply present at the funeral down south or the accident on the
western roadside. He is not exactly the model of an empathic participant or observer: there's
a funny feeling of aloneness in his images, a kind of solitude that always seems to be saying
"Don't look at me—just let me go about my business and I'll let you go about yours."

Watching a film like *Candy Mountain*, with its unlikeable protagonist crossing
paths with one amenable person and homey landscape after another, only reinforces the point.
Candy Mountain, one of the most undervalued films of the 1980s, has a wonderful kick to it.
The story appears to be an early cautionary tale about looming globalization: a miserable,
ambitious small-timer journeys to the end of the world in search of a legendary guitar-maker,
only to find that he's already been bought by the Japanese. In exchange for a bundle of money,
he's burning his guitars so that only thirty will be left around the world, thus increasing their
value. But you don't come away from *Candy Mountain* thinking about a message. Instead, you

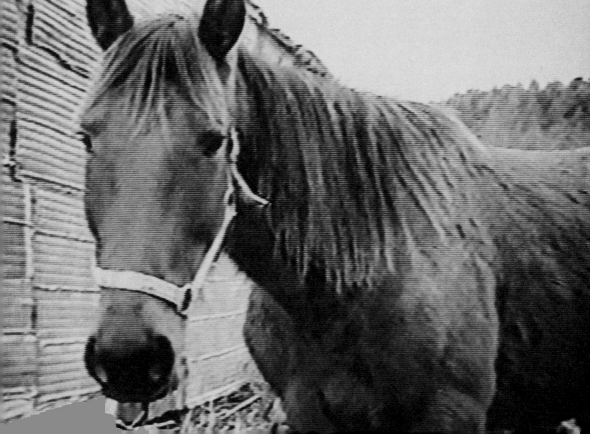

1 France, 1978

2 Quoted from Roberto Ohrt, *Phantom Avantgarde – Eine Geschichte der Situationistischen Internationale und der modernen Kunst*, Hamburg, 1990, p. 34.

3 Jack Sargeant, *The Naked Lens. An Illustrated History of Beat Cinema*, London, 2001, p. 18.

4 William Anthony Nericcio, "The Aesthetic Triptych of Jack Kerouac" (www.rohan.sdsu.edu/dept/english/textmex/RobertFrank/frankworking.html - 22k).

5 Allen Ginsberg, "Being the Notebook of Allen Ginsberg," quoted from Hans-Christian Kirsch, *Dieses Land ist unser*, Munich, 1993, p. 33.

6 John Clellon Holmes, study for the novel *The Horn*, as quoted by Kirsch, p. 162f.

7 Jack Kerouac, *On the Road*, Penguin Books, 1991 (orig. 1955), p. 173.

8 Kirsch, p. 65.

9 Allen Ginsberg, "Robert Frank to 1985—A Man," in Anne W. Tucker/Philip Brookman, *Robert Frank: New York to Nova Scotia*, exhibition catalogue, Museum of Fine Arts, Houston. Little, Brown and Co., Boston 1986, p. 74.

10 Kerouac, *On the Road*, p. 173.

11 Quoted from: Barry Miles, *William S. Burroughs – Eine Biographie*, Hamburg, 1994, p. 121.

About Me: A Musical

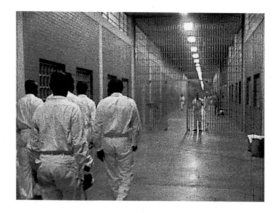

About Me: A Musical

The corridor and the light bulb, which casts a naked unprotected light on events, are two visual symbols that continually surface in different constellations and serial arrangements in Robert Frank's work. In *Cocksucker Blues* a cacophony of unspecified sounds drones in the background—archaic roaring that seems to hide secret messages in the amplitude of sound. In *About Me: A Musical,* the passage down the corridor is framed by an, as it were, close-harmony Evangelical a cappella singing: heaven and hell, declination of counterparts under the magic spell of a higher-order pictorial metaphor.

William Burroughs once described his novel *Naked Lunch* as "a plan, instructions, which enable different kinds of experiences in that they open the door at the end of a long corridor."[11] In Robert Frank's corridors there are no doors leading to the outside. One does not see the light at the other end of his tunnels, but instead is catapulted into other scenarios through the hard (film) cuts. Frank smashes genre, plot and symbolic content to lend a fragmented aesthetic form to the astonishment felt at the desolation of the mortal realm. There is no liberation at the end, but rather, "consumimur igni," consumption by fire: the phantoms' dance, imploding awareness, particle dusting at the edge of perception—fire walk with me!

Summer Cannibals

Cocksucker Blues, the film that documented the tour, became both famous and infamous: it shows party frenzy and sexual permissiveness, but mainly, within the entourage of the band, it contrasts the waffles of Zen Buddhists with heroin needles, the hysteria of the fans with the ennui in the backstage area. The Rolling Stones' lawyers prohibited public screenings of *Cocksucker Blues* because it cast the group in a bad light. Thus, through the withdrawal of the images, an over-dimensional myth was created that the actual work couldn't live up to. Robert Frank constantly played down the scandal value of his work by saying that he "…didn't see one single orgy during the entire tour. Unless you describe a girl getting laid by two guys as an orgy."

It is not the chronic of alleged excess that is remarkable, but much more so how little this film, which in terms of content and chronology marks the midpoint between *Pull My Daisy* and *Candy Mountain*, deviates from Frank's other works in its inner design: one finds the nomadic camera that constantly loses its protagonists and entirely abandons itself to the intuition of a *dérive* without any specific purpose such as in *About Me: A Musical* or in the music videos for Patti Smith's "Summer Cannibals." One becomes lost in an acoustic labyrinth of a sound score built according to complex switchboards that condense the tangle of voices, snatches of conversations, noise of departing aircraft, and brutally chopped elements of Stones songs into a type of brooding.

The most penetrating image in *Cocksucker Blues* shows the gladiators striding down an endless corridor that leads to the stage. It is a motif that also surfaces in the film *About Me: A Musical* created one year earlier. Here, however, it is a chain gang that treads a long hallway in a prison, behind bars, past the sullen, gazing guards.

Shock Corridor

Pull My Daisy and *Candy Mountain*, two works committed to music and its connotations, oppose each other asymmetrically. Through its perforated plot, Frank's debut formulated "the story of that seductive power that tears the hero, as though magically, from the monotonous existence of his everyday life,"[8] and in the absurd exaggeration of nihilistic gestures, at the same time includes its contradiction (in literature, Burroughs had meanwhile long deconstructed the metaphysics of *On the Road*). *Candy Mountain* is the return, almost thirty years later, of the indescribable other in a preserve of narrative conventions and little places of refuge. Robert Frank always navigated between these antipodean positions and trusted an aesthetic that the poet Allen Ginsberg described as "'focus swiftly,' 'invisible' … shoot from the hip—turn the eye aside, then click chance in the 'window on another time, on another place.'"[9]

This side of metaphysics, that other place could also simply present a foreign milieu in which Robert Frank—the traveler through the subcultures of an illegitimate America, with an ever-ready camera—discovers the mysteries of the organism behind the façade of social functioning.

When he got the contract to document the Rolling Stones tour in 1972, the liberation theology of the Beats was long over. It had gone through transformations: through the flower-power ideology of the hippies, Ken Kesey's acid tests, the mud fests of Woodstock. And it tasted that "spirit of evil" in Altamont, that opposed the euphoric energy of limitlessness, "the holy void of uncreated emptiness."[10]

The Rolling Stones, who had to watch as a man was stabbed in front of the stage in Altamont, were the double-headed priests of ecstasy and extermination; they revolved in their own orbit: "I felt as though I were in a space ship," Robert Frank once said. "I thought that the Stones were normal people. But I quickly found out that they don't breathe the same air as other people. They travel in thin air and they draw you along in their wake."

Cocksucker Blues

that it is a made thing. In *Pull My Daisy* one is constantly aware of the building blocks whose amalgamation is meant to lead to ecstasy. The magic trick is that this ecstasy still appears. Not through an emotional full-body massage, but rather, through little rhythmic shifts, discretely elevated degrees of intensity and asynchronous layers of sound and speech particles. When Kerouac brings the emotional content of his rap into a dance and frenzy—"is everything holy, is alligators holy, Bishop? Is the world holy? Is the organ of man holy?"—then the "inner pulse" (Isidore Isou) of the film begins to beat, the isolated elements fall seemingly naturally into one another and the propulsive motor function creates a shockwave, which, in the sense of Rimbaud, causes that *dérangement* of the senses in which "all forms of love, of suffering, of madness"[5] concentrate to the apotheosis of existential delimitation.

It is amazing that *Pull My Daisy* can still lead to this transgressive effect today although the sound modules, which constitute the acoustic chiaroscuro of its soundtrack, have suffered from the lost time and the shift in context in the parallel universe of popular culture.

The score by David Amram in its day quite possibly mediated some idea of those spiritual qualities that the Beats fantasized about in jazz: knowledge of that odyssey of a tenor saxophonist, as described by the author John Clellon Holmes: "All that he knows is that something in him speaks and the mechanisms of prophesizing listen to it. The tenor player swings further into a vacuum, he is completely lost in himself, and yet it is possible that at every moment he saves the rest of us with his earnest efforts to obtain mercy." [6]

Today, the unhurried harmonies and mild dissonances of the soundtrack to *Pull My Daisy* sound like the jazz of our grandfathers; mildew-flecked sounds from a bar after midnight, when cigarette ashes fall unnoticed under kidney-shaped tables. How was that possible, to transport through a forty-five-year time corridor the idea of a promise that can only be kept through eternity without letting the gloss of promise fade? It has something to do with the "state closest to emptiness," which the Lettristes, a French avant-garde movement of the 1950s, spoke of; with the idea of *détournement*—the estrangement of a material from its useful purposes to ungrounded aesthetic arrangements.

Despite an exuberant abundance of reality and an initially sense-oriented dynamics, in *Pull My Daisy* major existential exhaustion occurs: neo-dadaist choreography of movement and ecstatic unleashing of language sketch out a paradigm beyond pure reason and the practical appropriation of reality. The musical fragments continue to decompose on the soundtrack. They are robbed of their social functionality and circle solipsistically around the masks of an existence that seems self-referentially obliged only to the here and now: a materialized emptiness in the universe of blind mirrors. Cold ecstasy. It is this idea of a concentrated eradication of sense under the sign of convulsion that has remained modern, even if some of the strategic means employed have long become dated. The film knew more than its authors and actors, who dreamed of making "…the complete step across chronological time into timeless shadows."[7]

Speaking in Tongues

Much has been written about the spontaneous, intuitive, improvisational gestures in the creation of *Pull My Daisy*, Robert Frank's by now canonic debut made together with Alfred Leslie. Reading the contemporary reviews, one gets the impression that this film was made in the same way that one rolls a cigarette: fast, carefree and ecstatic. Rolled-up creative energies that formed themselves, as it were, into a work: A self-presentation of the still young Beat generation in harmony with their categorical imperative of elevating existence through jazz, drugs, religion and radical politics. Jonas Mekas described *Pull My Daisy* as "free improvisation" and its creators as "the true independents, the conscious rebels who reject every type of compromise."[3] Later analyses have bathed the magical primeval scene in another light. Above all, the claim that Jack Kerouac improvised the text track for the final cut of the film in a tenor saxophonist style proved untenable: "His wonderfully skewed narration had already been written out word for word," wrote William Anthony Nericcio:[4] "He spoke the text four times altogether, and the final version was mixed from three different takes."

Although perhaps the myth can be deconstructed in this way, not the aura, which the film still radiates today: *Pull My Daisy* is a thoroughly musical "adventure in sound." The combination of Jack Kerouac's finely modulated narrative voice, that lends the silent actors acoustic contours, with fragments of a driving bebop rhythm, an oboe solo, the sounds of a heavily panting harmonium and occasional blend-ins of chamber music epigrams, created an arrhythmic kinetic energy that keeps the film going without displaying that power of absorption that in conventional Hollywood cinema seeks to have the viewers forget the fact

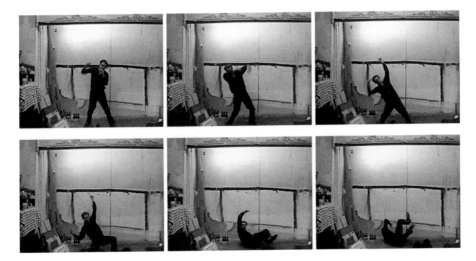

Pull My Daisy

Candy Mountain

Candy Mountain is perhaps an unusual porthole into Robert Frank's cinematic work. "We had too much money, and we had to satisfy too many needs of the money," the director conceded. "The rules were too strict; it wasn't possible to be spontaneous." On the other hand, the filter of a relatively conventional road movie offers, to a certain extent, the possibility to experience a bit about the use of music in Frank's films via a counter example. In hardly any of his other works is music introduced simply to set the emotion as occurs in the street scenes in *Candy Mountain*. The diagnosis, entirely in keeping with the disillusioned spirit of the times, is that desire for the impossible does not necessarily produce livable alternatives to the despised conventions of the "American way." This leads to a deconstruction of aesthetic strategies that bring the closed narrative to explosion, and in the intuitive unfolding of the materials attempt "the consolidation of a spiritual void."[2] Strategies whose variation and perfection Robert Frank had been working on since *Pull My Daisy*. On no account should one overrate *Candy Mountain* within the director's œuvre: for one, it is not possible to definitively confirm the extent to which co-director Rudy Wurlitzer determined the final product, and for another, Frank only rarely had the opportunity to work under comparably comfortable financial conditions. Nonetheless, the film is not simply contracted work, but rather, a striking punctuation mark; an oppressive manifestation of negative energy that was certainly necessary at this time in order to place, as a dialectical correlate, a reality dam resisting the impulses for liberation.

After several days of holding out, Silk signs a contract with a devious Japanese woman. He must produce twelve guitars for her, burn all the rest, and then never produce anymore. A Faustian pact, which provides Elmore with the necessary small change to keep on going, but extinguishes his creative sparks once and for all. Thus his *quest* ends in a huge guitar burning. Julius watches stunned as Elmore allows his instruments to burn at the stake, simultaneously burning his own dreams. The myth of the archetypical *noisemaker* instruments, which bring chaos into the order of social regulation and by talking in the tongues of their overtones and feedback symphonies tell of life on the other side, of the existential scenario of *angel headed hipsters*, now become glowing embers. The act of guitar-burning—for Jimi Hendrix in Monterey still a gesture of optimistic subversion—is now a symbol of resignation: where have all the flowers gone? Where are they? "In girum imus nocte et consumimur igni,"[1] said Guy Debord: We go in circles at night and are consumed by fire.

Hello Darkness, My Old Friend

Candy Mountain is a film that tells about the counterculture via the metaphor of musi. Therefore, like in most of Robert Frank's works, appearing in cameo roles are staunch representatives of popular culture and literary countercurrents: Arto Lindsay, Tom Waits, Leon Redbone, Joe Strummer. The road is the skeleton of the narrative that holds the film together. At every stop the protagonist, Julius Booke, is introduced to interesting characters who are each allowed to present a dramatic scene or a meaningful sketch to then fall away forever off the edge of the picture. The gray stretch of asphalt becomes the only confirmation of an ever more brittle trust in the *pursuit of happiness.*

Muffled and stoic, a heavy bass rhythm and blues beat accompanies the irrational trip on the road to nowhere: the promise of transubstantiation through acceleration of the body in indefinite space—a classical motif of the way counterculture has seen itself ever since Kerouac's *On the Road* and Woody Guthrie's songs from the Dust Bowl—turns into a constant recurrence of the same. "Freedom doesn't have much to do with the road one way or another," says Elmore Silk in the film. Although music is the real hero in *Candy Mountain*, alongside the disheveled protagonist Julius, it is only sporadically played: for example, when Arto Lindsay puts on a rough version of his D.N.A. noise aesthetic together with Joe Strummer in a New York loft, or a shaky lo-fi song rings out that is meant to lull a sick woman to sleep. At the climax of the film, Julius pulls an instrument out of the burning heap of guitars: laughing hysterically, he strikes the guitar's strings; neon lights glow from the body yet no single tone can be heard. Catatonic rigidity of a sound-dead space: "Hello darkness, my old friend, I've come to talk with you again."

Consumed by Fire:
On Music and Existential Rhythms in a Number of Films by Robert Frank

Thomas Mießgang

Julius Booke is a loser. In the wake of the 1980s Wall Street hysteria in New York he searches for an emergency exit to a career as a songwriter or rock star. He throws away his job, lends out his guitar, and doesn't really cut much of a figure as a hired musician in a ballroom. Julius sees his big chance when a group of veterans from the music business mention the legendary guitar maker Elmore Silk. Silk built the best instruments, each of which is worth 20,000 dollars by now: "I would buy every guitar that Elmore ever built." Unfortunately, the luthier has left the city and broken off all contacts to his prior life. Julius offers to hunt down the enigmatic genius and propose a deal for the sale of his guitars.

Thus begins *Candy Mountain*, a film that Robert Frank shot with Rudy Wurlitzer in 1987. It is a classic road movie that transports its protagonist from the depths of New York to the north of the U.S., and then over into Canada and Nova Scotia. His modest expense account is soon exhausted and Julius can only continue the journey by constantly exchanging his car for a more rundown vehicle. In the end he stands there with his thumb in the wind at the side of the road. "How can you do the road with no car?", asks a toothless driver who takes him a bit further.

Julius Booke's odyssey is a *quest* in the classical sense, and simultaneously a parody of the search for meaning. The path seeker follows a track of emotional devastation: he encounters abandoned family members and tormented women in various states of embitterment. No one wants to know where Elmore is at the moment. Elmore has long moved on; no one ever wants to see him again. Following meager clues, Julius finally tracks down the guitar maker in the middle of nowhere: a middle-aged man, restless and somewhat worn away by alcohol but nonetheless still attractive; a drifter who has transformed his hatred of the world into stoicism and is quite obviously completely uninterested in doing business. Julius still believes in his deal, but he must soon recognize that Elmore has completely different things in mind: "You're not even at the bottom end of my dance card."

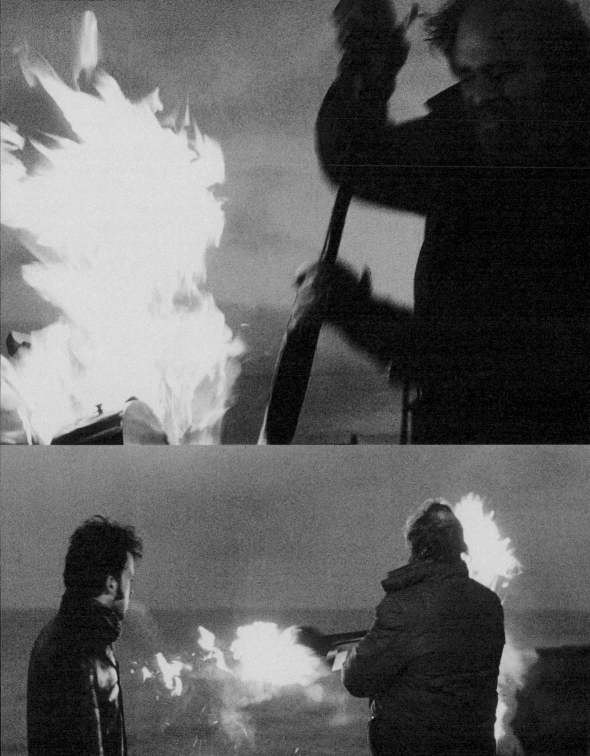
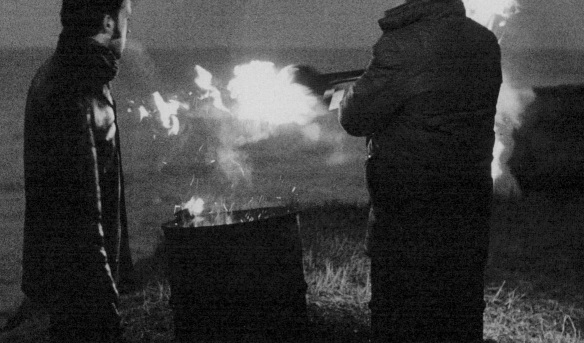

The video *The Present* leads Robert Frank to a point at which he can no longer expect anything from language: "I'm glad I found my camera. Now I can film. But I don't know what." He finds himself surrounded by objects of melancholy, most of which are connected with his son Pablo, who died after experiencing drug problems and mental illness. "The suffering, the silence of Pablo" is on a folder, the cover of which Frank films but does not open. The view from the window opens a dimension of objectivity, which could approach the Satori of Buddhism. Frank shoots a "crow film," and he films a dog who stares out the window, dissociated. "What does he see?" This question is asked from the same position where Frank stood years earlier facing Julius Orlovsky. In the meantime, all answers are forbidden; all that is still possible is an image in which also language is, quite literally, dissolved. MEMORY is written as lettering on a wall, a friend is called to eradicate this word. "It's actually impossible," after he has honestly tormented himself two letters remain: ME.

"Me and My Memory" has become the theme of Robert Frank's life, the filmmaker who found his way out beyond the presence of his pictures. "The evil (perhaps also the bliss) of language lies there: in that it cannot vouch for itself," wrote Barthes. "According to its essence, language is invention: if one wants to enable it to render actuality, this requires an enormous effort, we make an effort at the logic, or if that is missing, at the oath." The invoking voice of Jack Kerouac, the "ex machina" that could create an entire world, the fatherly voice of Robert Frank, which wanted to tell a story together with Pablo and Andrea, are silenced. The acousmatic drama is not preserved in any holy story; it can only be differentiated from a variety of voices, which—as a choir or as a murmuring—stand entirely on the side of the natural. They are all united in a gaze at the silent being (the psychotic, the animal, the dead), whose subjectivity can no longer be uttered or reproduced: "What does he see?"

[1] Roland Barthes, *Camera Lucida: Reflections on Photography,* trans. Richard Miller. New York: Hill and Wang.

The Present

Flamingo

of how memory and the present relate to each other in the topicality of the film (later the video) and in the presence of the developed picture.

The short video *What I Remember from My Visit (with Stieglitz)* from 1997 also contains a whole series of suppositions that do not attribute much value to the material picture, whereas memory is once again present through language. "What I remember from my visit with Stieglitz"; a voice with a French accent repeats the title insert, and a light bulb lights up (one of the many light associations: "Little light, lit up!" from *The Present*). The speaker is Jerome Sother. With Frank in the main role, they re-stage a visit with Alfred Stieglitz in 1943. All that is left of the actual event is an empty photo album, and a series of details that Sother enumerates: there were cookies, there was a hospitable atmosphere, chicken was served at lunch, Stieglitz could not mow the lawn as it was too damp from the rain. Particularly conspicuous were the "steel toes" that Stieglitz put on before going out to cut wood. In *What I Remember* there is a video picture from 1996 for each moment within this memory protocol. These pictures, however, work only as illustrations while the commentary from off-camera seems to be the genuine act of memory, although it is being spoken by the wrong man. Frank plays the role of Stieglitz without any trace of irony; there is no evidence of a "visit with Stieglitz," and the portrait that has been shot with the old camera shows Jerome Sother.

What I Remember is a play with voices. Remembering becomes polyphonous. The outer occasion for a visit from Sother to Frank becomes the motif to reflect on another visit— that of a young photographer to an old master, which possibly never even took place. In any case, the film leaves both possibilities open. There is no more "it was like this ..." accompanying the video images, remaining is the power of persuasion of a voice, which simply begins to enumerate. "This is the time to say a few words," says another voice in *Flamingo*. It belongs to Miranda Dali, although Frank could have said the text just as well since it is about his work: *projecting slides* and *building a house*. The photographs of building his house in the Canadian province of Nova Scotia once again have the quality of a silent film. It is logical that the commentary contains long pauses and at the end skeptically makes the film itself relative: "Okay, we're done. Paint it black." What is meant is the house, which from the beginning on is only a picture, a scheme in a dark landscape. In these late videos, the language itself is afflicted with melancholy, which grows still stronger with aging and with life's experiences (the early death of both children).

"I don't remember any of those pictures," Pablo says and thus expresses that he is not interested in making these pictures talk. He also speaks ambivalently, because the pictures are in the present (his father brought them), only he doesn't find any correspondence with his childhood memories. The family album remains silent because it only speaks with the father's voice. Frank tells of the years in New York and Europe; the children do not find this time at all unusual: "We've all come from normal to this": New York was normal, Vermont is the present. Pablo and Andrea refuse the linearity of sentiments of guilt and assignments of guilt. Similar to a psychoanalytical session, it is about uncovering the hidden sense of their statements.

In this film the childhood photographs have a completely different status than those that Barthes describes as "the unchangeable" ("It was like this …")—they are material in a fight over how it was. This confrontation loses significance only at the point where Frank inserts an old film, a mythological game, a silent holiday movie with music that frees the pictures as a whole. They are no longer under the spell of having to make a statement, which Kerouac still had at his disposal with the entire chutzpah of the Beat generation, and which Frank's authoritative fatherly voice claimed for itself at the beginning and also at the end. He has failed in his plans to make the pictures a medium for a common, reconciling interpretation of Pablo and Andrea's childhood. The children act dumb, they refuse to make the statement. The photographs (the medium that Frank had "given up" by this point in time) again fall within the pact of silence. Only the "film footage" is "actual."

Barthes wrote, "There is nothing Proustian in a photo." "The effect, that it (the photograph) has on me does not comprise the re-establishment of that which has been removed (through time, through distance), but rather the confirmation of that which I see, which is actually there." *Conversations in Vermont* seems to confirm this; the original family cannot be re-established through its album. Frank then continually comes back to the line of questioning

Conversations in Vermont

Conversations in Vermont

camera) is romantic: "Julius isn't replaceable. Why use an actor?" The film, however, is modern because it is not satisfied with the picture of the silent (ghostly) Julius, but instead attempts to catch up with him linguistically. The actor enters in Julius's place, precisely because this place is unreachable. It is not about *replacing* him, but *displacing* him, to catch up with him at a location where the voices become acousmatic, and are thus audible. There are striking takes that show Julius mirrored, that dissolve him in framed pictures and show him in a film-in-film, but none of these metaphors for his "other place" can come close to the words that are spoken "about" him.

Julius is the "satori" event in an artistic movement that believes it can appropriate Buddhism; yet it is not an emptiness through transcendent, but rather, psychotic means, and only a particularly elaborate montage of picture and sound can even come close to this experience. Freud, in his conception of language, differentiated between the idea of the word and the idea of the thing, and he understood the relationship between these two kinds of ideas as a memory: the sound of a word results in an idea of the word, which invokes a picture—the idea of a thing. In psychotic persons, this communication is disturbed. They can read headlines from the newspaper without any problem, but these words do not produce any images in their imagination. Julius would therefore not be moved to say anything because he cannot recall pictures belonging to the sound of a word. He lives in a hell of ideas of words; he has become an object of the voices.

In 1969 Frank began a film by turning on a record player: "Something's the matter with the record player." (Music is his ideal path for leading beyond the melancholy of photography, although that is another theme.) Voice is also dominant here: "This film is about the past and the present. The present comes back in actual film footage." The formulation is traitorously ambivalent: the past comes back. At the end Frank speaks from off-camera, his "deus ex machina" formula: "I call this film *Conversations in Vermont*." This is followed by the word "cut," which is already there at the end of *Me and My Brother*. For the conversations in Vermont, Frank visits his children Pablo and Andrea, who live in the countryside, go to school, and are part of a group that manages a farm and sings together, "Jubilate deo." The father speaks with remorse of his behavior during Pablo and Andrea's early childhood, at the same time he presents them with photographs dating back to this time and challenges them to recognize themselves in the pictures.

movement—its understanding of the body as a sound space that more or less naturally releases literature ("bursting with poetry," says Kerouac)—with an essentially more complex confrontation with the relationship between body and language, subjectivity, and communication. There is an unforgettable scene of a famous reading by the Beat poets Allen Ginsberg and Peter Orlovsky in *Me and My Brother*. At the back of the stage, Julius Orlovsky sits and stares. The poets attempt to integrate him into their performance and besiege him with their microphones: "Say something!" Julius remains silent but the entire film takes on the task of transporting outward the "voices" from within the mentally ill man and even assigning them with pictures, which are surely no more than invention.

This achieved construction is so meaningful because in it, a media historical statement is made. The film—and not the poetry, like for the Beats, or the photography, like in Frank's *The Americans*—is the "common denominator," for the mediation between subject and object, between inner and outer worlds. However, for Frank, film is not the medium of an enthusiastic subjectivity, as it is for Stan Brakhage, for example, but instead, already with *Me and My Brother* is very much influenced by a revaluation of the relationship of image (which follows) and language (which is prior). The presence of the photographic moment is broken by the absent subject of Julius Orlovsky. From the first take onward, linguistic signs shower down on Orlovsky, a neon sign in the image's darkness with a warning voice: "Watch out for the cars, Julius!" This indifferent witness, however, cannot even be lured out of his reserve by two homosexuals' "sex experiment" carried out in front of the camera—because he is at a different place: "Where he is seems like a meeting place."

Similar to the Beats' meeting point in *Pull My Daisy*, this place is composed linguistically. The pictures, first discovered on the path of visual digression, are compiled entirely by association and can only be integrated through the soundtrack. The "sensitive mike"—and not the camera—is the instrument that enables access to Julius Orlovsky's enigmatic subjectivity. The maze of voices, with which he presumably lives, has an outer correspondent in the multiplicity of diagnoses and assumptions about his state. The objection of a woman (from off-

Me and My Brother

onward and thus has nothing melancholic (but in the end, what is it?—Well, it is quite simply 'normal,' like life itself)."[1]

Through photography, Barthes misunderstood cinema, because he preferred to remain a visionary. But Robert Frank first really understood his photography through cinema, because he could integrate photography into a larger discourse within it. He was able to discuss photography in film. He could overcome the loneliness of the viewer. But to do that he needed a detour through silent movies. In *Pull My Daisy* the "forward momentum" of life, because it is only represented through language, does not quite fit right with the melancholy of the images. Jack Kerouac's voice in *Pull My Daisy* corresponds with a "deus ex machina," which cannot manage to refrain from beginning with a little act of creation. The opening line begins: "Early morning in the universe." Michel Chion speaks of "acousmatic beings" that were not invented by sound films, "since Jehova is the great original ACOUSMATIC." All of this comes into play with Kerouac's voice. He acts like a silent film narrator for whom the slow pan through the loft in the New York Bowery moves a little too patiently. Through his cascade of words he provokes the slapstick moment about the poet Apollinaire, who falls at Balzac's grave. Through the insistent question "Is everything holy?" he invokes that quality in the visual material that strives to go far beyond the chance (or, as Barthes writes, the contingency) of the moment. The text is primary; through it, the visible is defined. In a long play on words about the word "cockroach," Kerouac literally makes the invisible appear because Frank cannot do much more than pan over the walls and the furniture behind which the cockroaches hide. The voice is given an exorcizing function, but the further away the historic moment is, the more the images become objects of melancholy, and the persons involved become phantoms. (Pablo, Robert Frank's son, already makes an appearance here. Later, everything will revolve around his presence and absence.)

In sum, Robert Frank's cinematic work actually contains something similar to an acousmatic drama: at the beginning of *Pull My Daisy* the words over the images are strong. In the later videos the voice is still omnipresent, but only as part of melancholic registration, approaching Jonas Mekas' fragile "ecstasy." Frank opposes the expressive optimism of the Beat

Pull My Daisy

Exorcisms.
The Drama of the Voice in Robert Frank's Films

Bert Rebhandl

In Robert Frank's short film *OK End Here* the woman's first words are: "Deus ex machina. What does that mean?" The comment still belongs to the associations from a dream. It requires translation from a foreign language. But it is also an analytical term from a specific context—the theater—which takes on multiple, sexual, and other possible meanings through the circumstances of this morning scene. The woman's boyfriend is lying next to her; the film deals with the start of the day for two lovers who have spent the night together. Their morning conversation is wrested from silence. The man devotes himself to everyday things; the chatter from the television set seems to offer him some relief. The woman still dwells on her dreams: "At home my dreams are different."

Talking would be proof of love, which the man is not able to produce. "Do I bore you?" asks the woman. It is the arrival of a befriended couple that first ends this difficult situation. The visit to a restaurant leads into the outer world's polyphony, which opposes the entropic silence of the New York apartment. In the midst of the maze of voices in the bar an older woman reads a letter out loud, but despairs at the disinterest of her neighbors. "I told you, she's a bore," someone says about her after she has already left. The verdict is spoken from the same off to which the woman escapes. Is that not precisely the function of a "deus ex machina"—to decisively influence a scene from off-stage?

Robert Frank was first a photographer and then later became a filmmaker. Still images are silent and unchanging; films, however, can have sound and chronology. In the foreword to the photo volume *The Americans* Jack Kerouac wrote that in it, Frank works "with the strange silence of someone who is following something." Also, the photographs' perspective establishes a pact of silence that is first resolved in the encounter with literature and film, and above all with language. In *Camera Lucida* Roland Barthes wrote that the reference point in the photo, its object, is a ghost. Photography is "without future (and its pathos, its melancholy can be found in that); it does not contain the slightest urge for continuation, whereas film pushes

Bobby McMillan, as he delivers the morning newspaper to subscribers in and around Mabou. As they drive through the wild, bleak, North Atlantic landscape, night slowly changes to day, and Mr. McMillan offers thumbnail sketches of the people on his route (some of whom we glimpse as they come to out to fetch their papers). The piece is filled with aleatory moments that John Cage might envy. Even before Mr. McMillan describes how he "makes the circle" in getting from one house to another, we might realize that the phrase *Paper Route* could be a metaphor for Frank's life and the trail of photographs and movies and writing he has left behind him and which also leads him into the future.

 The circle, as metaphor and image, reoccurs throughout Frank's work. When Mr. MacMillan talks about "making the circle," his reference is geographic. When Frank responds, "Make the circle? That's what we all do," he has something more metaphysical in mind. For a moment, the shadow of death falls across this seemingly casual and good-humored little piece. But the reference can also be read purely in terms of Frank's films, circling us back to *Pull My Daisy*, which opens with an incomplete pan around the empty loft, then cuts to an overhead shot of the round table in the middle of the floor. And although *Pull My Daisy* does its best to dispense with narrative, its climactic sequence is a 360-degree pan, which reveals, as if by accident, a violent quarrel erupting between the husband and the wife—the domestic drama the film has tried to suppress. After Milo shrugs off his angry wife, and he and his friends go out the door into the night, the camera lingers for a second or two on the circular ornament on the stairway balustrade. It's the last image before the final fade to black.

Paper Route

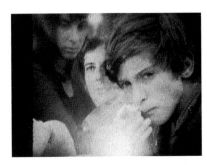 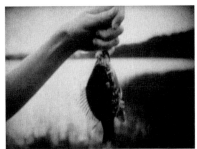

Conversations in Vermont

specifically on the work of Michael Snow and Hollis Frampton. Like Frank, Frampton was a photographer before he turned to film while Snow has become as celebrated for his photographic pieces as for his films. In this context, *Mute/Blind* (1989) can be read as an angry response to Snow's piece *Venetian Blind* or to a number of other pieces where Snow arranges photographs as a grid and employs the loaded word "blind" as part of a punning title. *Venetian Blind* is made up of a series of black-and-white poloroids that Snow took of his own face with the cityscape of Venice in the background. The images were taken blind, in the sense that Snow held the camera at arms-length in front of him and clicked the shutter without looking through the viewfinder. Their arrangement in vertical and horizontal columns suggests the slats of that shutter-like household object—the venetian blind. Frank's *Mute/Blind*, on the other hand, is a grid-like arrangement of photographs of a small blind dog surrounding photographs of the statue of a male deer. The photographs of the deer statue have been treated with dye so that the deer's eyes look as if they're gouged out and streaming blood. The photos are messily tacked to a piece of creased, crimson fabric. The effect is as if Frank were muttering between clenched teeth, "You want blind? I'll give you blind."

In the 1990s, Frank replaced the cumbersome 16mm film camera with a lighter, more flexible video camera. With it, he has produced pieces that have a grace and spontaneity absent from his moving picture works since *Pull My Daisy*. *The Present* (1996) and *Paper Route* (2002) are among the most beautiful and elegantly shaped works Frank has made in any medium. Both are diaristic pieces that begin with Frank wondering what story he's going to tell. The search for a story becomes a kind of running gag throughout the twenty-three minutes of *The Present*. The piece is extremely fragmented. Hop-scotching between his New York loft, his house in Mabou, Nova Scotia, and various European cities, Frank encounters old friends and neighbors, contemplates his messy workspaces, and talks to himself, the birds, the deer, his wife, June Leaf, and whomever else crosses in front of the lens. Movie-making becomes a conversational act. The artist is part of the world he records. The effect is very different from Mekas' voice-overs, which are responses to recorded images (memories) rather than to real life. Which may be why the video is titled *The Present*.

Paper Route is similarly conversational, but its subject is a single person, performing a single activity within a circumscribed space. Frank rides with a middle-aged man,

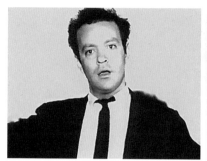

Me and My Brother

North America. Mick Jagger refused to allow the film to be released because of the possible legal repercussions from the depiction of behind-the-scenes sex and drug-taking, but he has allowed limited museum and benefit screenings. (It's hard to believe that Frank and Jagger didn't know what they were getting into from the start—that Frank would be incapable of censoring his own eye and that Jagger would never allow what Frank recorded to be available for public consumption.) In the U.S., the film is available on VHS bootlegs, where the degraded image and sound quality have little effect on its power as a road movie (among the more extraordinary scenes is one where Jagger and Richards wander into a Black juke joint somewhere. in the Deep South and the locals gradually realize who they are) and as a performance documentary. Other Rolling Stones documentaries have on-stage sequences as exhilarating as those in *Cocksucker Blues*. What Frank captures that no one else has is the moment in the underground passageway that leads to the stage, when, in response to the distant roar of the crowd, Jagger's energy shifts and he transforms himself from the disciplined professional musician we've seen in his dressing room into a superhuman.

 Conversations in Vermont (1969) was Frank's first openly autobiographical film, a form that has subsequently dominated his work for over thirty years. Its subject is his relationship with his then teenage children, Pablo and Andrea. Andrea died in a plane crash in 1974 at age 20. After many years of mental and physical illnesses, Pablo committed suicide in 1995. It's impossible not to attribute the change in Frank's work during the 1970s to the tragedy of Andrea's death and Pablo's deterioration. In addition to making films, he returned to the more immediate medium of photography. Rather than single image photographs, however, he produced multiple-panel pieces and collages that combined images and words. During the 1970s, the photographic object became the sign of postmodernism, all but displacing painting and sculpture. Unlike most of this work, which was basically conceptualist, Frank's pieces were flagrantly emotional—a direct translation of personal anguish into object. They were even more raw than the writing of the Beats, mediated as it was by the ethos of "cool." One has the sense, looking at these pieces, not merely that feeling has taken precedence over form, but that it would have been some kind of obscene cover-up to bring form into the picture at all. .

 And perhaps, the photographic pieces are also an attack on the so-called "structuralists" who dominated avant-garde film from the mid-1960s to the late 1970s,

Me and My Brother was four years in the making. Frank films Julius at home with Allen and Peter. We learn from a psychiatrist's report that Julius had his first psychotic break while working for the Sanitation Department, so Frank takes Julius to a garbage depot, and films him shoveling refuse. Allen and Peter go on a poetry reading tour. They take Julius on the road with them and Frank tags along with his camera. It's on this tour that that Julius goes missing for many weeks, forcing Frank to bring in a professional actor to take his place. (Like everything in the film, this anecdote may be fact or fiction or one superimposed on the other.) The actor is Joe Chaikin, then the leader of the Open Theater, an experimental theater troupe. Frank also turned to playwright Sam Shephard, who often worked with Chaikin, to script some scenes for the film. In the end, the actors, many of them Open Theater members, outnumbered the non-actors (people who were playing themselves, rather than characters). Frank also recruited two young Broadway actors, Christopher Walken and Roscoe Lee Browne, to alternate in the role of the director. Often when we see them speaking, it's Frank's voice that we hear.

Frank doesn't ask Chaikin to create the illusion that he is Julius. Rather, he films the actor's process of engaging with Julius as a character. *Me and My Brother* is a film about performance—not only the performance of an actor for the camera, but also the performance of the filmmaker shooting a movie. More broadly, it's about life as a performative act. All of Frank's work grapples with the connection between inside and outside—between feeling, thought and perception (interiority), and expression. How do they come together in taking a photograph, putting paint on canvas, making a film. In an open letter published in 1969 in *Creative Camera*, Frank wrote: "In 1958, right after finishing *The Americans* I made my first film. I knew film was first choice. Nothing comes easy, but I love difficulties and difficulties love me. Since being a filmmaker I have become more of a person. I am confident that I can synchronize my thoughts to the image and that the image will talk back to me. It's like being among friends."

But for Julius, interior and exterior do not come together. The connection between emotion and expression, thought and action, is blocked or severed. We don't know what, or even if, Julius thinks, feels, perceives, because most of the time he's silent and immobile. Amazingly, however, when Julius returns to the film at the end, he can speak. (It seems that when he wandered away, he ended up in a psychiatric institution where he was given shock treatment.) Julius delivers a rather devastating critique of the film, which suggests he knew all along what Frank was up to with his camera. "The camera seems like a reflection of disapproval or disgust or disappointment or unhelpfulness, inexplainability to disclose any real truth that might possibly exist," says Julius, nailing the two-way relationship of projection and introjection and of filmmaker and subject.

A more pleasurable, rewarding and generous depiction of performing artists at work and play, *Cocksucker Blues* (1972) is a documentary of the Rolling Stones on tour in

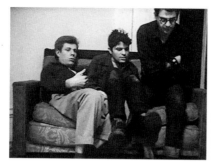 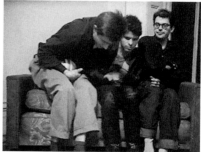

Pull My Daisy

Lost Lost Lost (1975). Mekas' hand-held shooting style and his rapid-fire montage was clearly influenced by Stan Brakhage, but unlike Brakhage himself and the diaristic filmmakers also indebted to him (Bruce Baillie, Warren Sonbert, Andrew Noren), Mekas gave equal weight to both picture and sound. If *Pull My Daisy* was a "signpost" for Mekas' own filmmaking, it was because he learned at least two things from it. One was the necessity of recording—from an insider's position—an incredibly rich and passionate moment in cultural history. The other was that voice-over narration could do something more than provide information. It could be an expressive element, shaping the rhythm and emotional tone of a film. When Frank's films became more directly diaristic, beginning with *Conversations in Vermont* (1969), he also came to rely on his own voice as an expressive instrument. There is something plaintive in the voices of both filmmakers, suggesting feelings of loss too deep to be assuaged by the images on the screen. And although Mekas and Frank have both lived in New York for over a half century, their speech remains heavily accented with the sounds of their first languages (Mekas' was Lithuanian, Frank's was German.) The accents mark them as permanent outsiders to the culture they've memorialized in their art.

Frank followed *Pull My Daisy* with two short fiction films. *The Sin of Jesus* (1961) is a bleak, heavy-handed allegory somewhat influenced by Bergman and only slightly redeemed by its stark black-and-white cinematography. In *OK End Here* (1963), a photographer and his girlfriend realize that their relationship is quietly falling apart. Filled with Antonioni-like silences, the film suffers from the inability of the actors who play the couple to convince us that they've known each other for more than five minutes. The failure lies as much with Frank's direction as with the actors themselves.

The associative, fragmented, multi-layered *Me and My Brother* (1968) reunites Frank with beat poets Allen Ginsberg and Peter Orlovsky. The film is a portrait of Peter's catatonic-schizophrenic brother Julius, and it's also a film about the problem of "portraying" Julius, who is the ultimate non-actor, in a film. "He has to be told each thing to do, otherwise he just stands there and looks at his mattress," says Peter, at one point. And that's on a good day. Frank tries various strategies. Indeed, he seems to have made up the film as he went along, using whatever stock—black-and-white or color—he could get his hands on and developing scenes— some improvised, some scripted in advance—in response to the stubborn object that was Julius.

was shot and which would be made into a film by Shirley Clarke in 1961, involved a group of junkies hanging out in a crummy apartment waiting for their dealer to bring them their daily heroin supply. Similar in their anti-dramatic structure, their circumscription within a single space, and their drug-warped sense of time passing, *Pull My Daisy* and *The Connection* influenced a strain of American avant-garde filmmaking that includes most notably Jack Smith's *Flaming Creatures*, the early 1960s films of Ken Jacobs, and many Warhol films from the silent *Haircut* (1963) to *The Chelsea Girls* (1966).

In 1960, Jonas Mekas and producer Lewis Allen invited two dozen filmmakers to the first meeting of the New American Cinema Group. Among the invitees were Frank, Leslie, Peter Bogdanovich, Emile De Antonio, Shirley Clarke and Gregory Markopoulos. The group was not limited to filmmakers. It included a distributor, two actors, a lawyer, several producers—all of them passionately devoted to making films outside the commercial system. There were as yet no clear divisions between avant-garde, narrative and documentary filmmakers. The heterogeneity of the group was reflected in the films they made during the early 1960s. And indeed, that heterogeneity has sparked Frank's moves from fictional narrative to documentary to home movie and around and around again for more than forty years. Often, he see-saws between genres within a single film. This restlessness distinguishes Frank from almost all his early film colleagues. (Clarke is another exception.) Even Jonas Mekas, whose work and life have striking parallels with Frank's, had, by 1965, settled into the diary form that would define all his future films.

But in the early 1960s, the European art film still exerted a powerful hold on the imaginations of the emerging New American Cinema. Mekas' first film *Guns of the Trees* (1961), like *Shadows*, was a feature length slice-of-New-York-life that owes more to early Visconti than to *Pull My Daisy*. A fascinating failure, the film evidences both the near impossibility of making convincing narrative features with the meager financial resources American independents had at their disposal, and also Mekas' flagging commitment to the feature narrative form itself. Mekas' second film, *The Brig* (1964), is a film recording of the Living Theater's production of Kenneth Brown's play about the daily experience of prisoners in an army stockade. Mekas shot the production with a hand held 16mm camera, moving amid the on-stage action as if he were responding to a real-life situation. The film confounded categories of fiction and documentary so thoroughly that many in the audience at the Venice Film Festival, where it won the documentary grand prize, believed that they were watching a film of an actual army prison.

Almost from the moment of his arrival in New York in 1949, Mekas had been keeping a 16mm diary. It was not until the mid-Sixties, however, that he began editing this on-going record of his life and the life of the fragile and fractious cultural community, in which he was a galvanizing force, into a series of films that includes at least two of the greatest works of the New American Cinema: *Walden: Diaries, Notebooks and Sketches* (1964-1969) and

screening, it was going by the slyly sexual handle of *Pull My Daisy*. Loosely based on a play by Kerouac, the twenty-eight minute film is set in a cluttered, grubby downtown loft and takes place within a single, ordinary day. The loft is home to railroad worker and saxophonist Milo (played by painter Larry Rivers), his painter wife (played by Delphine Seyrig, the only professional actor in the film who was, at that time, married to American painter Jack Youngerman), and their young son (played by Pablo Frank, the son of Robert Frank and his first wife, the artist Mary Frank.). Much to the annoyance of the wife, the loft is invaded by Milo's friends—a trio of poets (Allen Ginsberg, Peter Orlovsky and Gregory Corso, playing themselves) and a musician (played by David Amram, who wrote the score for the film). The poets poke fun at the wife's guests, "the Bishop" (a Bowery preacher, played by art dealer Richard Bellamy), his wife and sister. The wife berates Milo for mistreating the Bishop. Milo shrugs her off and departs with his friends.

Although he never appears on the screen, the star of *Pull My Daisy* is Kerouac, who improvised the descriptive voice-over while watching a fine-cut of the picture. Since the film was shot without sound, it was left to Kerouac not only to explain what's happening but also to give voice to the words the actors are saying. His verbal riffs combined with Amram's jazzy score and the antics of Ginsberg, Orlovsky and Corso give *Pull My Daisy* its sense of spontaneity and high spirits. (Ginsberg reported that Frank encouraged them to horse-around.) The abrupt, syncopated rhythms of the editing also add to the sense that the film was caught on the fly—the editing style pre-figured, but only by a year, the cinéma-vérité editing approach of the Maysles brothers, Ricky Leacock and D. A. Pennebaker. But, in fact, Frank shot multiple takes of each scene (a customary practice in fiction filmmaking but definitely against the rules of cinéma vérité) and is said to have accumulated as much as thirty hours of footage. (As he would continue to do throughout his career, Frank collaborated with a professional editor—here Leon Prochnik). Shot in 35mm black and white, *Pull My Daisy* has a grainy but etched look that resembles the photographs in *The Americans*. Except for one slow, 360-degree broken pan around the loft, Frank employed a combination of static shots, small pans and tilts. And while the image gives the impression of having been "shot from the hip," the camera remained on its tripod throughout.

Pull My Daisy premiered in 1959 on a double bill with John Cassavetes' first feature, *Shadows*. The venue was Cinema 16, the weekly series that showcased all manner of non-mainstream film from Eastern European art flicks to medical shorts to avant-garde work from the likes of Stan Brakhage and Maya Deren. The juxtaposition of the two films generated a flurry of polemics in the pages of *Film Culture Magazine*, which Jonas Mekas co-edited, and in Mekas' influential column in the *Village Voice*. Mekas championed *Pull My Daisy*, deeming it "as much a signpost in cinema as *The Connection* was in theater." Jack Gelber's play *The Connection*, which had been produced by The Living Theater just a year before *Pull My Daisy*

The Americans are those of "strangers in a strange land"—bewildered, lonely, despairing, angry, isolated even when caught in an embrace. What unites the young and the old, the rich and the poor, the Black people and the White people in Frank's photographs is their isolation.

The Americans is a deliberate, devastating attack on the air-brushed, happy-face image of America in the Eisenhower era. The book is not a side-show—it is an encompassing vision. (The title is not *The Other Americans* but *The Americans* plain and simple.) Derided by the cultural establishment when it first appeared, it became one of the most influential works of 20th century American art, affecting not only photography but film as well. Filmmakers as various as Jim Jarmusch, Wim Wenders, Gus Van Sant, and Curtis Hanson are indebted to the eye of Robert Frank.

Frank was not the first photographer to marry the snapshot aesthetic (off-kilter compositions, graininess, muted gray scale) with a poetic, personal vision, but he did so with a ferocity that had not been seen before. The anger in *The Americans* is directed, by and large, not at the people in the photographs, but at the hypocrisy of both commercial and art photography in refusing to expose the failure of the American dream. It was a hypocrisy Frank knew first-hand; he earned his living in the glossy fashion photography world, and some of its most celebrated figures sponsored his application to the Guggenheim Foundation for funding for *The Americans*. Frank could have requested almost any one of them to write an introduction to the U.S. edition of the book. Instead, he asked Jack Kerouac, whose novel *On the Road* (1957) put the Beat aesthetic on the cultural map. Kerouac's short essay turned the photographs into stories, linked to one another by Frank's eye. The photographer's vision became the equivalent of the writer's narrating voice.

After completing *The Americans* Frank took on two "proto-cinematic" projects. He produced a series of images of New York, shot through the windows of moving buses—thus defying the concept of the still photograph. And he worked on an advertising campaign for the *New York Times*, which involved sequences of images—some of them shot with a 16mm film camera—collaged within a single frame. While not as ubiquitous as it would become by the mid-1960s, the movie camera was already a seductive tool, and not just for people who defined themselves as filmmakers. In the early 1950s, several still photographers made forays into film: Janet Loeb, James Agee, and Helen Levitt's *In the Street* (1951) and Morris Engel, Ruth Orkin and Ray Ashley's *Little Fugitive* (1953) are groundbreaking works in the history of New York movie-making. Frank's first film, *Pull My Daisy* (1959) was also a collaboration. The end credits on the film read "adapted, photographed, and directed by Robert Frank and Alfred Leslie, written by Jack Kerouac."

If *The Americans* is based in the vernacular form of the travel snapshot, *Pull My Daisy* is the underground art world's home movie. The film's original title (the only title that actually appears in the film) was *The Beat Generation*, but by the time of its first public

Circling.
Beginnings, Continuations, Renewals: Robert Frank's
Personal New American Cinema

Amy Taubin

"So we make the circle. You understand now, Robert."
"Make the circle? That's what we all do."

(From a conversation between Bobby McMillan and Robert Frank
in Frank's 2002 videotape *Paper Route*)

"October 1, 1960: Robert Frank came, in the morning. We gave him 4000 feet
of outdated film for leader. He was tired, angry, beaten down by work, lack of money,
businessmen, and contracts. 'I'll never make a film like this again,' he said. Unshaven, black,
tired, he was almost talking to himself." (From the diaries of Jonas Mekas, published in limited
edition through Anthology Film Archives, NY)

Even before Robert Frank made his first movie, *Pull My Daisy* (1959), he was
already thinking like a filmmaker. Frank's *The Americans* (1958), a book of 83 photographs
shot during various trips up and down, across and all around the United States between 1955
and 1957, is, above all else, a road movie. In making the images, Frank was guided by the
photographic imperative of "the decisive moment," (an imperative he later renounced); but
The Americans is not simply a collection of such moments. The book is more than the sum of
the photographs within its covers—resonant, beautiful, and, yes, iconic as each of them is. *The
Americans* is a narrative work. It tells the story of a journey that Robert Frank—a Swiss-Jewish
immigrant who arrived in New York, a city of immigrants, just after World War II—took,
in search of real Americans. As everybody knows, real Americans do not reside in New York
because New York is not really part of America. What Frank found, perhaps to his surprise,
when he left New York, were people who were no more at home than he was. The faces in

I think. And he was working with video, and then when he liked the images on the video he photographed them with this giant 20 x 24-inch Polaroid, and then lined them up as a triptych, quadruptych, or whatever. I saw that. I didn't realize how he did it. He was just taking life-size or even larger than life-size photographs of the video screen. I said, "Well, that's an interesting thing." He said, "Well, if you're a photographer you've got to keep moving on. In this business, you've got to keep moving on. Otherwise you fall asleep or otherwise you settle in to some kind of repetition."

WHY DO YOU THINK THAT ROBERT CHOSE KEROUAC TO WRITE AN INTRODUCTION TO "THE AMERICANS"? ORIGINALLY WALKER EVANS WROTE THAT TEXT AND ROBERT REJECTED IT AND CHOSE KEROUAC INSTEAD. DO YOU THINK THAT WAS A TRANSITIONAL MOMENT FOR HIM?

Robert told me about that the other day. He said Walker Evans was very aristocratic, although he took popular American scenes. His nature was aristocratic. And in fact, when he came to visit the set of *Pull My Daisy*, apparently Evans was wondering why was Robert hanging around with these American ruffian Bohemians. Then, I suppose, Walker meant security and respectability as a preference writer in historicity, but Kerouac meant creation. If I had been Robert, I would have been so scared to move away from Walker Evans and jump into something new. That's amazing, an amazing human choice that he would jump into unknown Kerouac instead of classic Walker Evans as his patron, or introducer.

DO YOU THINK THAT ROBERT WAS AN INTREGRAL PART OF THE BEAT GENERATION?

Well he was apparently working independently on the same principles, which were spontaneous mind. He was looking for some supreme reality, actually, depending on his own Whitman, from the lineage of Whitman, depending on his own nature rather than on a received aesthetic, or a received moral, or a received sociology, but reflecting his own helplessness, hopelessness, his own failure, his own inability, his own inability to live up to whatever super ideal standard he was supposed to live up to, but depending on his own senses, like Jack…. Jack's was a more romantic, national ambition. Robert was more world-weary and unillusioned. But on the other hand they both had an eye for wild detail, eccentric detail, crazy people, crazy Americana…. In that sense certainly, they created things together that were remarkable.

[1] Kaddish = A Jewish prayer recited by mourners during the year of the death and on its anniversary.,

Robert, I think, one time moved Kerouac's entire family from wherever it was, Long Island, down to Florida. And Kerouac constantly had to move his mother around. She would be dissatisfied living in Ozone Park or Northport, and so Jack moved her down to Florida and he had to move her back once, he moved his mother about five times. Burroughs she rejected, me she rejected, a queer Jew, and Lucien Carr, an old friend of Jack's, she disapproved of. And I think Jack's father, on his deathbed, made his mother swear to protect Jack from all his friends. But Robert was a later friend, after Jack's father died, and was one of the rare people who were sort of anonymous to Mrs. Kerouac—just a friendly presence, not an aggressive presence. I guess he took it easy with her, Robert probably knew that kind of peasant.

WHAT DO YOU THINK OF ROBERT AS A WRITER? YOU WERE TALKING A BIT ABOUT THAT.

Ah, there is some kind of basic sincerity about him. You know, he doesn't say much. The main subject matter very often is how to avoid the consequences of fame. How do you avoid the hyper-consciousness of being an artist, how do you stay with life as it is with an ordinary eye? That's one reason why he gave up the still photographs; he got tired of looking through the camera, through like a frame. He wanted something larger. He wanted to be in the world. And that's I guess why both his writing and comments on his photographs were so scratchy and include his family, his friends. The subject of his writings seems to be: how do we get off, how do we continue the struggle, how do we keep moving?

Robert said, "Well, once you've got all your photographs catalogued and itemized, put in place with the numbers on them, then the work is done, there's not so much work." So, I said, "Well, I'm having trouble keeping up with it, I have to hire a secretary to keep the numbers together and file them. How do you do it?" I asked. "Oh, I, I only take ten pictures a year." "Ten pictures," I said, "how do you do that?" Well, what he was doing was working with this giant big Polaroid camera in Cambridge that the Polaroid company had for a while at MIT,

Pull My Daisy

Me and My Brother

day, and where the symposium, poetry reading, was, and meet old friends that were coming up, people who haven't seen each other for twenty-five years like, ah, I think John Holmes and Carl Solomon and Herbert Huncke and John Holmes hadn't seen each other for decades and decades and decades. So they were all part of the same mythology, the Beat Generation or *Pull My Daisy* or whatever it was, San Francisco renaissance, poetry, 1950s art. So Robert stationed himself on the front porch with a cup of coffee, soundman, and a silent camera—silent in the sense that it didn't make noise, but he could—it recorded everything. He just recorded everybody's morning chewing the fat and conversation and meetings and ordinary, everyday, no big deal, the fellows among themselves and the girls with each other, just talking. Burroughs coming up to visit and talking about trying to get more out of his Bowery loft and Robert asking him a question, "Is it worth money, what are you trying to sell?" and Burroughs saying, "I've got to sell it, I've got a key and an eviction notice," and odd people just talking to each other, David Amram singing, skipping around and singing some old 1920s song. So it was all completely home-like, and it was called *This Song for Jack*. And in one of the opening scenes Robert had this really funny group of boozers, sort of Hells Angels boozers down on the mall in Boulder, he'd gone out in the rain and found a couple of bum-like ancient Beatniks and stopped them and asked them what they thought of Kerouac. This is the documentary aspect, a crazy documentary. He was talking to aging Beatniks and asked, "What do you think of Kerouac?"

WHEN DID YOU FIRST SEE *THE AMERICANS*?

I don't remember. It must have been some time after 1959 when Grove Press put it out.

DID IT HAVE AN IMPACT ON YOU?

No, it took quite a while before—I just took it for granted. Kerouac really liked Robert, and Kerouac's mother did. Robert was one of the very few people that Kerouac's mother would accept, because he was Swiss and spoke French, and he had a European background and wasn't queer, had a family. He had a thing of his own that he was doing but he also had a car. And so

Yeah, he moved out and retired from the world, it was interesting, at the height of his celebrity. He merely retired from the world, having encountered personal tragedy that would have knocked anybody over. It knocked him over for a while, I guess.

WHAT DID HE RESPECT IN PEOPLE?

I think integrity. I think dumbness, in the sense of genius dumbness. There's some kind of wise, well, first of all, workmanship. He understands that. And say with Sid Kaplan, the photographer, several times when he's talked to me about Sid, he said, you know, the thing about Sid, he's real slow. He's immovable, like sort of slow and immovable, but he knows what he's doing. I think Robert liked that, the fact that Sid is totally himself, like a rock. Robert has this ability to work with people who you would think would be the opposite of his glamour. Not that he's so glamorous, but there is some glamour about him in the sense that he's this extraordinary photographer.

DO YOU HAVE A SENSE THAT YOUR OWN WORK, AS WELL AS ROBERT'S, AS WELL AS THAT OF OTHER PEOPLE WHO WERE WITH YOU IN THE 1960s, WAS AUTOBIOGRAPHICAL? CAN YOU EXPLAIN IT THAT WAY?

I never thought of Robert's work as autobiographical, but now in hindsight I realize it was autobiographical and had become increasingly open. In seeing himself objectively as part of the scene, it's an odd thing that he does with it. Years later in Boulder, Colorado, in 1982, we had the twenty-fifth anniversary of Kerouac's publication of *On the Road* and Robert went out, somewhat unwillingly, he wasn't sure he wanted that, but I was very eager to come out and do some little film 'cause it was like *Pull My Daisy* twenty-five years later, except with more characters. Like Burroughs was going to be there, Gregory Corso was going to be there as himself, Peter and myself, and Jack Micheline, the poet that Jack Kerouac liked, and John Clellon Holmes, and Carolyn Cassidy, who was played by somebody else in *Pull My Daisy*, she was Kerouac's first wife who was a really photogenic, amazing person, but most of all, Herbert Huncke, who was an extremely intelligent talker and very charming and ingenious as a per-sonage. I wanted Robert to come out and we managed that he was able to get funding for another film, which he did mostly on his own. Robert simply sat on the porch, stations himself on the porch where we were all living, it was up in the one old dark, multi-roomed dormitory place where most of the writers were staying. And every morning, everybody would get up and chew the fat, and have coffee together, and figure out what they were supposed to do for the

illness, finally became *Me and My Brother*. Peter had two brothers, Lafcadio and Julius. Julius was the one. And the only role I had was one as a waiter. Once in a while, Robert would set up a scene that we would have to act out. In my house, Julius and Peter were eating, and I was coming on as a sort of funny Hungarian waiter, serving them food. So that was funny, improvising scenes. So it took maybe two years of just solitary labor on his part, like a still-photographer going out, you know, certain scenes, he went out with maybe one photographer, had only one guy as his crew, maybe two at most, friends or amateurs. Then at one point, Peter's brother Julius wandered off and got lost in the mental hospital. So the main character was gone. So I think Robert got Joseph Chaikin, the actor, and he used him as a stand-in for Julius for some scenes. Then at the very end, toward the last scene in the film, Robert turns to Julius and asks him what he thinks about making a movie. Julius has been almost silent all through the film. Then Julius comes up with some astoundingly conscious answer. Later he became almost like one of Julius' best friends. Julius still asks after Robert Frank, and Robert goes and sees him whenever Julius is around, there is generally a meeting.

There's a funny compassion in Robert. Maybe not for himself but for other people, for not exactly clochards, but for people whose condition on earth is not what it looks like in the White House, not what it looks like in a middle class home, not what it looks like in a good Swiss Berger family, but for the outcasts, and the outcasts that are exactly real, somebody really stuck in the world, brought out of his control, maybe.

HE CAME FROM AN UPPER-MIDDLE CLASS SWISS FAMILY, YOU KNOW.

I knew very little about that although by now he was already a very mature fifty-eight- or fifty-nine-year-old man. I never managed to ask him about it, or overcome my shyness and impose upon him, and start asking him about his family.

HOW DO YOU THINK HE WAS TRANSFORMED FROM THE MIDDLE CLASS SWISS KID TO ROBERT FRANK, THE ARTIST? WAS IT COMING TO AMERICA?

No, I don't think it was that, because in his pictures in Europe, first pictures in Europe, he seemed to be the same, solitary guy. So he worked, he got out of his family and worked. And he was technically qualified by all the apprentice work he did there in the Old World European photography outfit. So I guess he just got out on his own, and I don't know if he was transformed. There's still some element of some of the European Bohemian about him—tolerance, I guess. Years later, Robert had a lot of tragedies in his life, with his daughter in a plane crash and his son was very ill, his marriage broke up, a long period of solitude and withdrawal from the world after all the tragedy. And his own work got out of his hands for a while, his own photography, some other people owned it.

and arranged it exactly chronologically and made an arrangement of all the images in it that were pictorial and photographic. And then he paid me something like ten dollars a day, something like five or six dollars an hour, or eight an hour, depending on how long it took me to do it. And I lived on that money for about two months. I felt amazed that anybody would take me that seriously.

FOR ME, LOOKING BACK AT THAT TIME, IT WAS ALMOST A VISIONARY THING TO LOOK AT A POEM LIKE *KADDISH* AND TRY TO DO A FILM OF IT.

Later I thought about it. I followed my story chronologically but Robert wanted to flash forward, also to my present day life, and depart from the enclosed historical narrative up to the present. I resisted it quite a bit because I felt that the integrity of the film was in danger. But I was willing to try to figure out what he was trying to do, and try to work with that. I didn't have much choice. It was his movie, anyway. I argued about it a little, I read about fifteen scenes. Then we had to raise money, or he had to raise money. I was too shy about it, sort of standoffish. I thought he couldn't raise enough money to do it, actually. So the film never got made.

So finally after about a year, in 1964, '65, he began filming around the house, filming Julius Orlovsky, who is also from a mental hospital like my mother had been, and Peter, and their relationship. So what began as *Kaddish*, a study of mental family tragedy and mental

Pull My Daisy – Allen Ginsberg, Gregory Corso

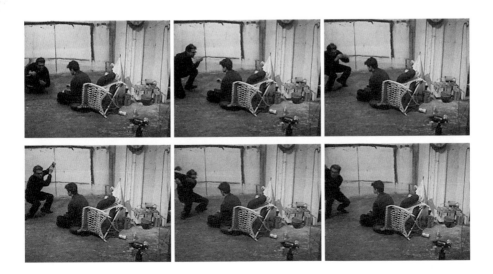

Yes, over the years we've kept doing some things together. I don't know how, at first it was a little tenuous. I think he liked Kerouac, because they both had this spontaneity, an allowance of accidents, and an allowance of accident in mind or accident of space, as part of what was real. They could show other people what interested them in writing or in pictures. That may be the thing that I liked most in Robert's work, his helplessness for the actual fact of chance, and his acceptance of that, and his willingness to include that.

HE USED IT TO HIS ADVANTAGE, TOO. HE SAW THAT HE WAS ABLE TO USE CHANCE IN HIS WORK.

Yes. Two years ago Robert had bought a JVC video camera, a new toy, and he came over to my house. I hadn't seen him in a while, and we had a long relationship over my *Kaddish* project.[1] I was really eager to read him this new poem. It was twenty-five years later, an epilogue to *Kaddish*. The vision and the dream I had about my mother, white shroud. So I sat in the chair and started reading it to him, and he had his JVC and he filmed me reading this poem to him for the first time, with all the interest I had in reading it. And afterwards he said the reason he likes the JVC, the video, was that it's like stills. Accidents happen. You can hear the scraping of the chair, the taxi honk outside, people clearing their throat. It included reality. It was more flexible to include reality, like the accident of the still photo.

DO YOU THINK MAYBE THAT VIDEO WAS AN EXTENSION OF *ME AND MY BROTHER*?

Well that's another story. Sure, that's why he was interested. He liked *Kaddish*, or somehow *Kaddish* appealed to him. It was recently written. I had gone, left it behind, published by City Lights, I was in India, went around the world, got back to New York. I was relatively broke, didn't have much money, had a cheap apartment on the Lower East Side finally. No work, I didn't know what I was doing, was living day-to-day, actually. And he had the idea of making the film of *Kaddish*. And *Pull My Daisy* had such great historical success.

I know I didn't say much about that, but *Pull My Daisy* was one of the first totally improvised films, and in a way it completely changed Hollywood. It affected the entire film world. That and a few other films, like John Cassavetes' *Shadows*, films from the underground, really did have a catalytic effect, altering people's awareness of what you could do: improvise and be open and sexual if necessary. So I was glad Robert was interested in *Kaddish*. We had to make a script and I didn't know anything about film scripts. We went out and I came to Robert's house every day or every other day, a couple of times a week, and we'd sit down at his typewriter, at his office, at his desk, and write a scene. I took the poem and cut it into pieces

from some kind of psychosis sect, arrived with his mother. This priest came visiting Neil's mother, and I think I was there with Peter Orlovsky.

YOU WERE ACTUALLY THERE WHEN THE PRIEST CAME?

Yeah. Yeah. But the actual scene has been replaced by the movie in my memory. The movie is now more vivid, pictorially. Robert and Al Leslie, the painter, both of them lived on the Bowery, and it's always amazing when you can get lofts on the Bowery. During this time it was a community of artists like Willem De Kooning and Franz Kline, who were friends of Robert's. Apparently he had a whole circle of friends that developed after we first met—kind of a home life in a way. I lived on 2nd Street about five blocks away with Peter. So we went to Al Leslie's loft, oh, every day or every other day for a couple weeks. Robert made Gregory Corso play himself, or try to, and he had the painter Larry Rivers play Neil Cassidy. He had a certain amount of energy, but he wasn't as cute as Cassidy. And Delphine Seyrig, who later got to be a famous actress, played Neil Cassidy's wife. It was the wife pissed off because all these Bohemian guys were coming to visit her hard-working railroad husband, who was also a kind of a wild party-goer, party-giver, all of them a little spiritual, talking about holiness. Ah, but acting a little silly. So what we had to do was invent, following the script in a very general way, not keeping to the actual dialogue and not keeping to the actual scenes. And that's where Robert was good. He didn't make us memorize the script and we didn't have to act, basically.

DO YOU THINK THAT *PULL MY DAISY* WAS A REFLECTION OF WHAT WAS HAPPENING AT THE TIME?

Very much so—Kerouac objected to only one thing that was there, a little tiny note of violence. I don't know who put that in, Robert or Al Leslie, when someone in the film got miffed and put an imaginary finger pistol to his head, to the other guy's head and went, pow! Maybe Larry Rivers to Gregory. And also a slapping scene, although Kerouac covered that nicely in his soundtrack by saying, "Out of Frank Sinatra, unrequited love is a bore."

HOW MUCH OF THE FILM DIRECTION DO YOU THINK WAS ROBERT'S AND HOW MUCH WAS FROM ALFRED LESLIE?

I don't know in hindsight, but it seemed to relate more to Robert at the time. It was his compassion or sympathy, his attention that I've found most attractive—some quality of glum approval, glum attentiveness. I kept thinking of him as the glum Swiss man all those early years. Ah, and I began to develop a kind of paternal liking for him. He seemed like a father figure, he had a family and a couple of kids. His son Pablo, at any rate, was there.

A Conversation with Allen Ginsberg

Philip Brookman

Philip Brookman interviewed Allan Ginsberg about Robert Frank on October 13, 1985 in New York City, during production of the television documentary *Fire in the East: A Portrait of Robert Frank.* This is an excerpt from their conversation. *Fire in the East* was produced by Anne Wilkes Tucker and Paul Yeager, and directed by Philip Brookman and Amy Brookman for The Museum of Fine Arts, Houston and KUHT Public Television, Houston. A collection of interviews and videos from this project is housed in the Archives of The Museum of Fine Arts, Houston.

HOW DID ROBERT FRANK FIT INTO YOUR WORLD AND THE WORLD OF YOUR FRIENDS?

So once Robert took my picture. He was living on 3rd Avenue on the Bowery and we went downstairs to the backyard, which was a pile of old lumber and garbage, against an old Bowery brick wall. And I went down there in sort of like a pit of old lumber and rusty iron, canyons, and pieces of boiler, and stood on it, and he took my picture against the wall. That's still one of the best pictures he took. I didn't meet Robert until 1958, and I actually didn't know anything about him at all as a photographer. I heard he was supposed to be a big photographer, but that didn't mean that much to me. I didn't think photographers were as important as poets or prose writers. I was a little flattered seeing that this photographer thinks we're important enough to take pictures of. But he didn't require us to pose because he was making a movie.

We were making a movie that was called *Pull My Daisy*, which was built on a script of Jack Kerouac. I'd never seen it before. I didn't know Kerouac had written it. And it's a very simple and down-home story of family life, seen in Neil Cassidy's Los Gatos, California household, with his blond wife and I guess a couple of his kids, three young babies, and a scene that I was actually present at in real life, when a visiting priest, some kind of a California priest